Rolling

HarperCollins*Illustrated*

Stone

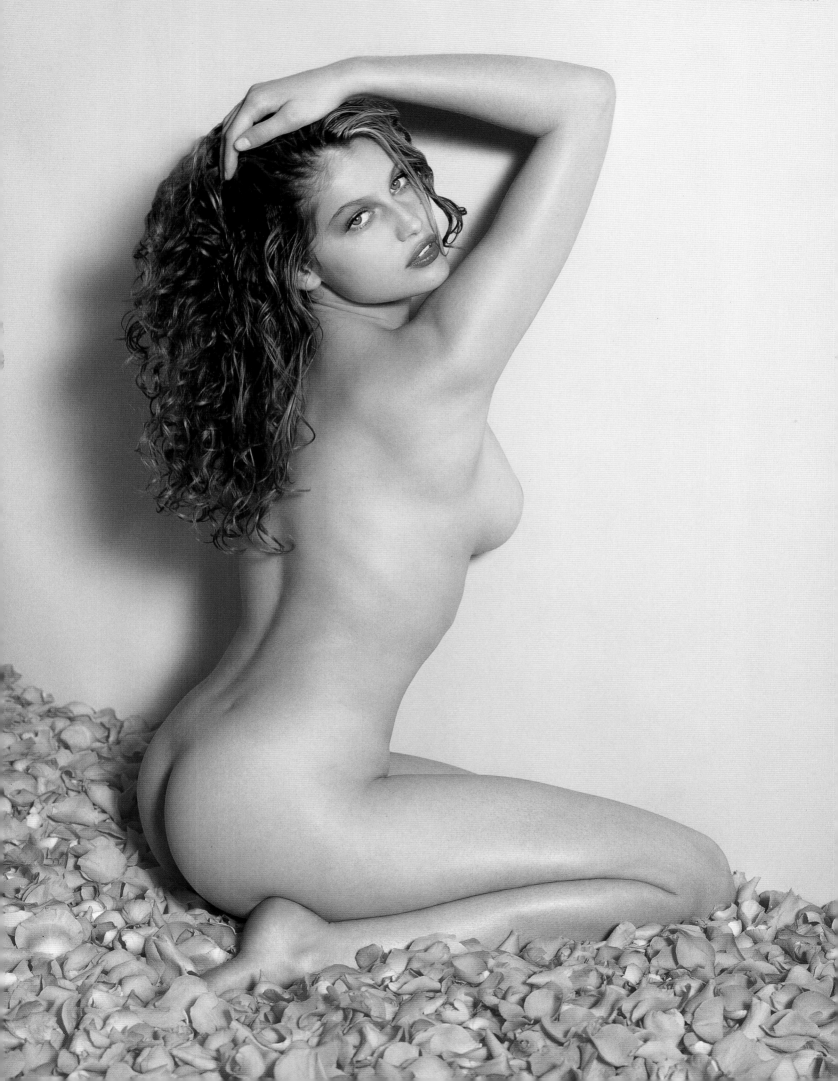

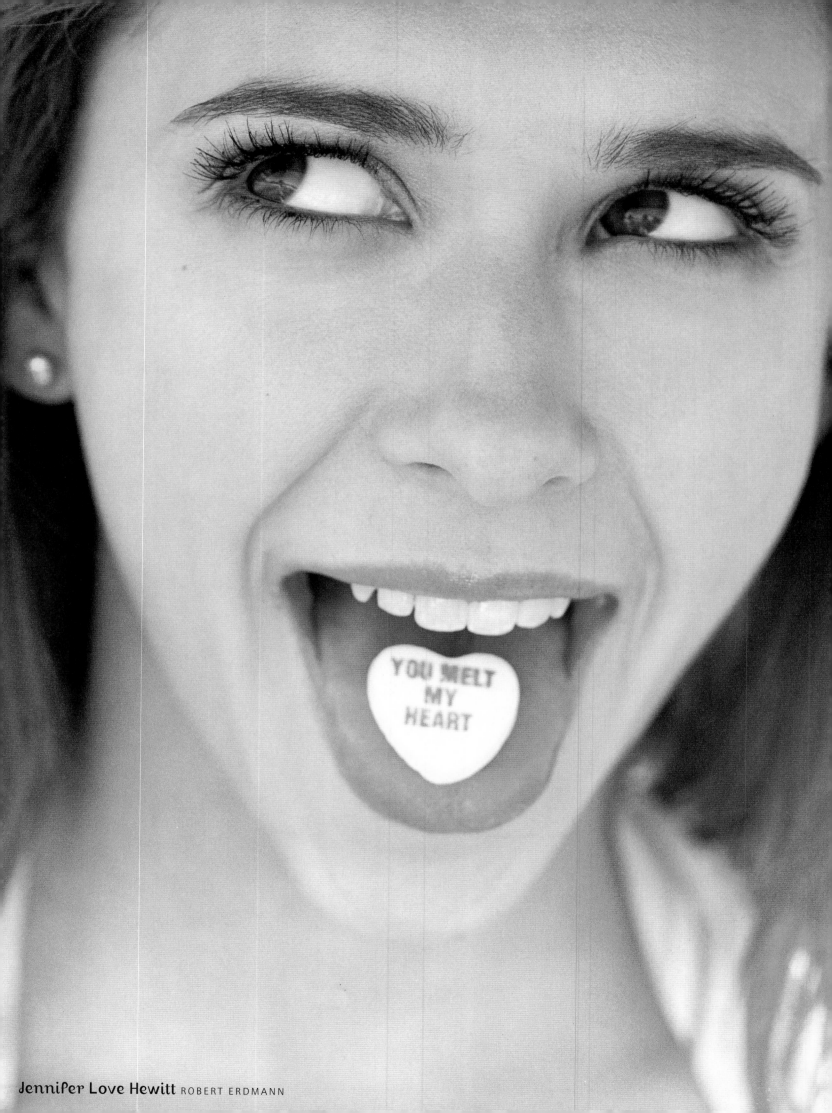

Jennifer Love Hewitt ROBERT ERDMANN

"On with the dance! let joy be unconfin'd;
No sleep till morn, when Youth and Pleasure meet
To chase the Glowing Hours with Flying Feet—"

—LORD BYRON, *CHILDE HAROLD'S PILGRIMAGE*, THIRD CANTO (1816)

House

"Young blood, young blood, young blood
I can't get you out of my mind."

—THE COASTERS, "YOUNG BLOOD" WRITTEN BY
JERRY LEIBER, MIKE STOLLER AND DOC POMUS (1957)

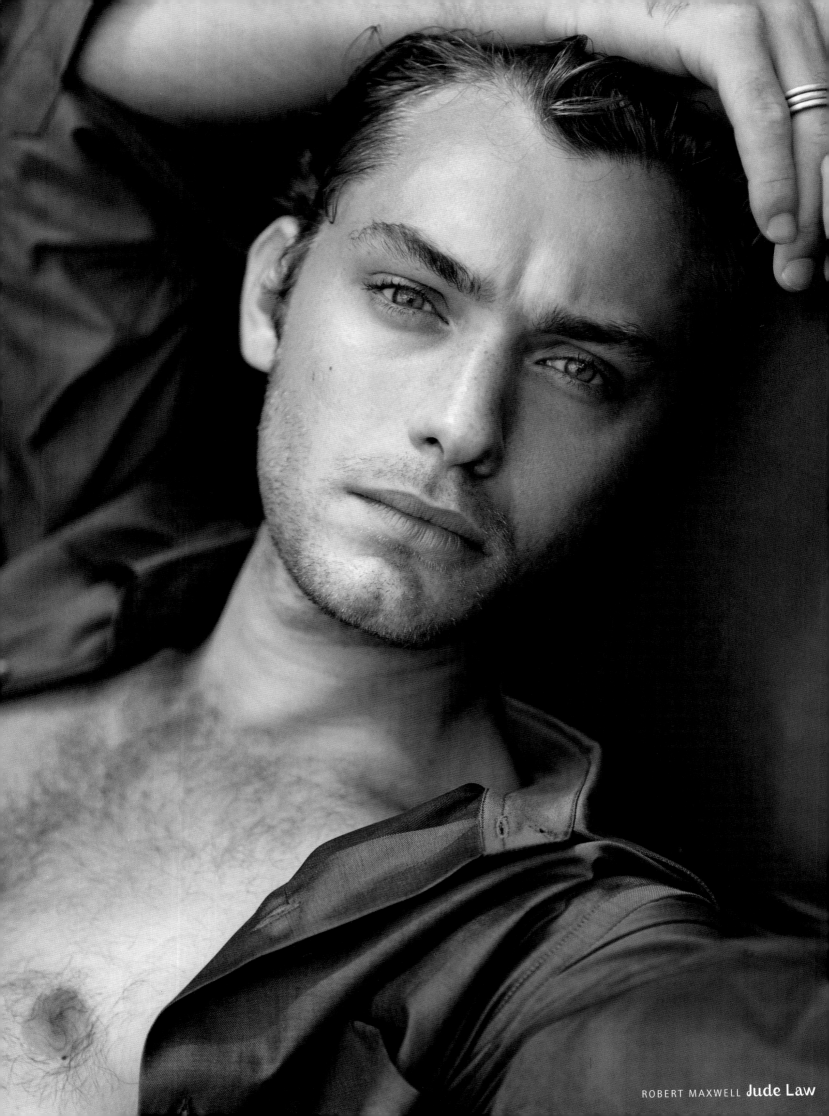

ROBERT MAXWELL **Jude Law**

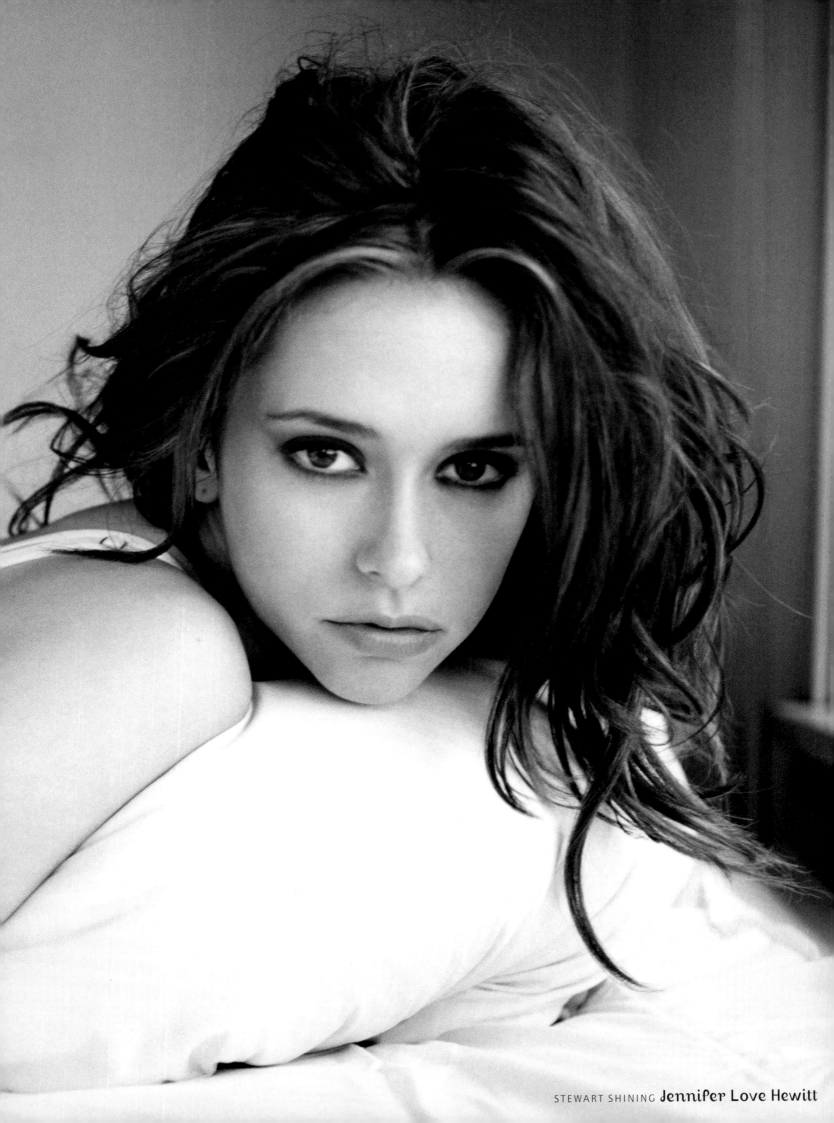

STEWART SHINING Jennifer Love Hewitt

Is it just me, or is it getting hot in here?

HotHouse – a balmy book full of heat-seeking images that capture the essence of the assorted hotties we can't get out of our minds – is dedicated to the fetching principle that youth isn't *necessarily* wasted on the young. Even to a feverish thirty-something writer, all the sweet birds and babes of youth on display within these pages at their most glowing, glamorous, intimate and flamboyant have become captivating, sometimes pulse-increasing, subjects of desire.

All of our lovely *HotHouse* flowers – preserved for posterity by some of the world's greatest photographers – are seen in full bloom and stand deliciously at the corner where Youth and Pleasure meet and often hang out. These fin de siècle stars – pop icons in various levels of training and undress – appear to move on flying feet. Often they have been graced with other remarkable body parts as well. Turn the page and you'll likely find yourself feeling hot and not at all bothered.

Yes, Virginia, most of these artists – actors, singers and other ravishing fellow travelers in the business of show – are rather young chronologically; all of them are young at heart. Each and every one of these lovelies has created, at least for a brief shining moment, the lovely illusion that he or she is indeed larger than life, to borrow a phrase from those early Twenty-first-Century philosopher kings, the Backstreet Boys.

And let it be said that these folks have never seemed larger than in these iconic photos, a credit to all the photographers whose work appears here. If the cover shot of the Academy Award–winning babe Angelina Jolie – who showed writer Mim Udovitch that tattoo above her bikini line which (translated from the original Latin) means "What nourishes me also destroys me" – doesn't utterly destroy you, get a pulse. To catch a forbidden glance of David LaChapelle's controversially naughty-yet-nice session with Britney Spears (did a young lady's bedroom ever look more fabulously, worryingly inviting?) or Mark Seliger's titanically charming shots of Leonardo DiCaprio (a lot more fun than a day at *The Beach*) is to cast your eyes over some of our freshly minted icons bathed in an illuminating and, yes, endlessly sexy new light.

HotHouse performs an invaluable public service by gathering together in one humid location many of the young men and women who are experiencing, wallowing in and beating the sultry heat of fame. The portraits collected herein capture these creatures acting up, acting out or simply taking it all off. (Memo to self: Must learn Seliger's secret for instantaneous garment removal.)

History teaches us that at any age, this whole fame thing can be a daunting, often overwhelming proposition. It can stunt your emotional growth or simply kill you. It can also be a little like a dream. "It feels good," the perennially upbeat Jennifer Love Hewitt told me for her ROLLING STONE cover story in 1999. "The best way I can explain

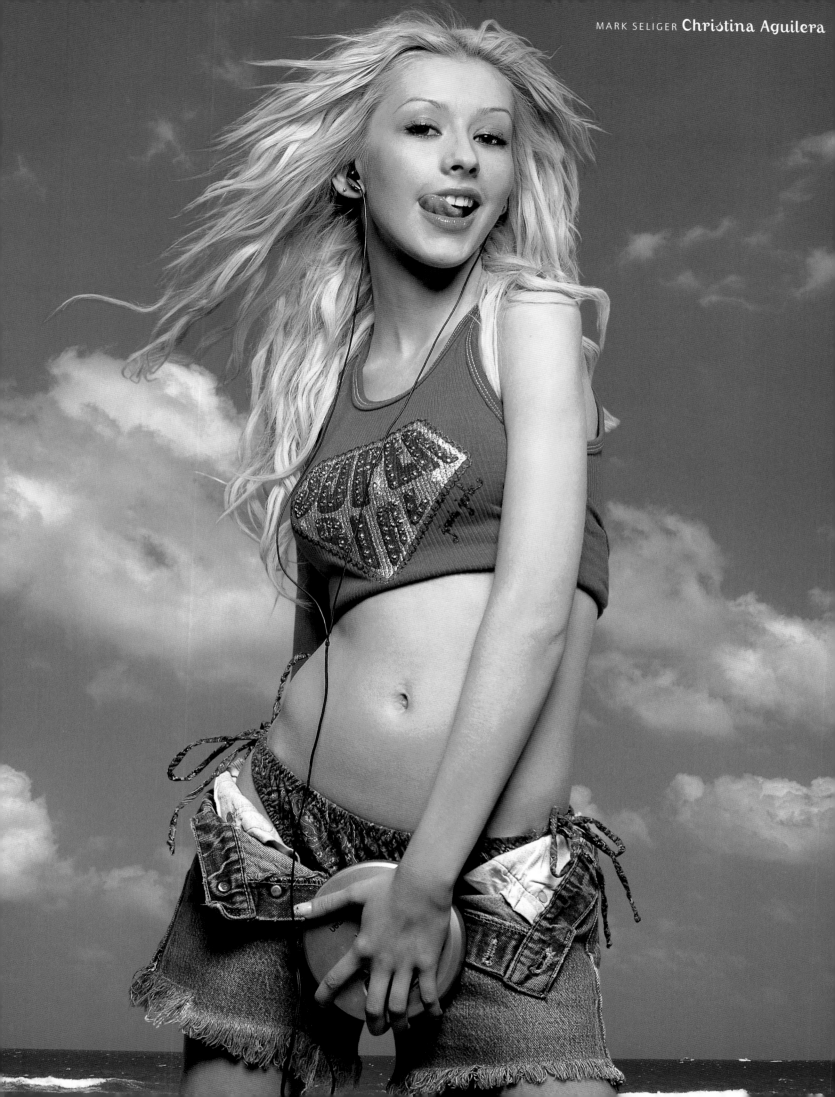

it is, it's like the Fourth of July – when you watch the fireworks and you don't understand how anything could be so big and bright, but they still enchant you, even though it seems like, wow, you could never touch that. That's what my life feels like now."

HotHouse – which you *can* touch – represents a group home to young Hollywood, like Katie Holmes, Sarah Michelle Gellar and Barry Watson, who almost simultaneously have become fixtures on both the big screen and that powerful smaller one.

This book documents a rather dramatic changing of the musical guard, too. Mariah Carey – who appears in fine form here – is something of a grande dame in this company. For an earlier generation that came of age around the original Woodstock – those for whom Britney Spears covering "(I Can't Get No) Satisfaction" suggests a sign of the Apocalypse – the sound of Young America may always mean Motown. But while oldies may still be goodies, the current sound (and, lest we forget, the current look) of Young America is now on display not just in ROLLING STONE but also on *Total Request Live*, where Carson Daly is Walter Cronkite and Christina Aguilera – not Aretha Franklin – is the Queen of Soul.

A new breed has emerged and with it a return to the old-fashioned, nonironic, "let's put on a show!" attitude. As a rule, our new generation of stars appears far less interested in raging against the machine than in finding a profitable, pretty place inside it. Don't fear this inevitable shock of the new, yuppies and X'ers – it's a lot more interesting and fun to join in and check out all the sights and sounds. Some hard-line elders may reject the new order out of hand, but ultimately it's not only impossible but also foolish to stop time. Pop culture periodically demands young blood to replenish itself.

Boomers probably best remember the Coasters' version of the song "Young Blood," but the young bloods leaving you breathless within these pages are anything but coasters – they're achievers, some even overachievers. The hippie crowd may be put off by the new generation's Alex P. Keaton–like ambition, but, hey, that's *their* problem. Truth be told, anyone who ever auditioned for a movie or released a record was most likely trying to be a star. "The Beatles started this," Backstreet Boy A.J. McLean told me when the band appeared on the first ROLLING STONE cover of the century, after winning every category in the magazine's Reader's Poll except Best Zionist Dogcatchers. "They were actually the first boy band," this bright Boy noted of his Fab forefathers.

Debbie Gibson was right: There is such a thing as Electric Youth, and its surge just keeps getting stronger and stronger over time, and ever sexier sooner. "All I did was tie up my shirt!" Spears innocently told ROLLING STONE writer Steven Daly in 1999, discussing her famous – or is that infamous – schoolgirl video for ". . . Baby One More Time" – which Daly memorably described as her "strutting statement of intent." Technically,

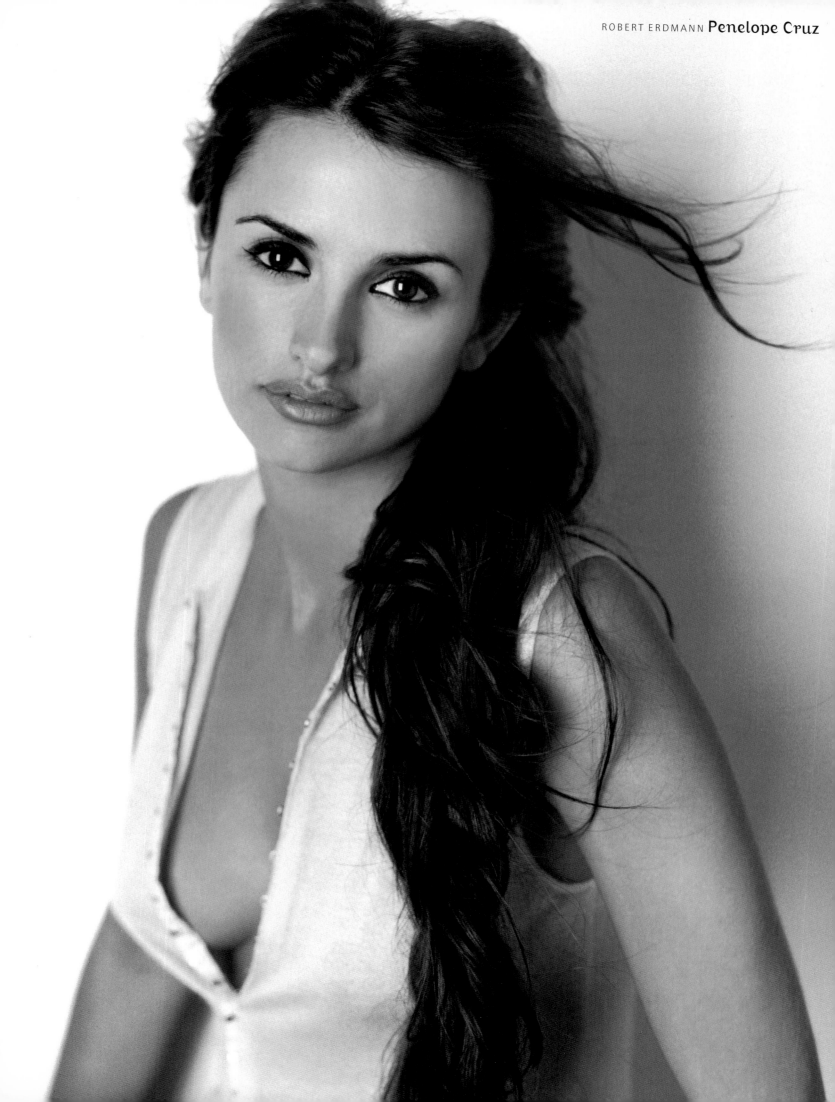

Spears was correct, but in tying up that shirt, she tied the tongues of millions of boys and girls of all ages. Not that there's anything wrong with that. Remember Elvis Presley – rock & roll's first teen god – wasn't just a great singer, he was also Elvis the Pelvis, our first strutting, hip-shaking King.

For a few change-resistant naysayers, Young Hollywood will never take the place of Old Hollywood – Angelina Jolie will always remain first and foremost Jon Voight's little girl. For these spoilsports, our procession of pretty pop acts from Florida is something like a horror movie – *It Came From Orlando*. That sort of cynicism is easy and ultimately misguided. It's a simple matter of pop-culture physics – for every seductive action, there must be an equal and opposite seductive reaction. That's the way it works: Every generation gets to dream up its own Nirvana. To keep the customers satisfied, the look, sound and smell of teen spirit changes all the time.

In the fall of 1999, Christina Aguilera discussed her time on the *The New Mickey Mouse Club* with ROLLING STONE's Anthony Bozza, who rightfully called the show "a petri dish of germinating teen talent." In fact, the *Club* was home for not only Aguilera, but also for Spears, future 'N Sync–sters Justin Timberlake and JC Chasez as well as the Artist Later to Be Known as Felicity, Keri Russell. It's a Mickey Mouse World now, folks – the rest of us just live in it.

Pete Townshend's famous declaration, "Hope I die before I get old" from the classic Who song "My Generation," has long been a rock rallying cry, yet society's definition of what is actually old keeps changing. Just when it seemed the world didn't trust anyone over the age of twenty, we witness a miraculous rebirth such as veteran guitar-god Carlos Santana becoming all the rage. Yes, it helped that youngsters Rob Thomas, Lauryn Hill, Everlast and Wyclef Jean came along for Carlos's remarkable ride, but his resurrection as a cultural force proves we really only get old when we stop growing. One can still be smooth at any age.

In his memoir, *My Early Life: A Roving Commission*, Winston Churchill – who just happens to bear a striking resemblance to Backstreet Boys and 'N Sync moneyman Louis Pearlman – gave this enduring piece of advice to young people inheriting the earth: "You will make all kinds of mistakes; but as long as you are generous and true, and also fierce, you cannot hurt the world or even seriously distress her. She was made to be wooed and won by youth."

Here's hoping that the youthful forces who are magnificently revealed and celebrated inside *HotHouse* can rise to that historic challenge. In the meantime, while waiting for the test of time, fan yourself off, sit back and prepare to be wooed and won.

— David Wild

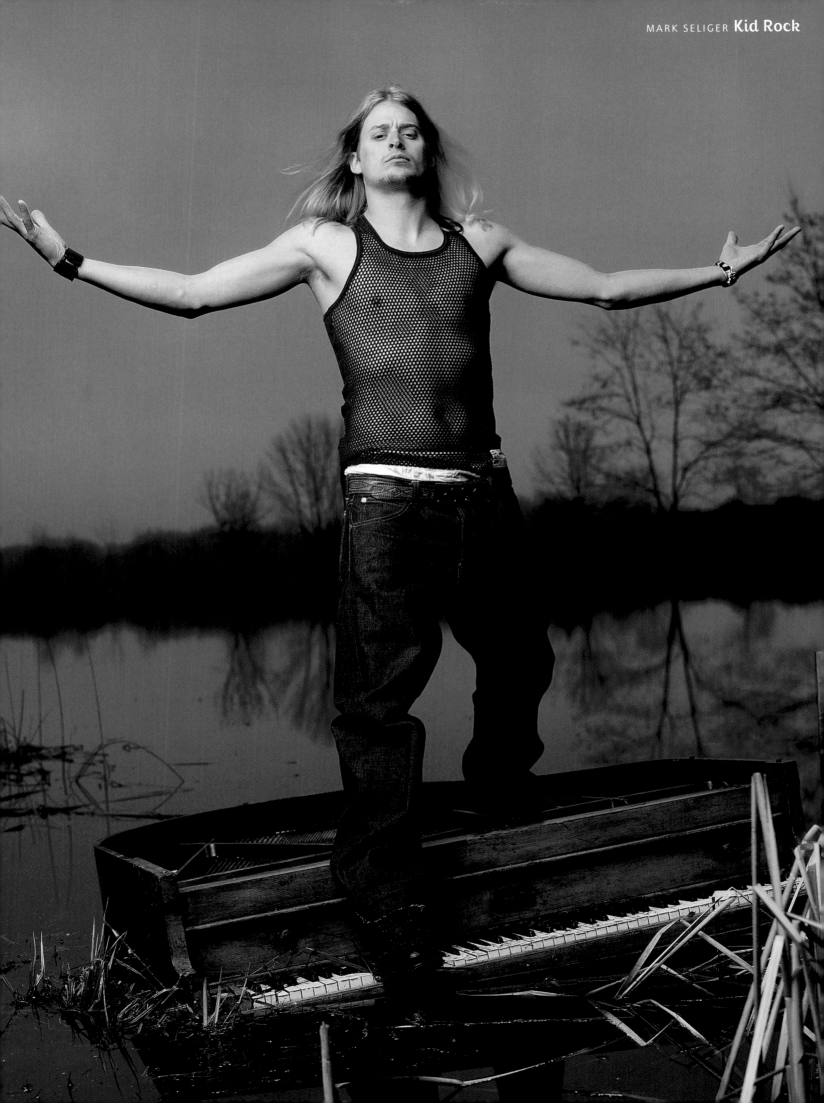

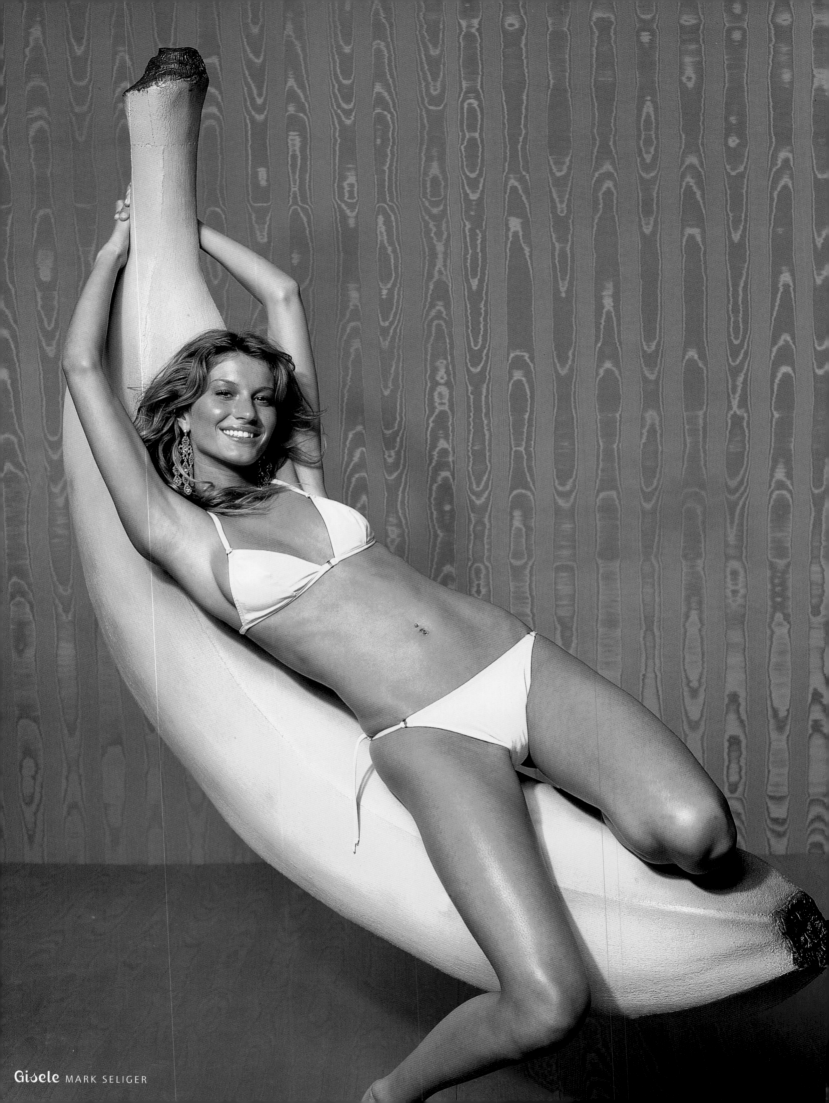

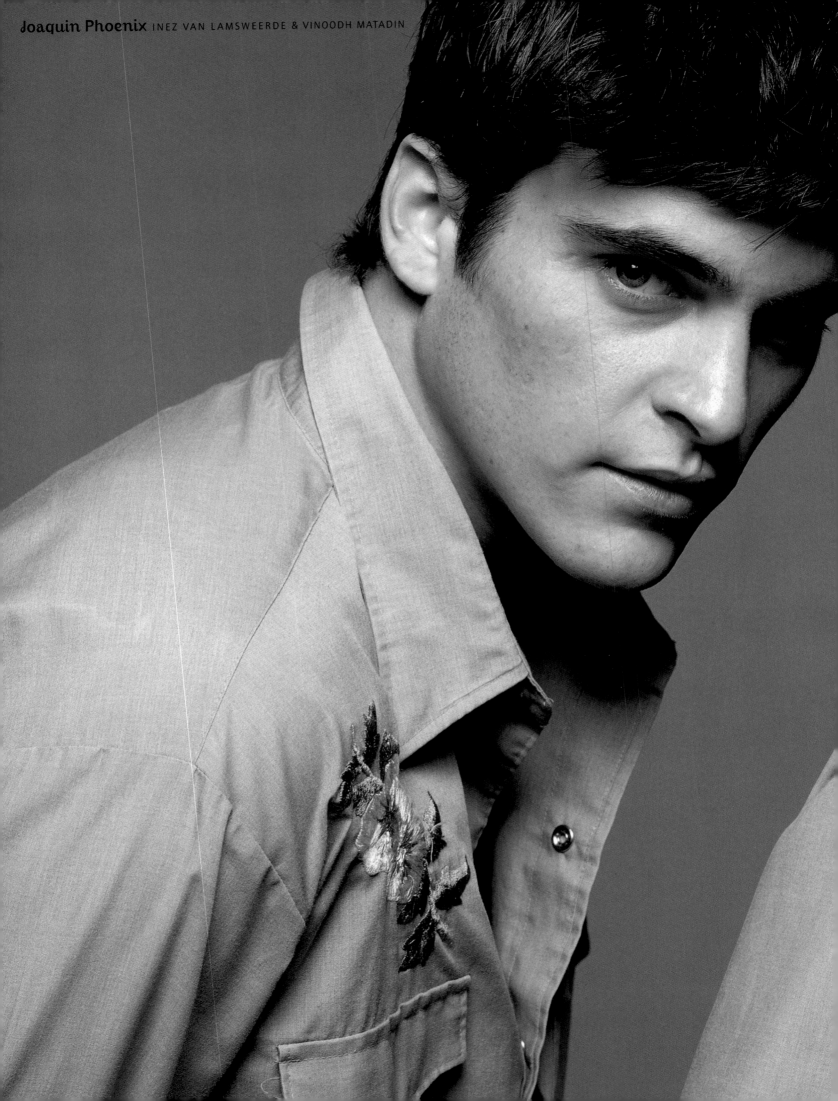

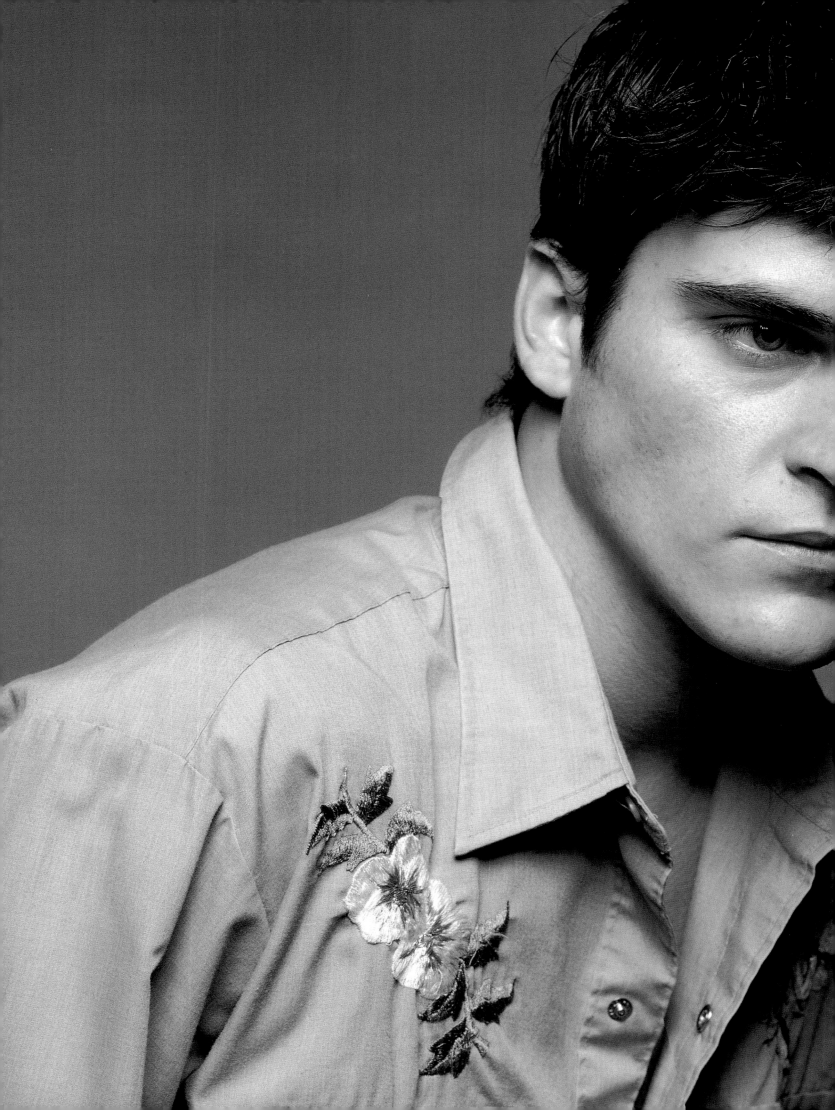

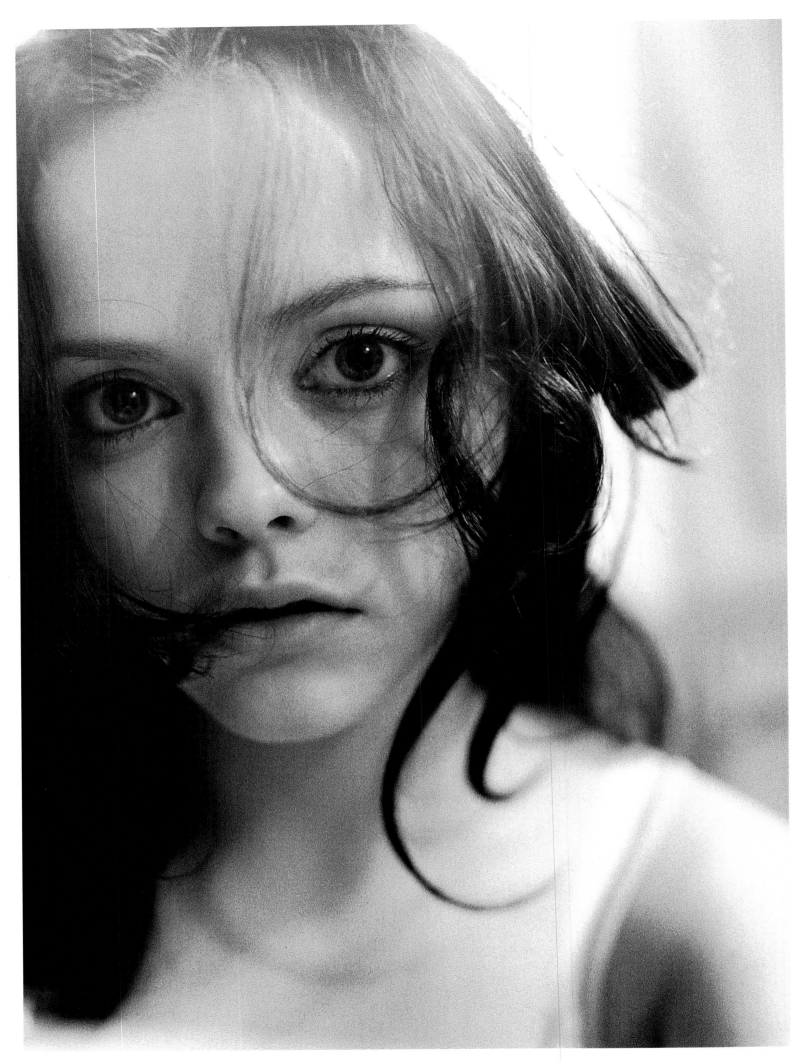

Christina Ricci PEGGY SIROTA

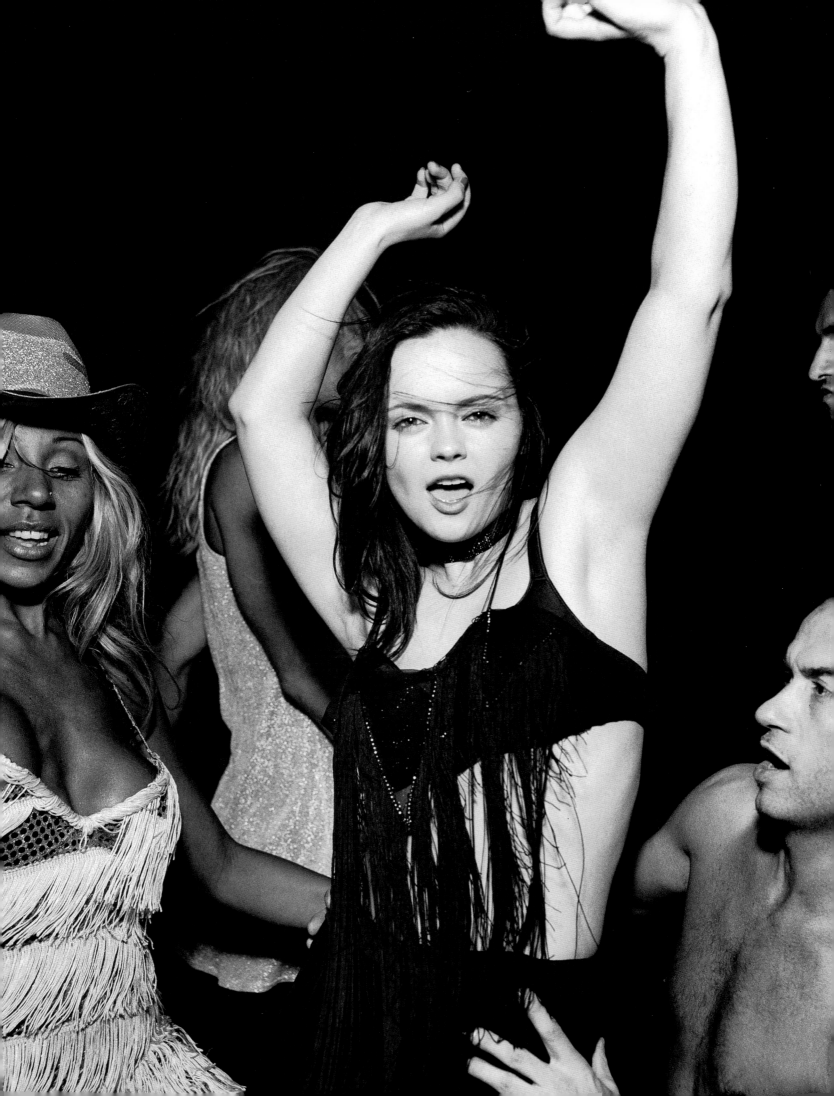

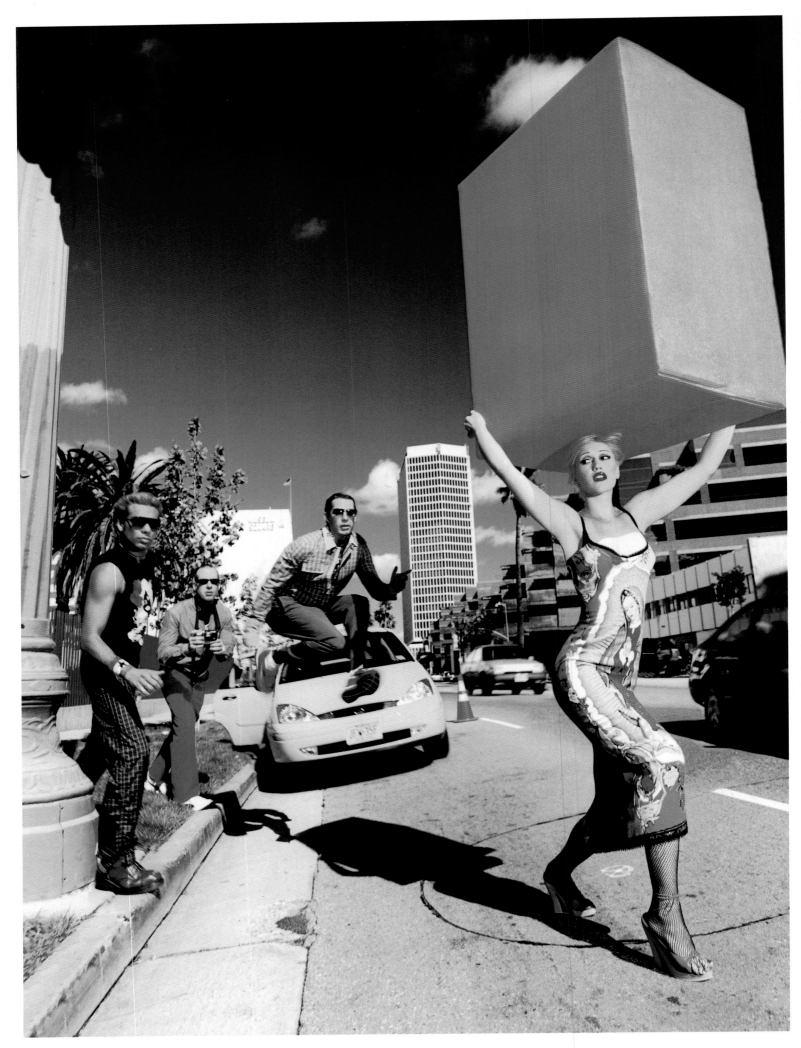

No Doubt DAVID LACHAPELLE

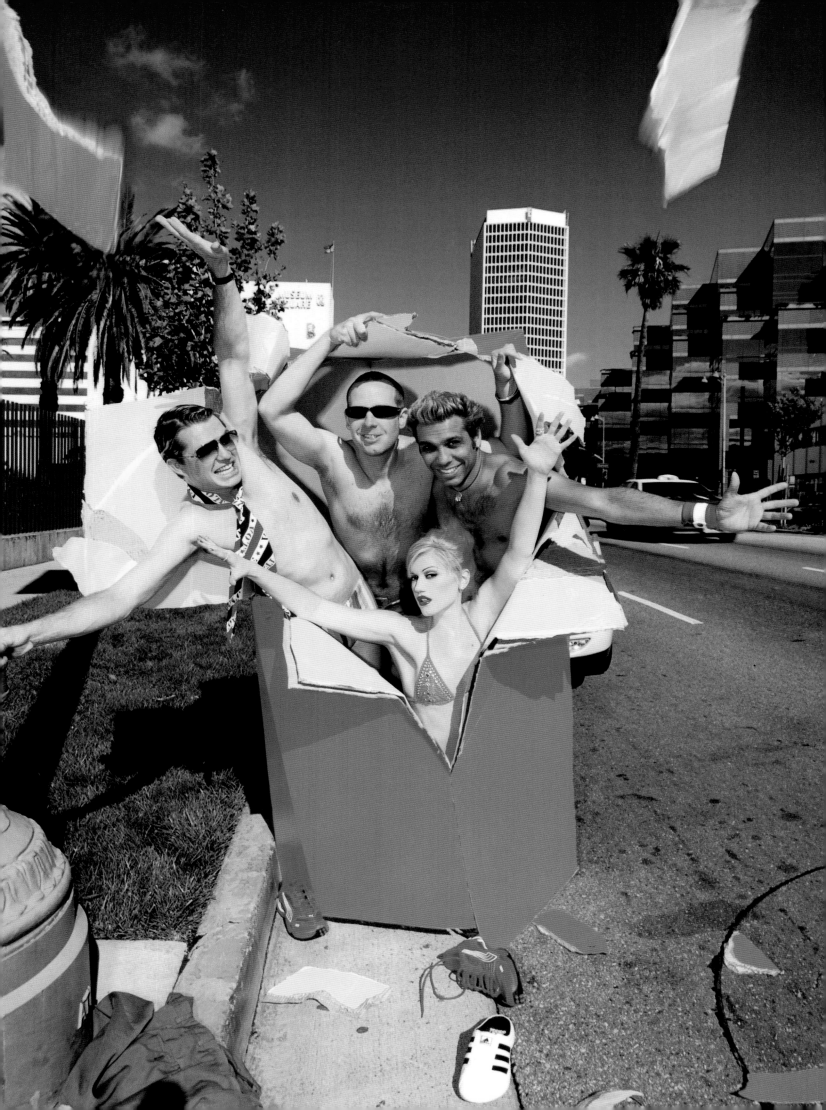

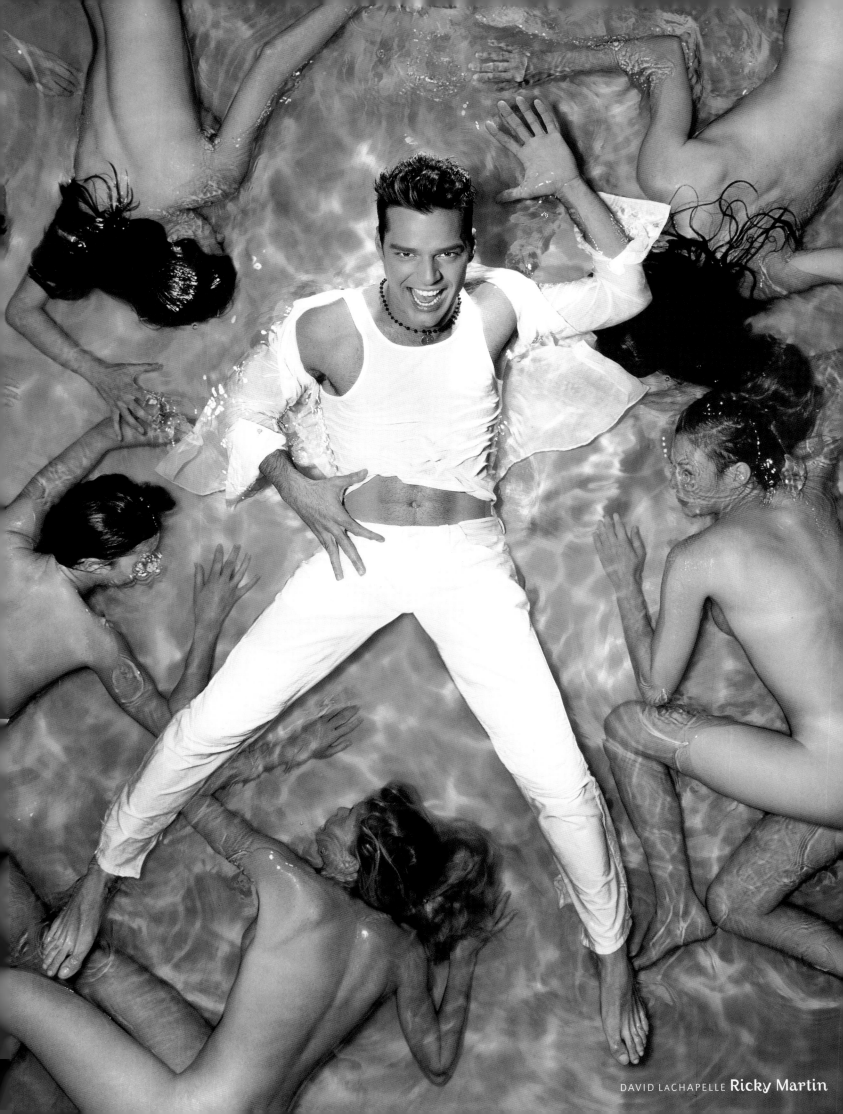

DAVID LACHAPELLE Ricky Martin

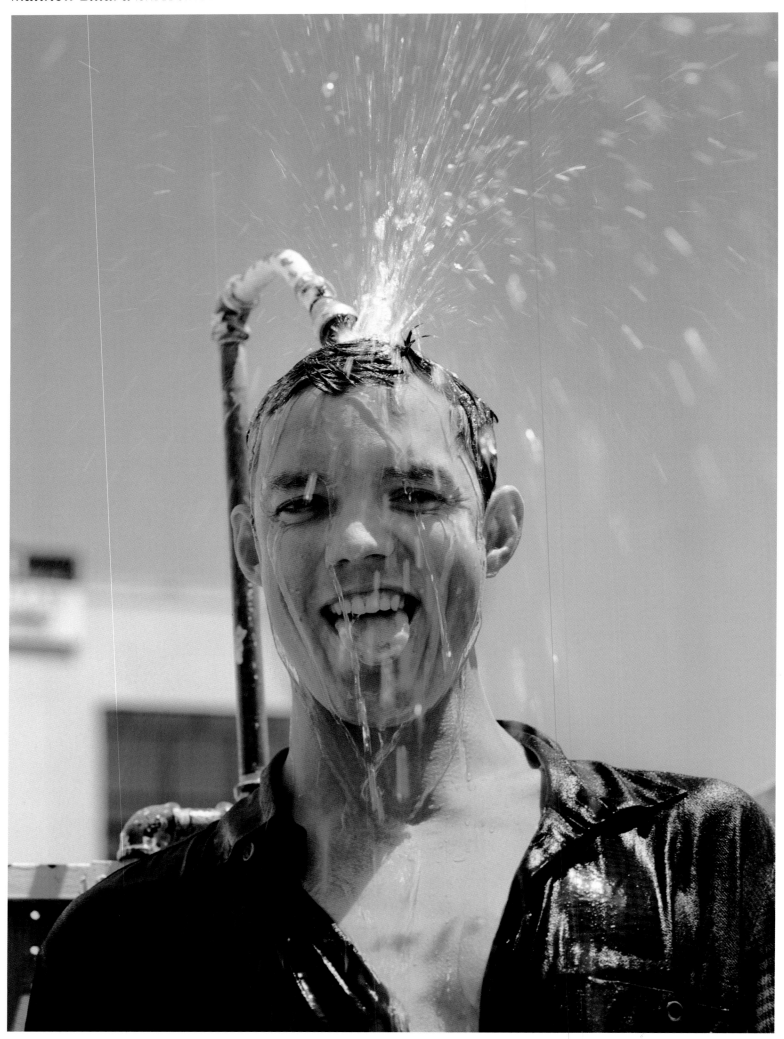

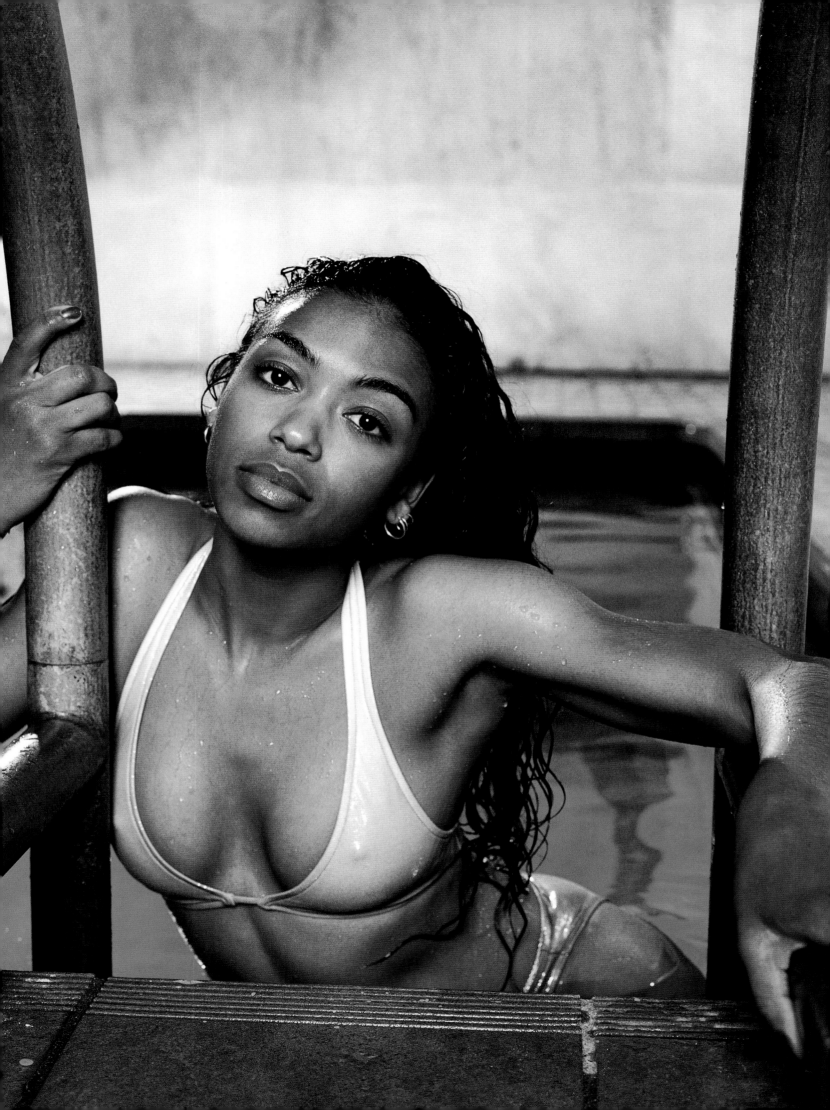

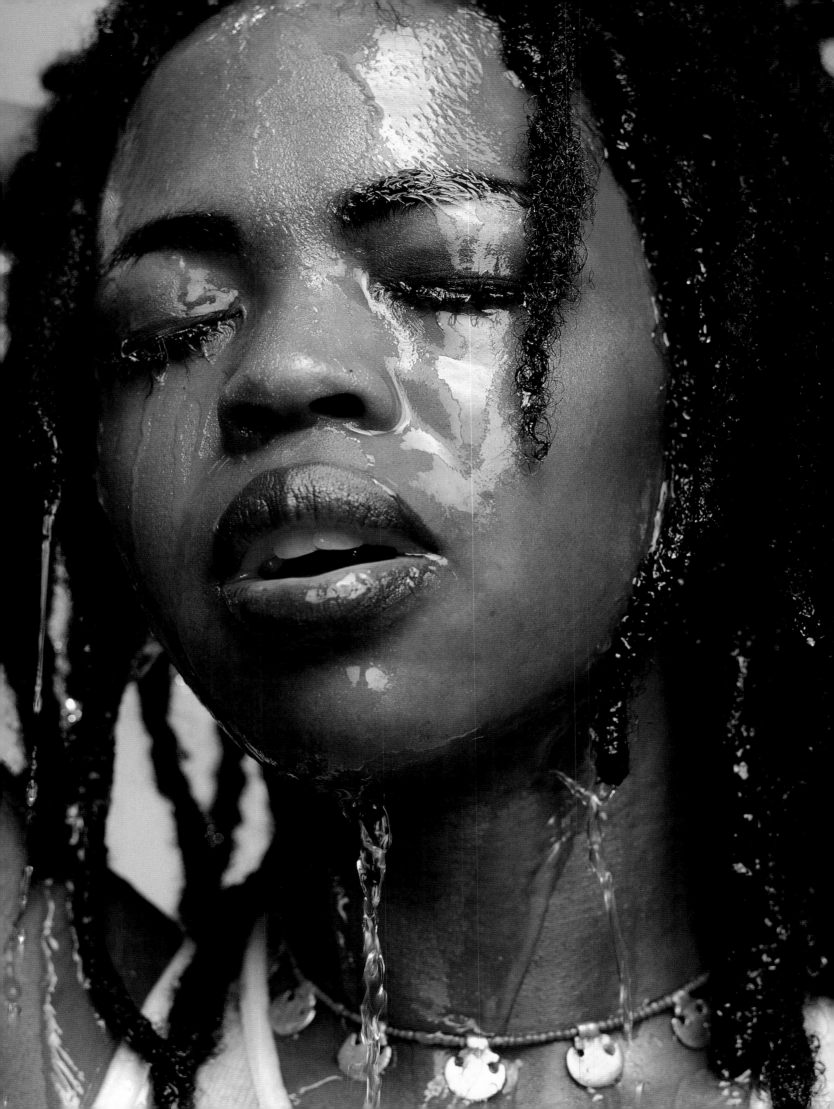

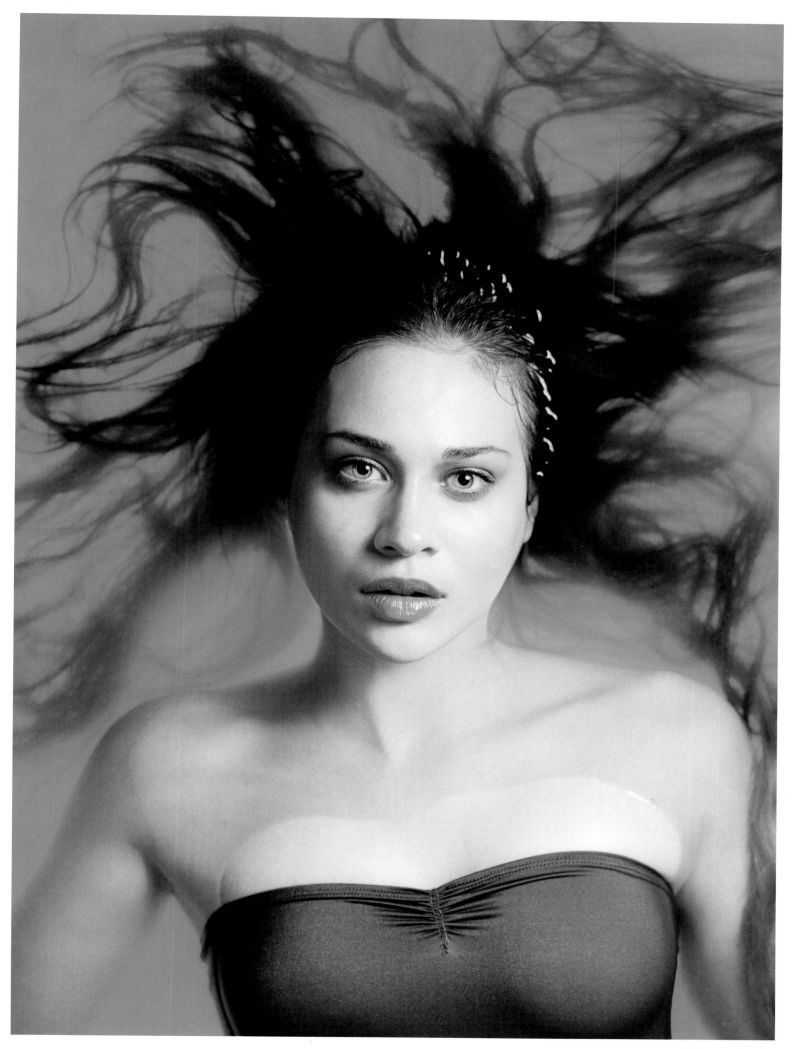

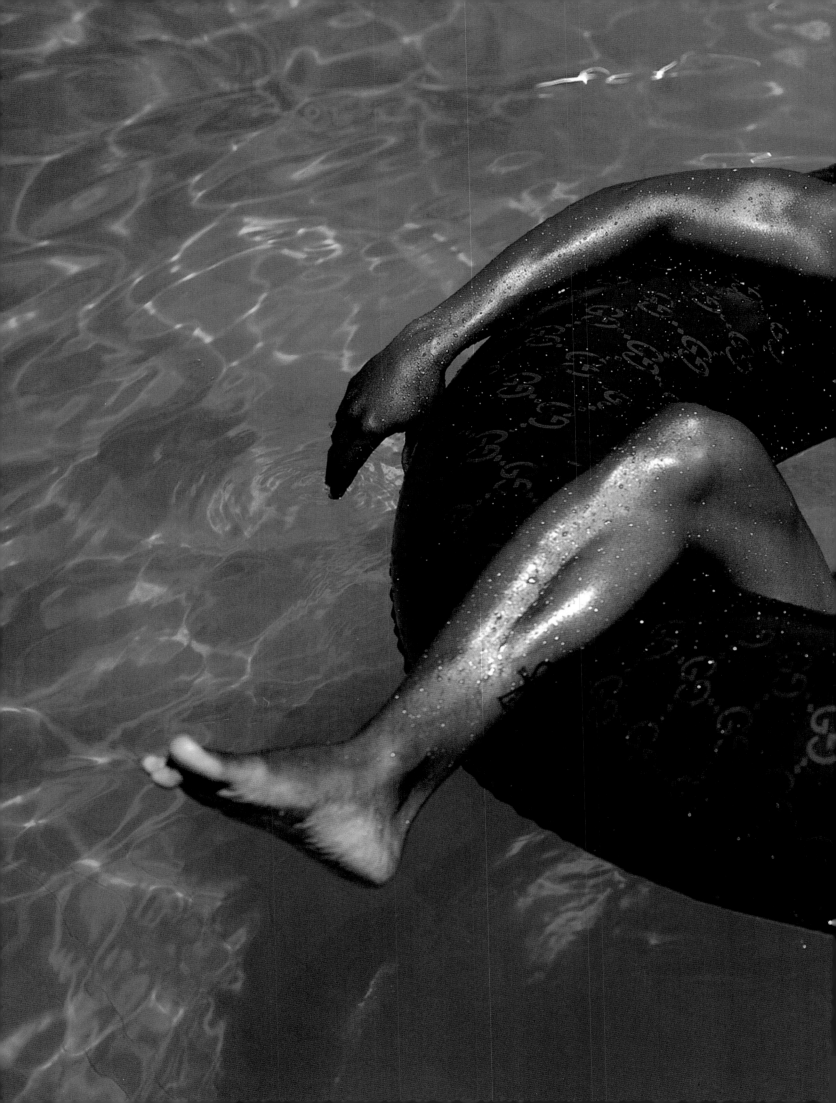

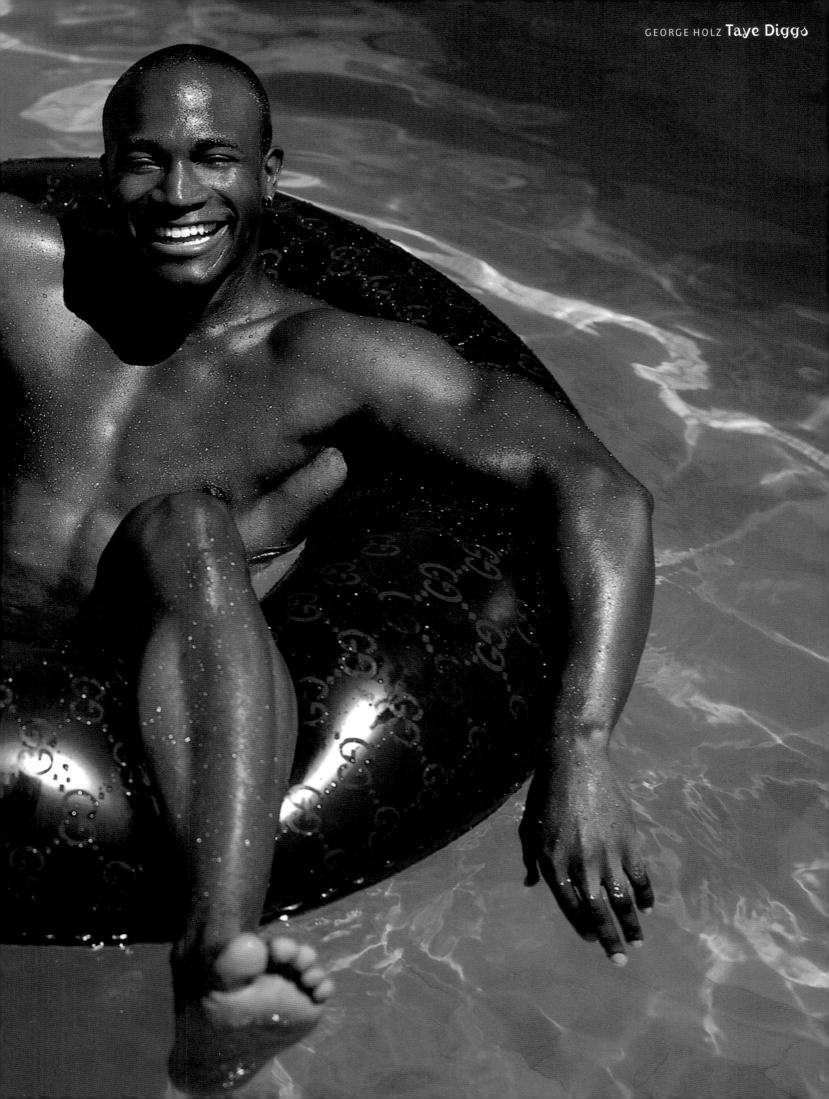

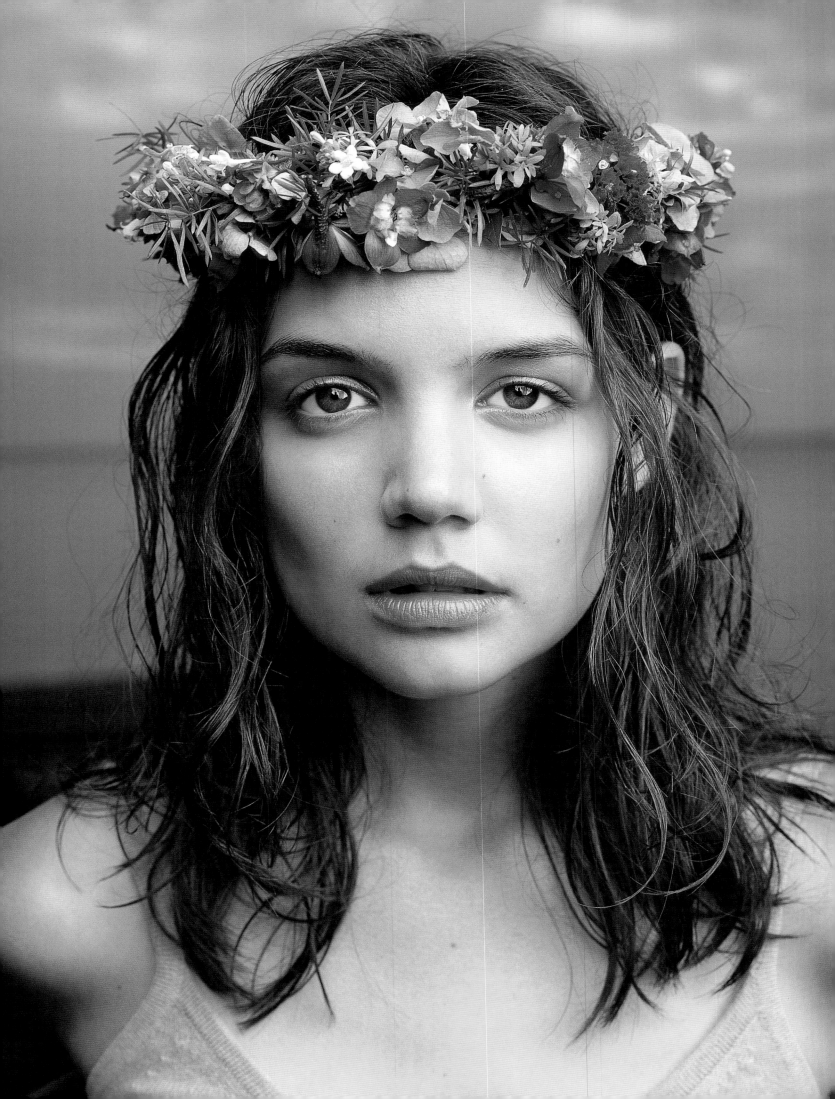

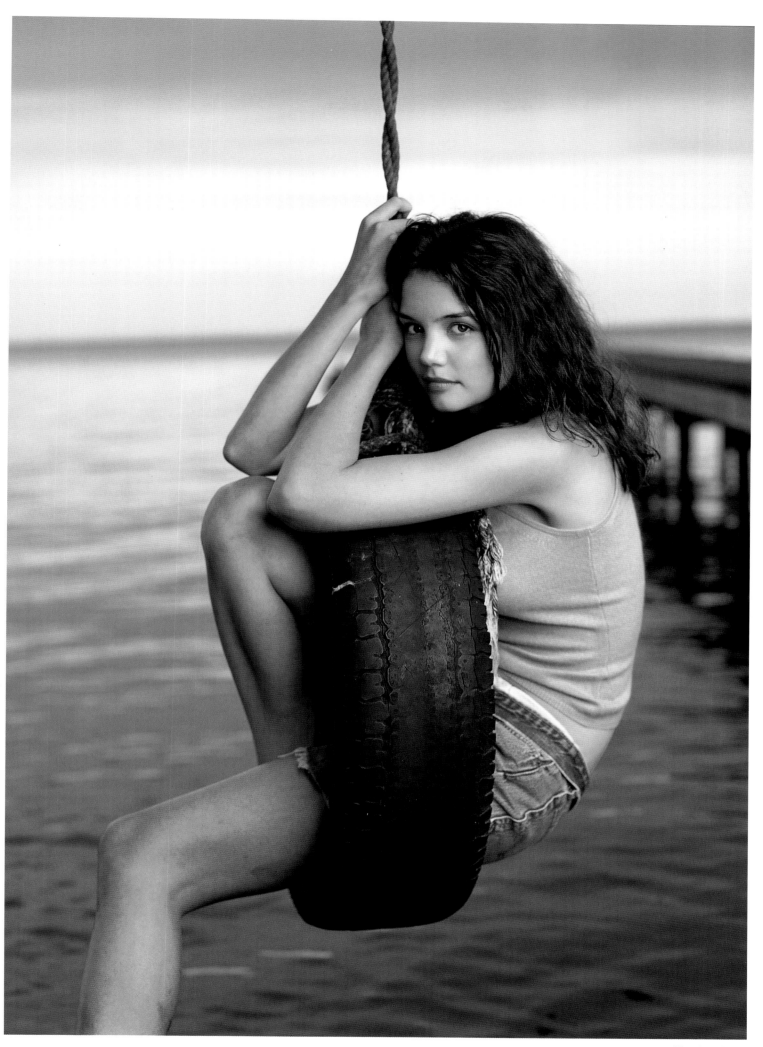

MARK SELIGER **Katie Holmes**

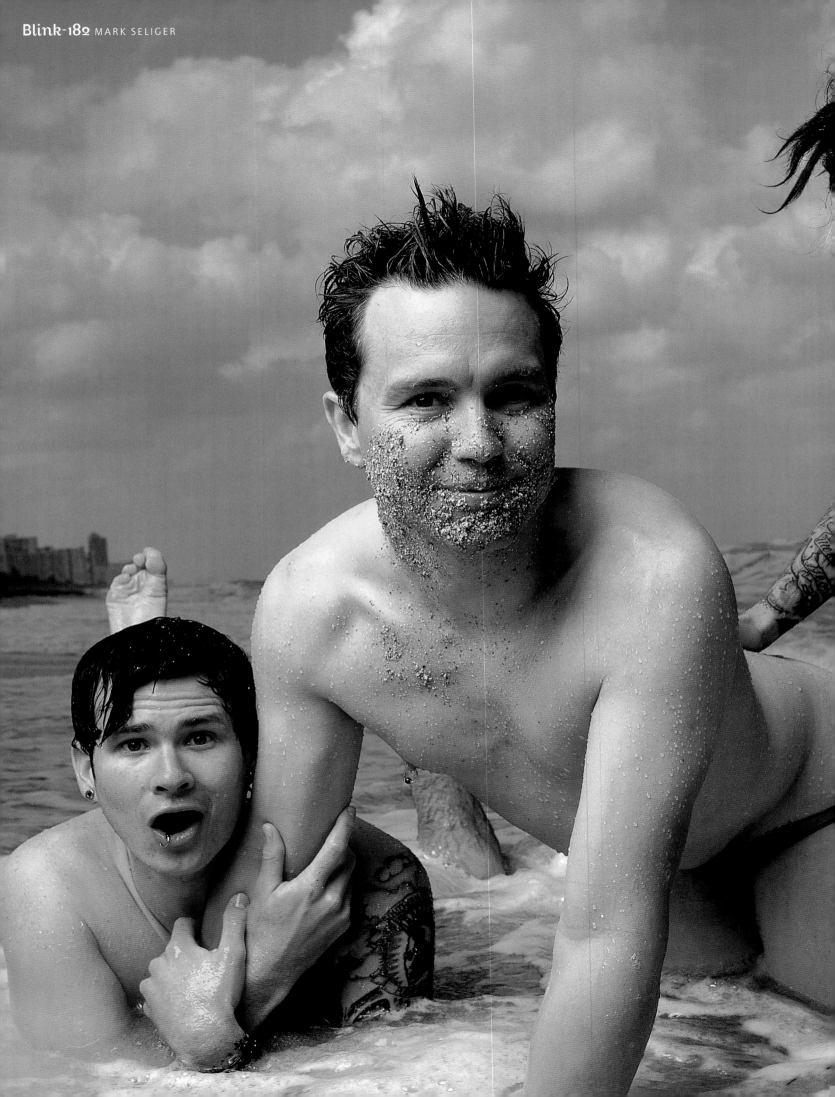

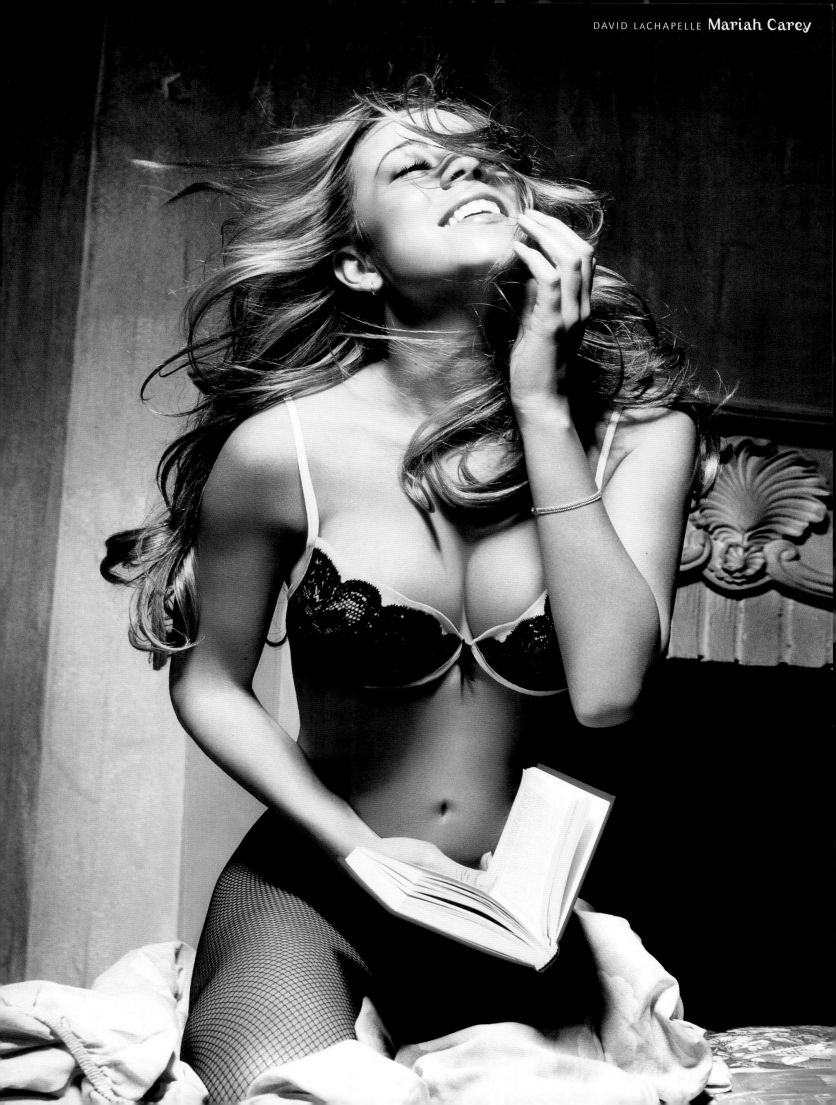

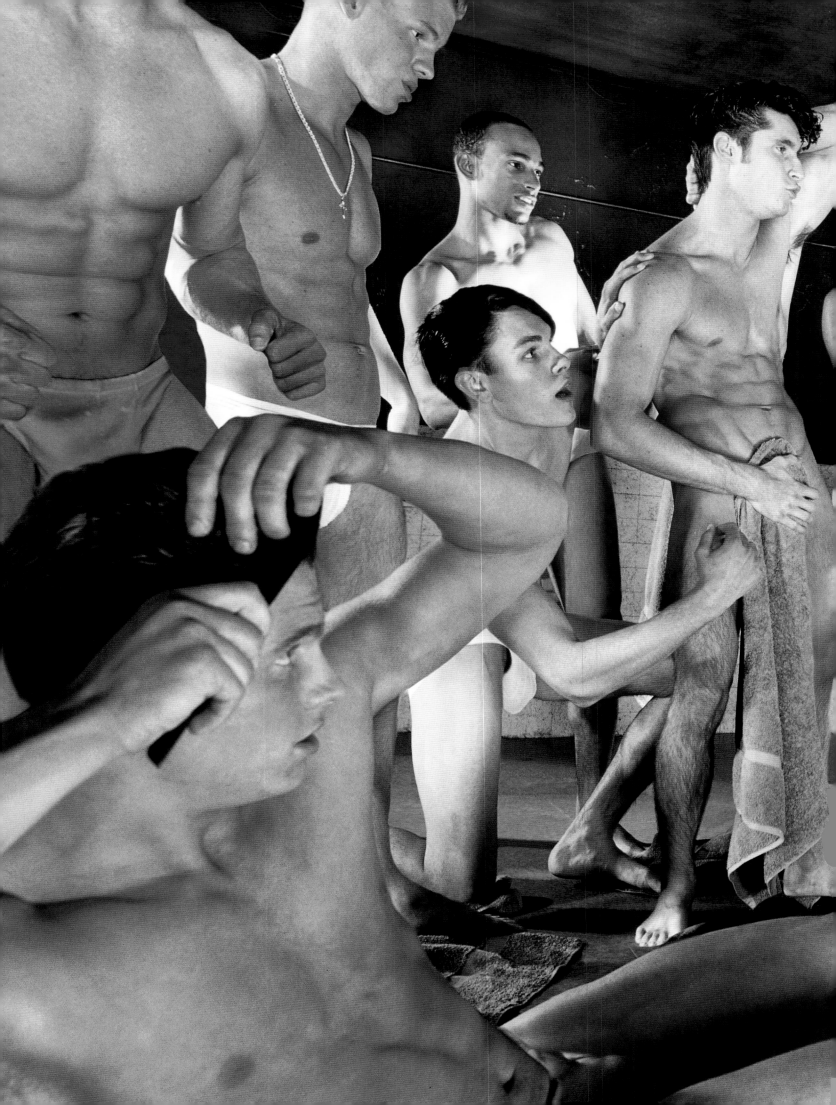

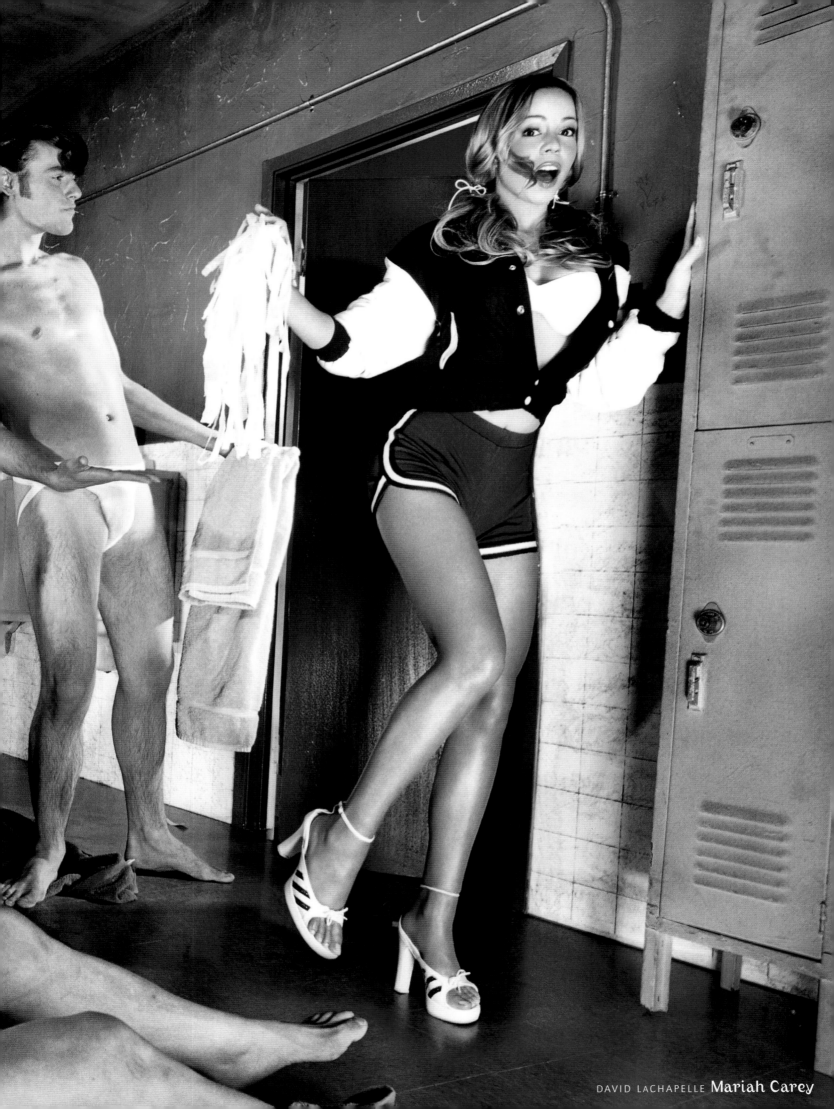

DAVID LACHAPELLE **Mariah Carey**

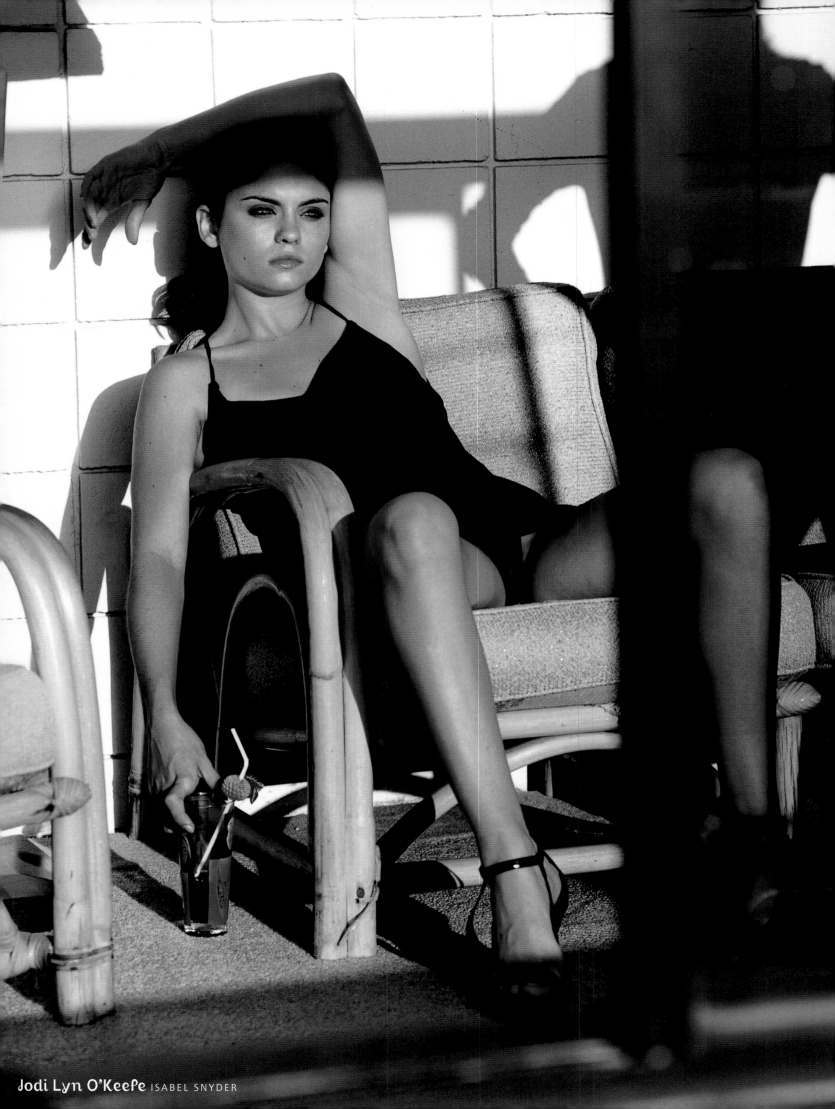

Jodi Lyn O'Keefe ISABEL SNYDER

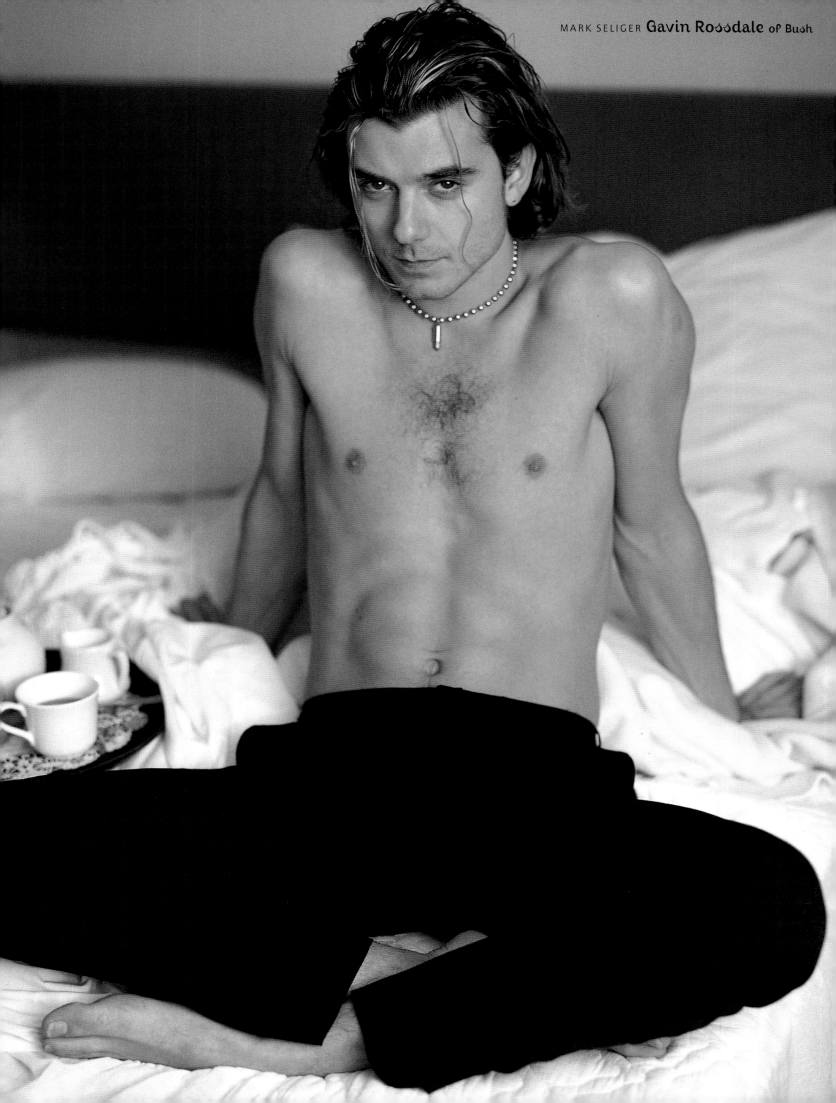

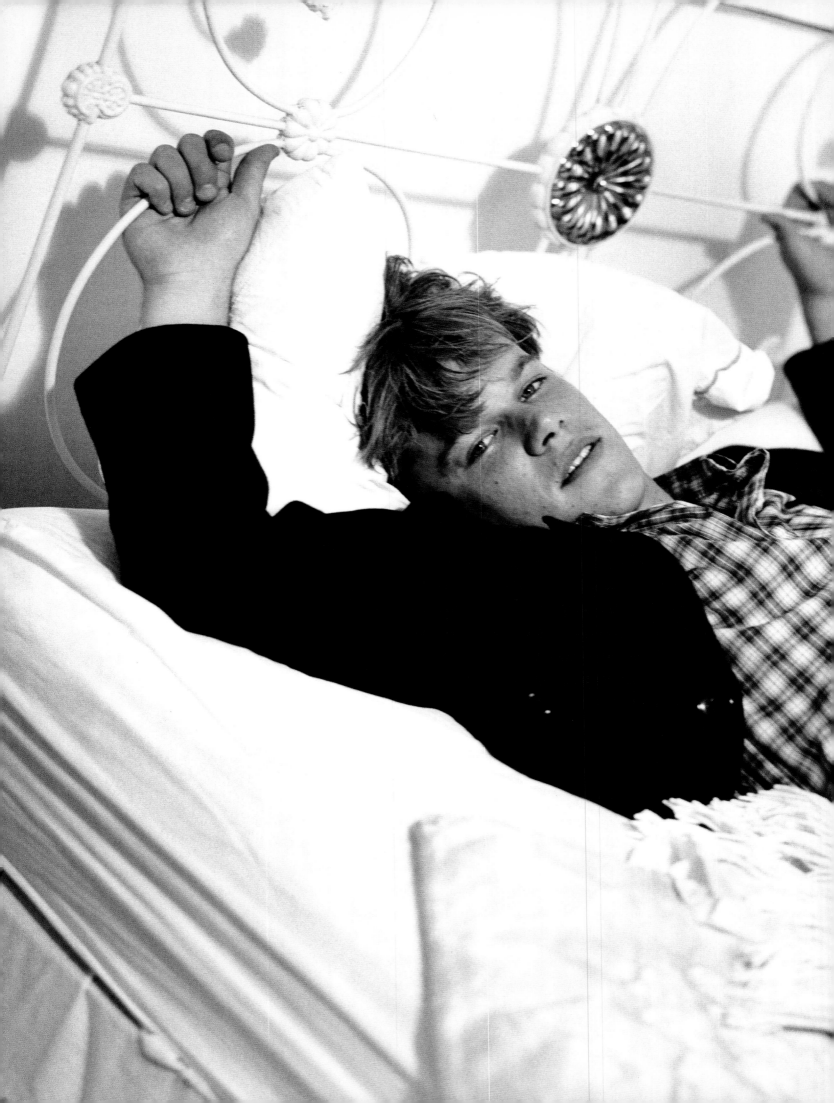

BRUCE WEBER **Matt Damon**

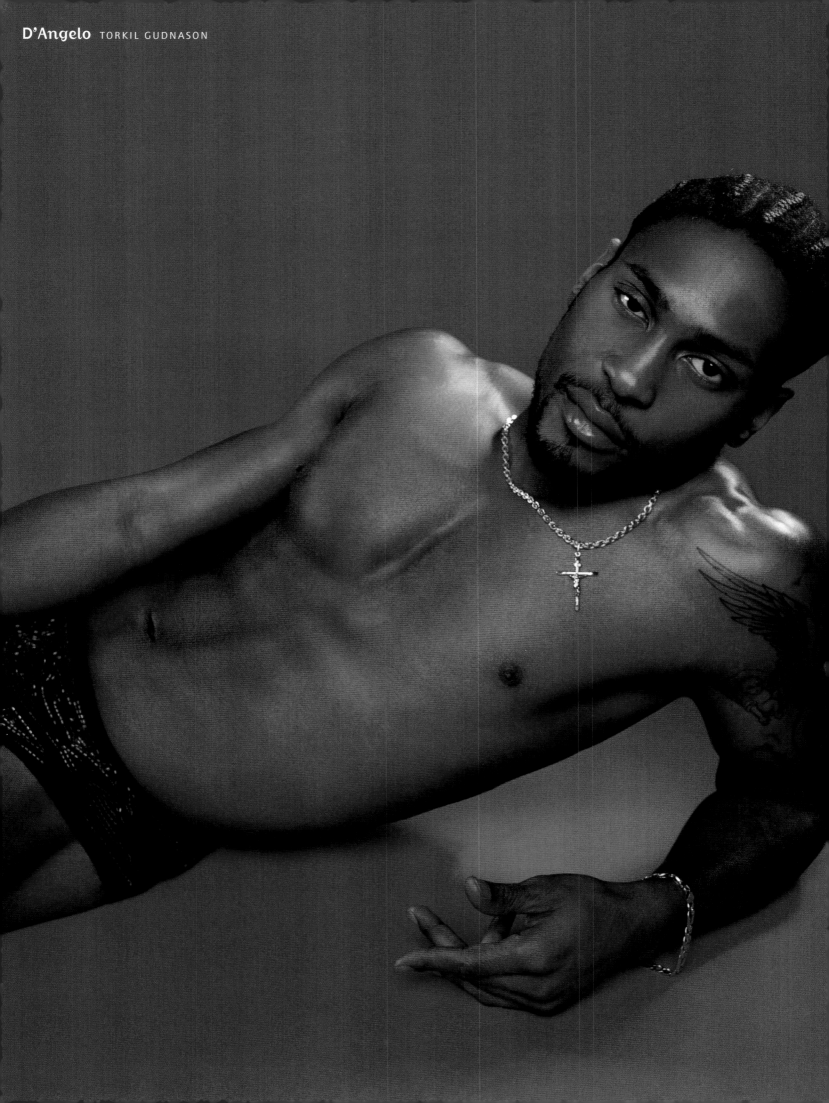

D'Angelo TORKIL GUDNASON

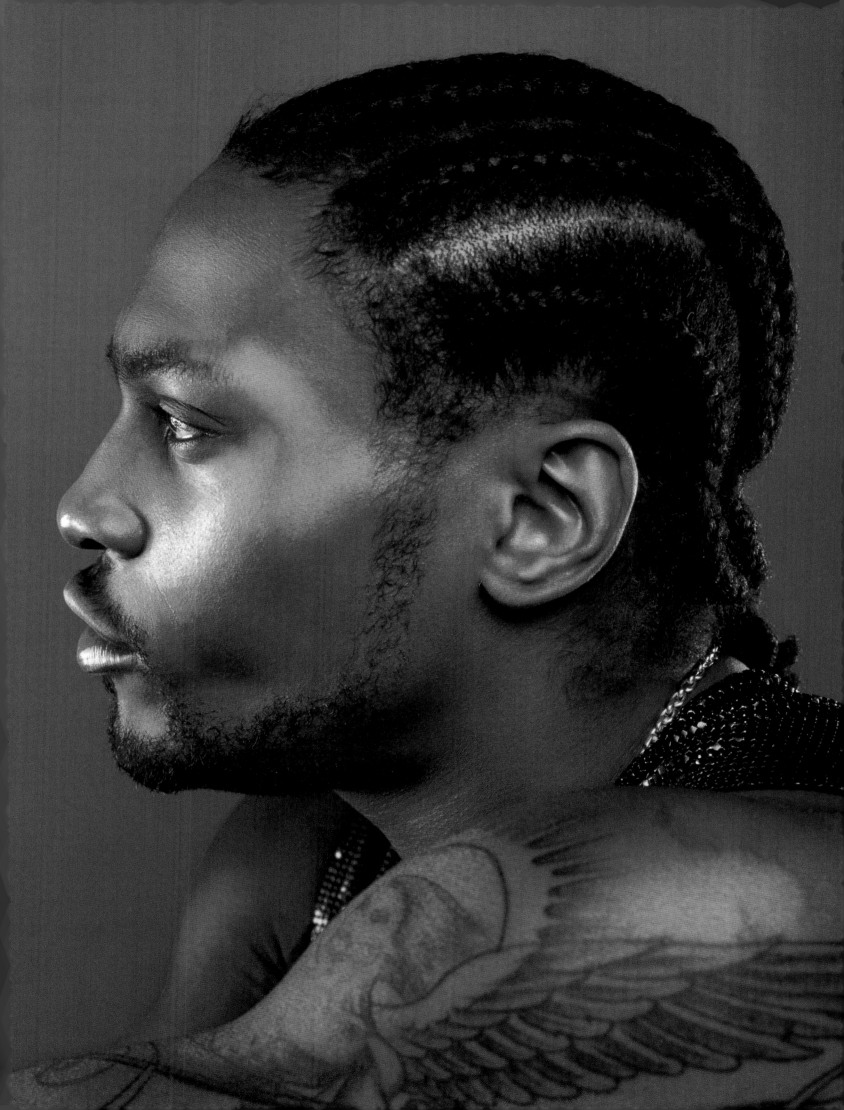

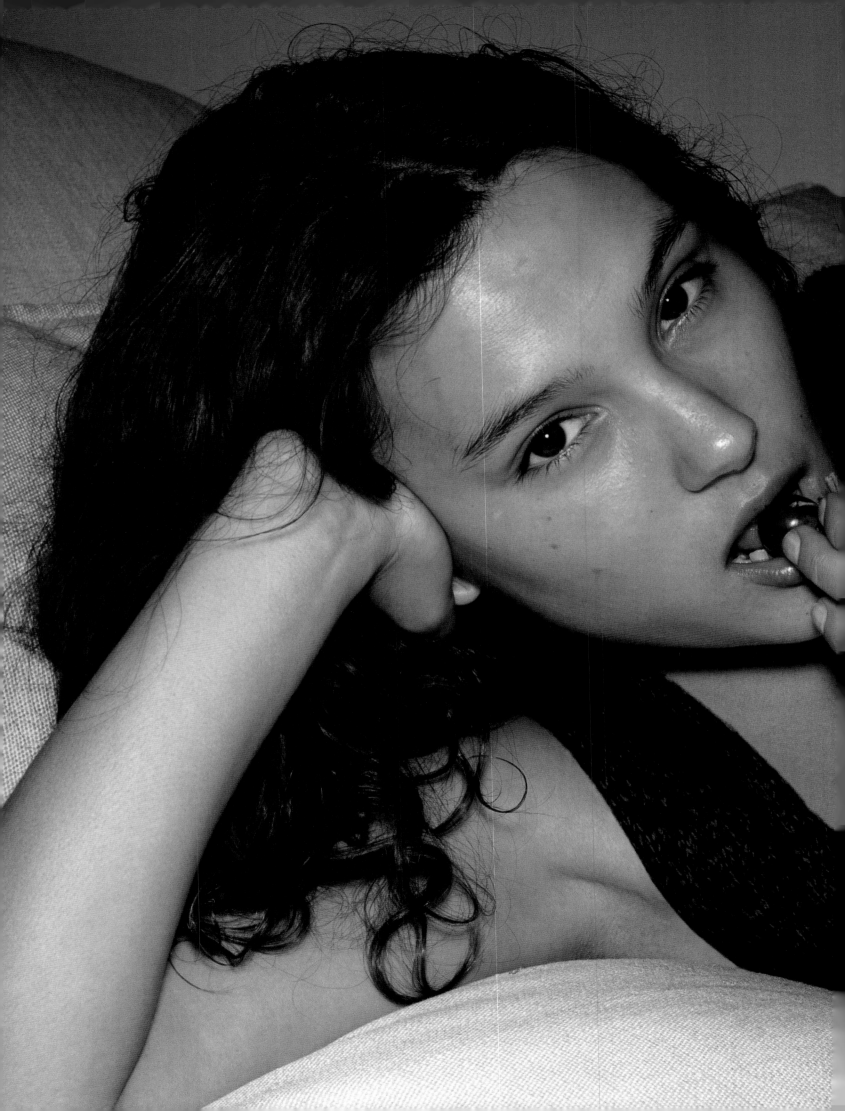

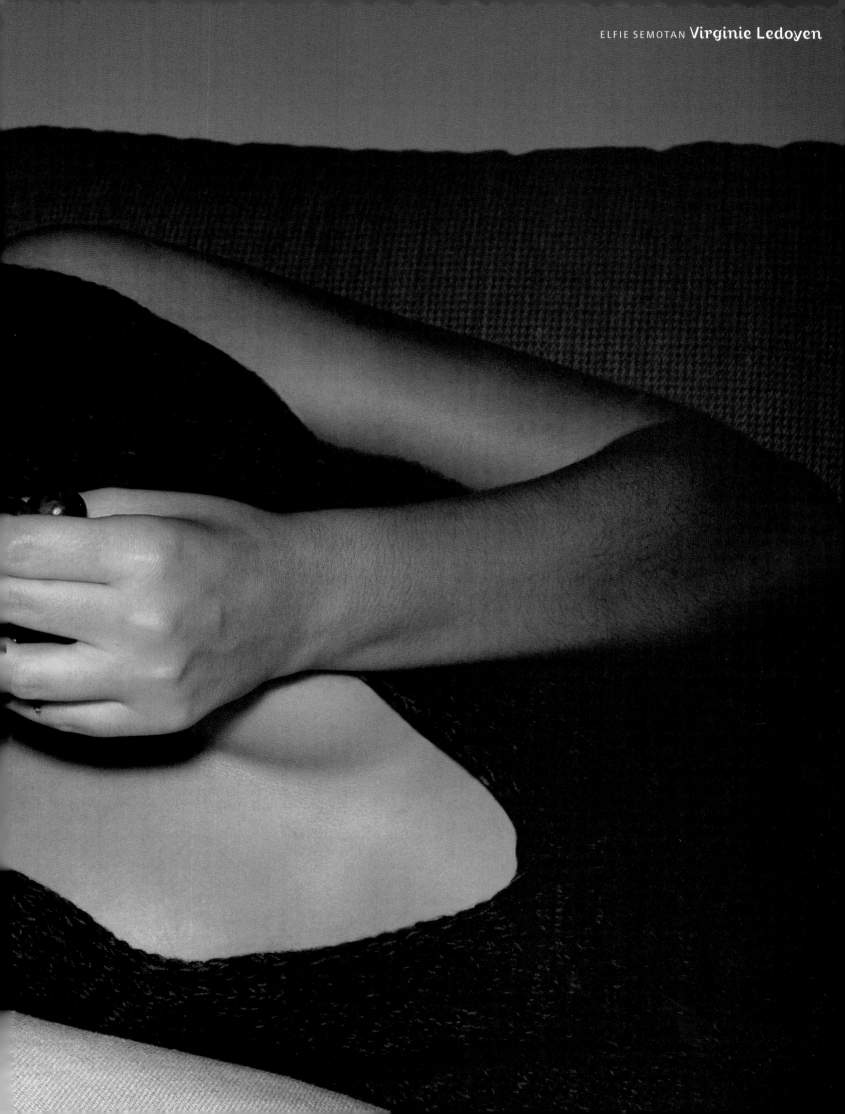

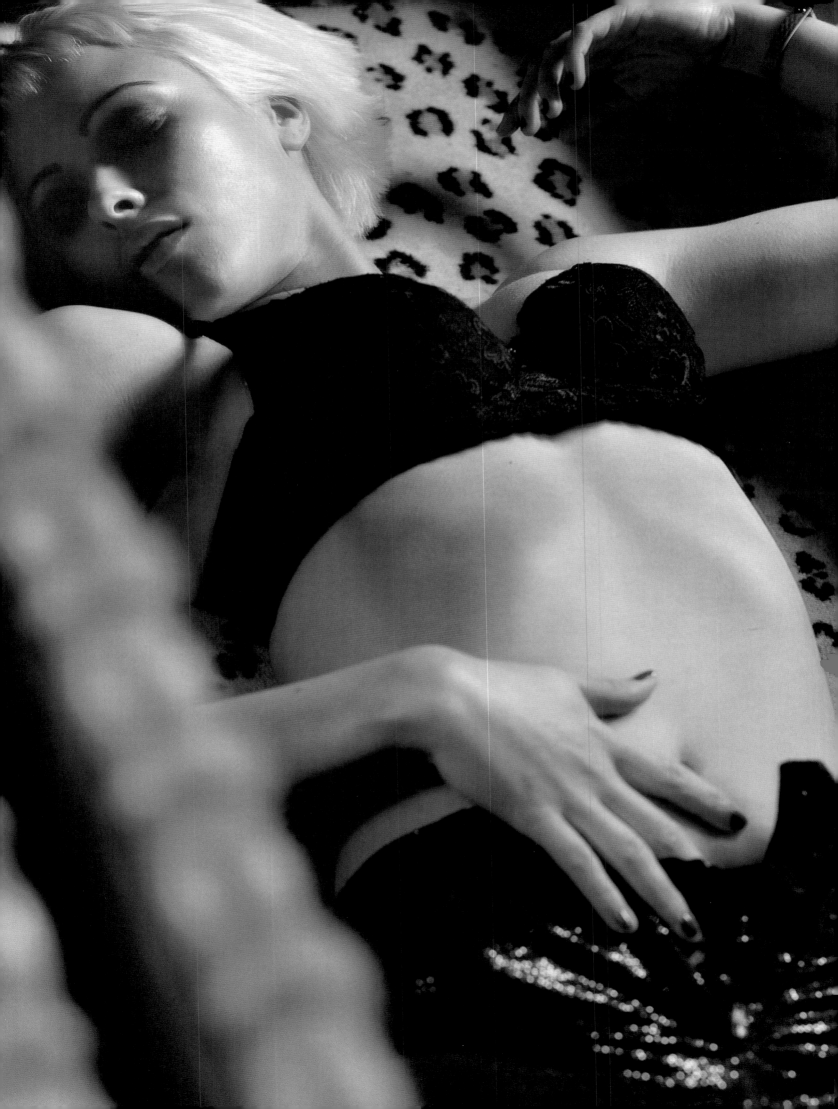

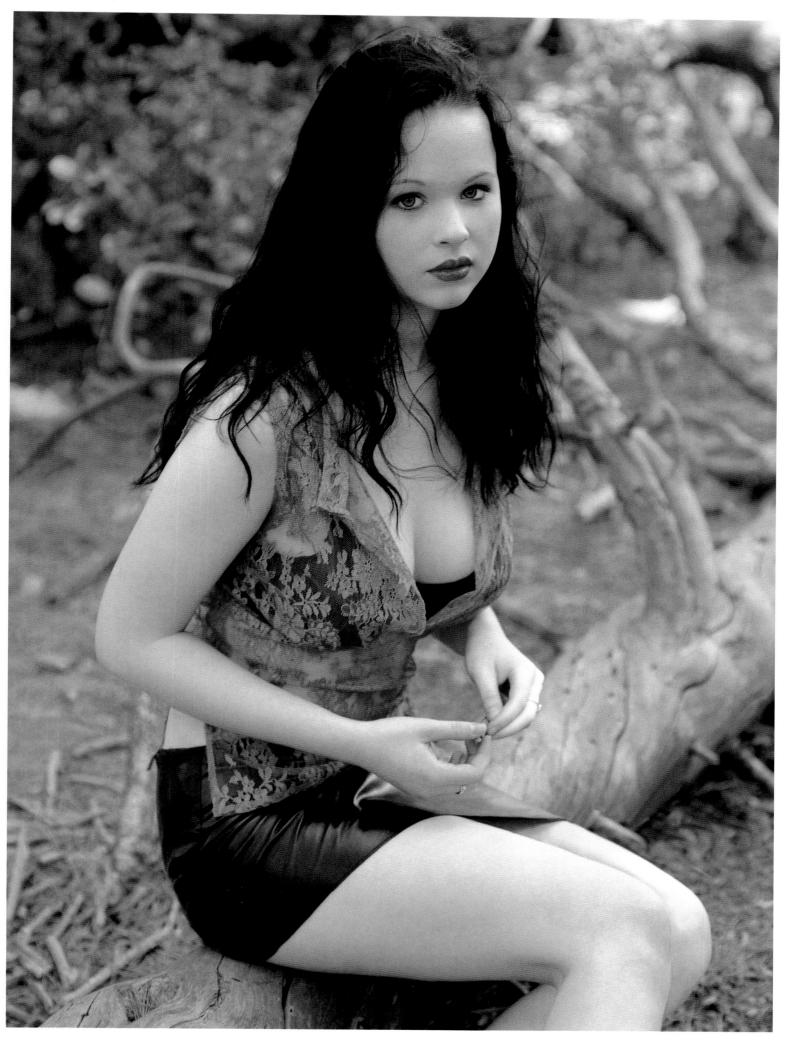

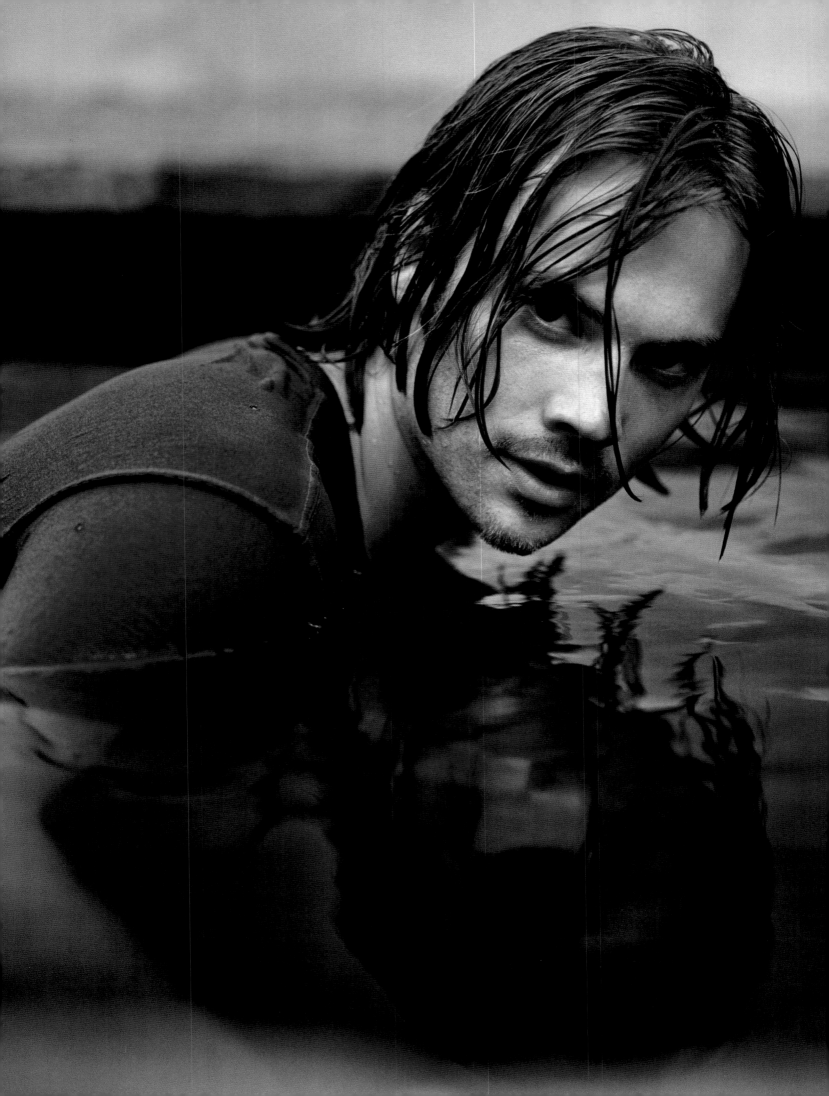

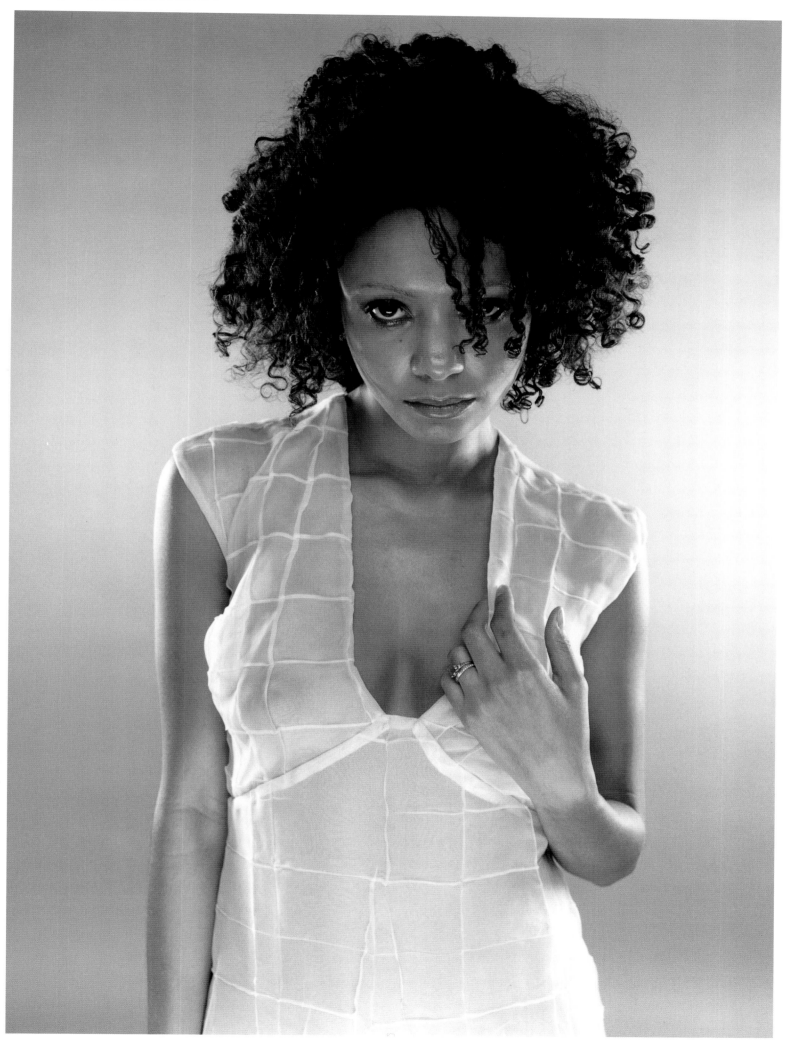

JUSTIN CASE **Thandie Newton**

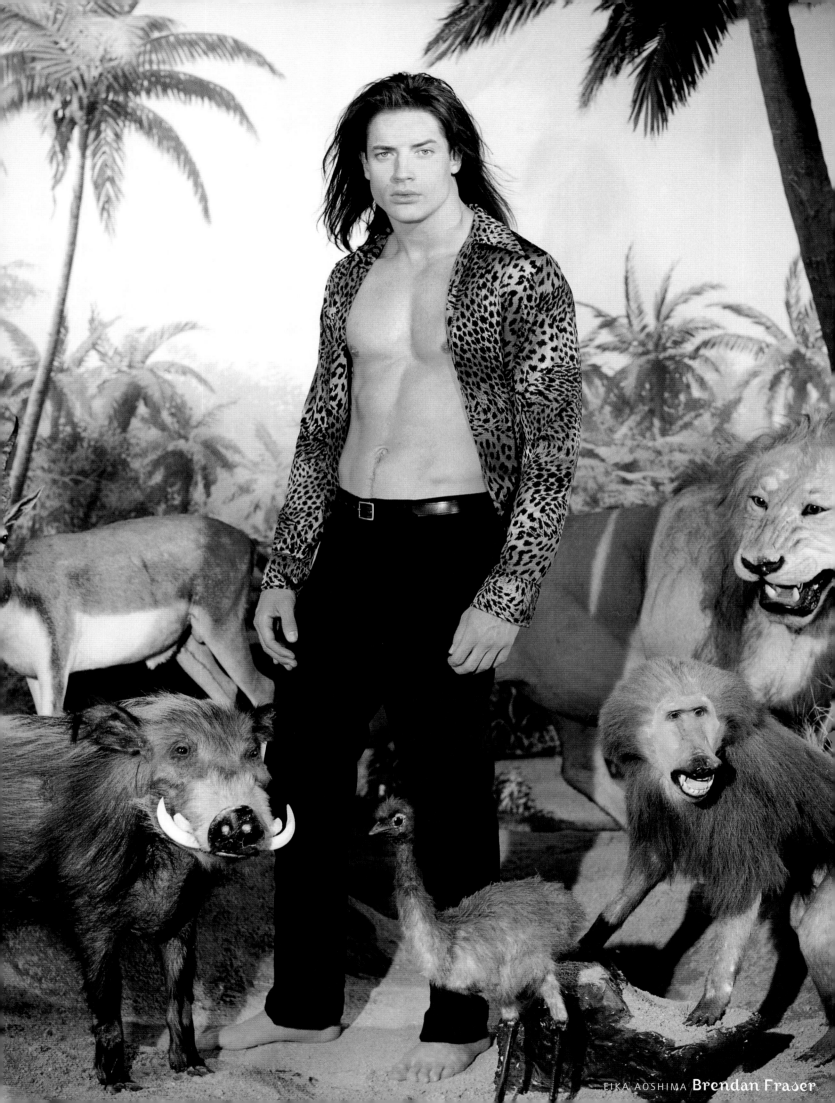

EIKA AOSHIMA Brendan Fraser

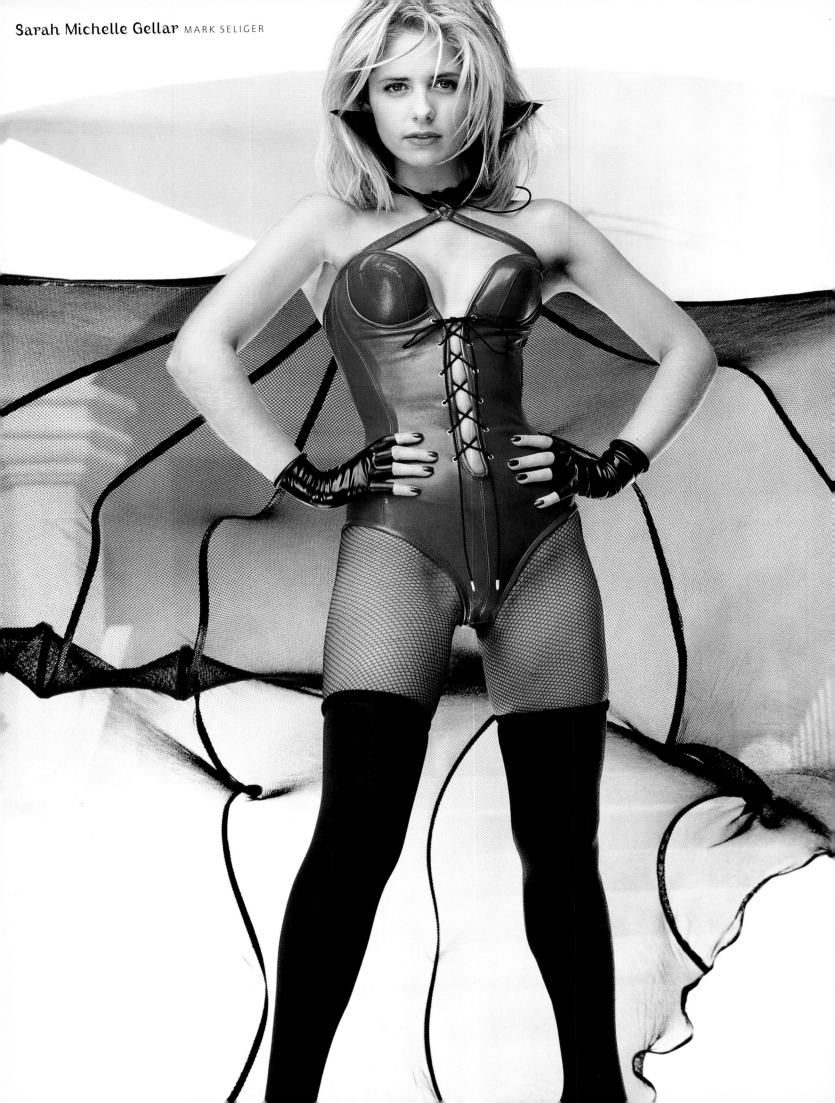

Sarah Michelle Gellar MARK SELIGER

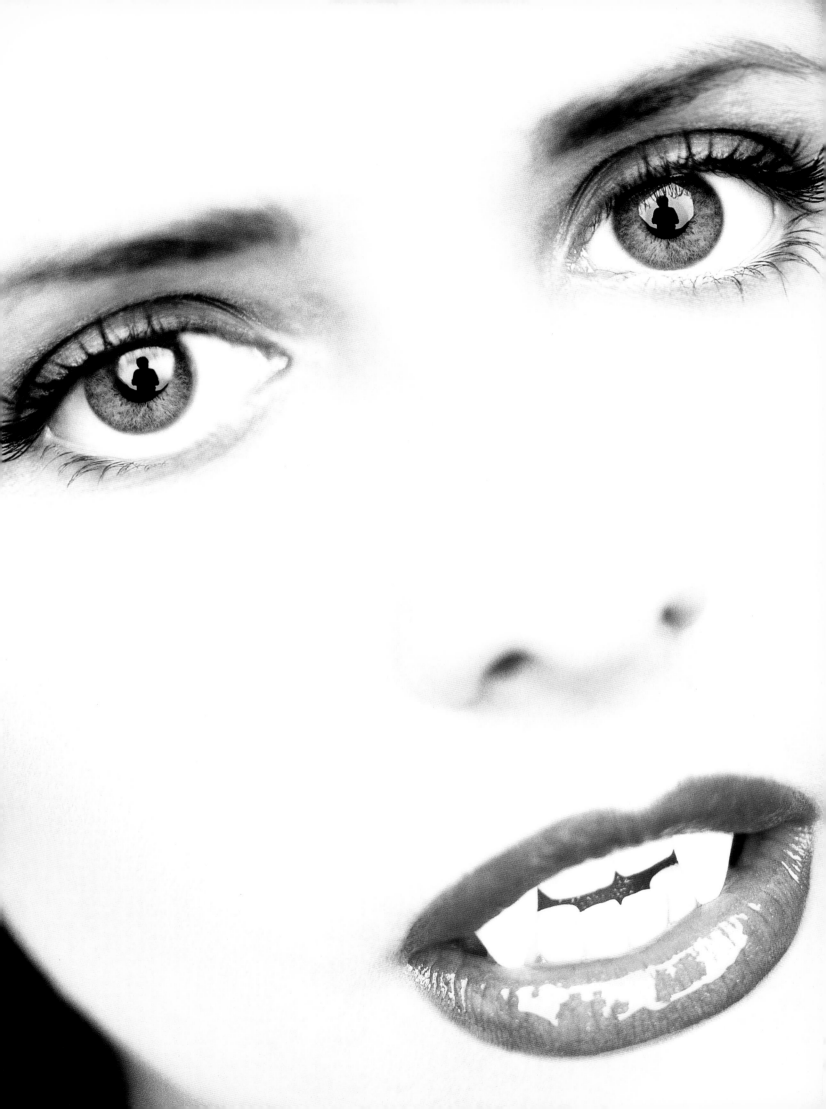

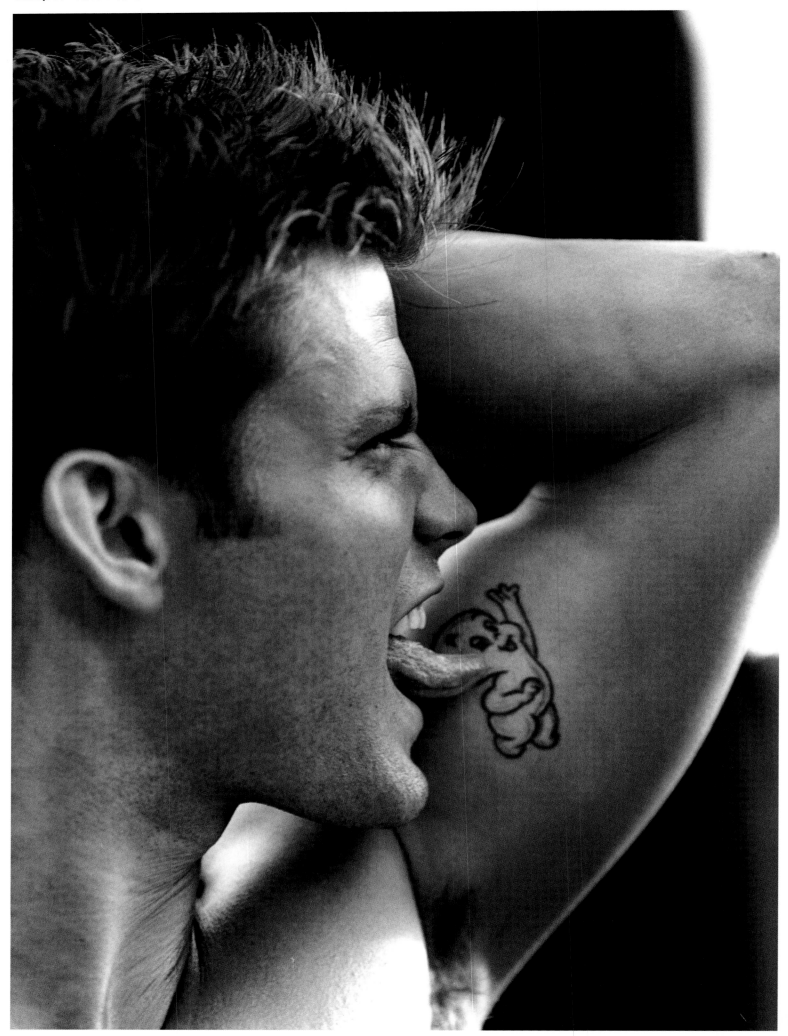

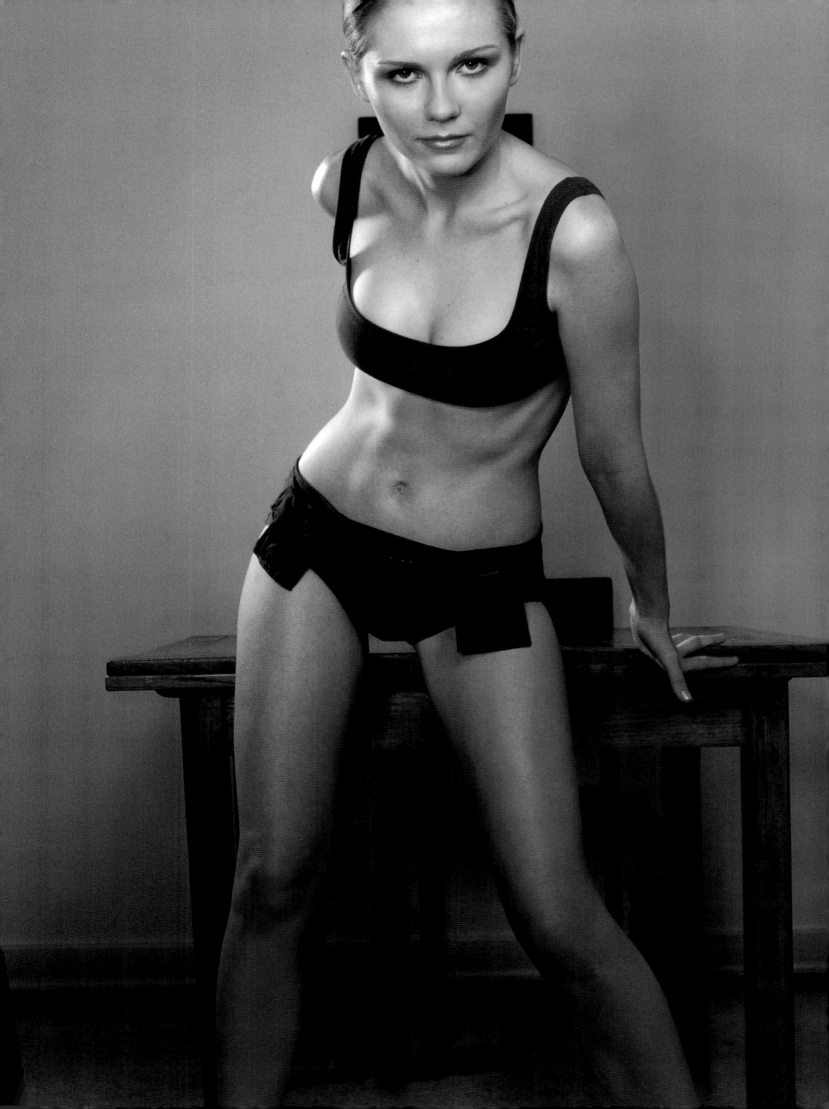

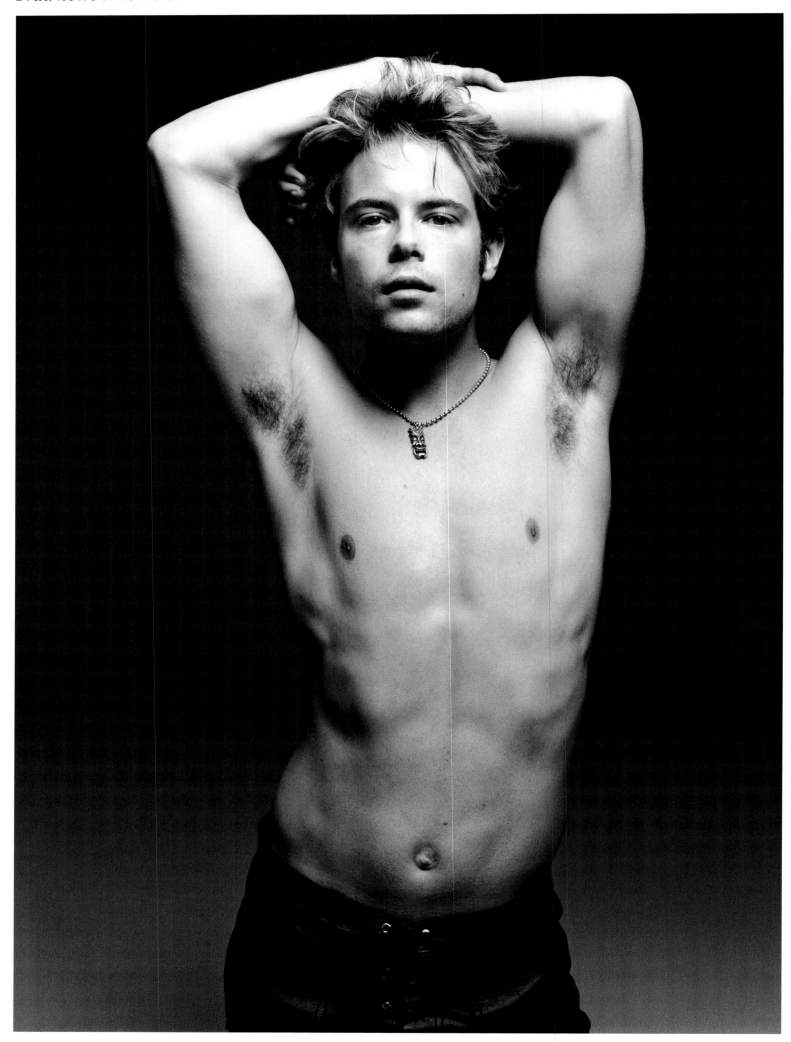

TONY DURAN **Jennifer Lopez**»

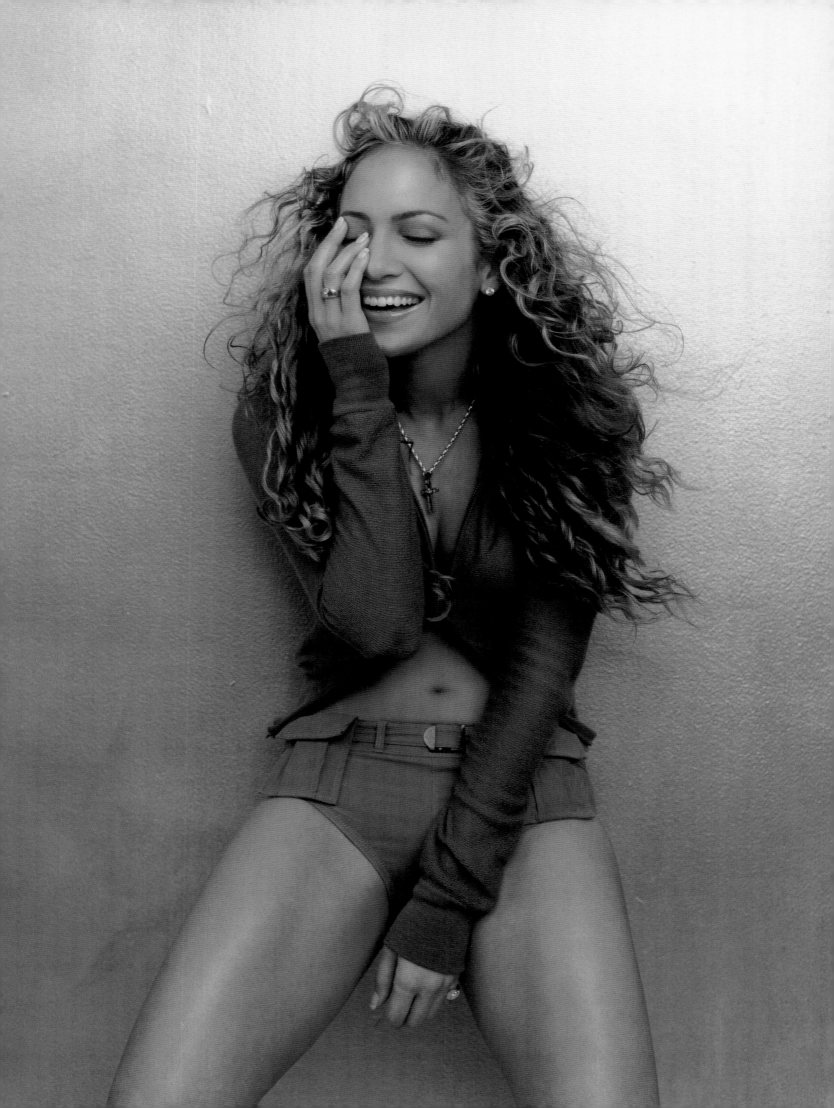

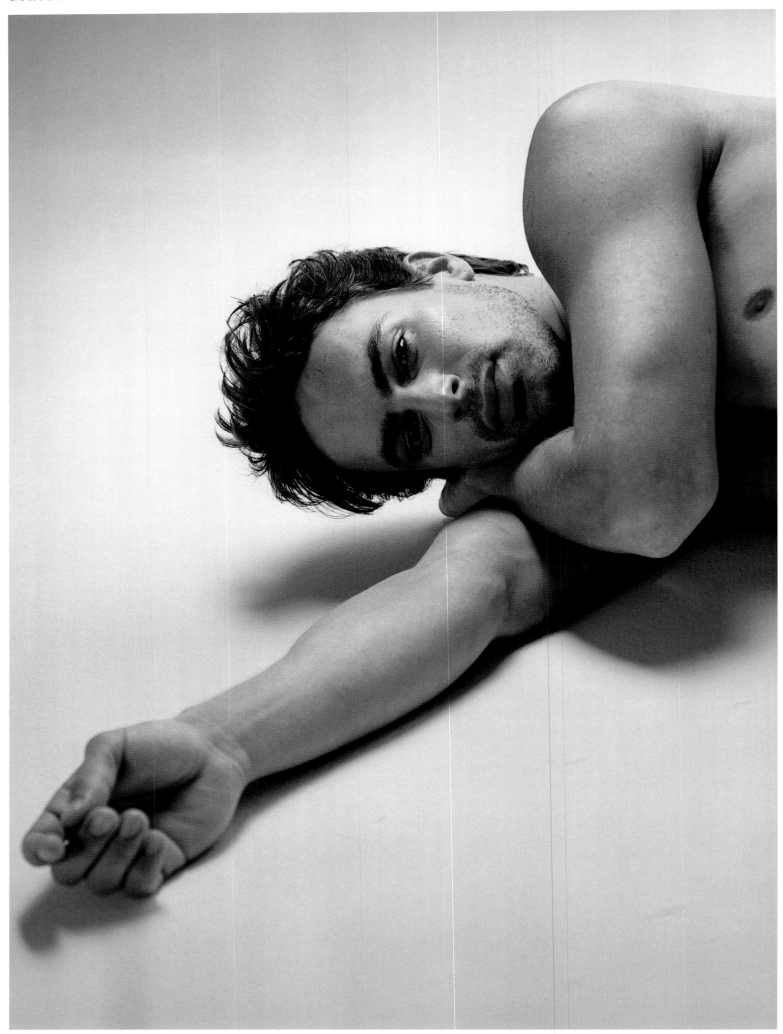

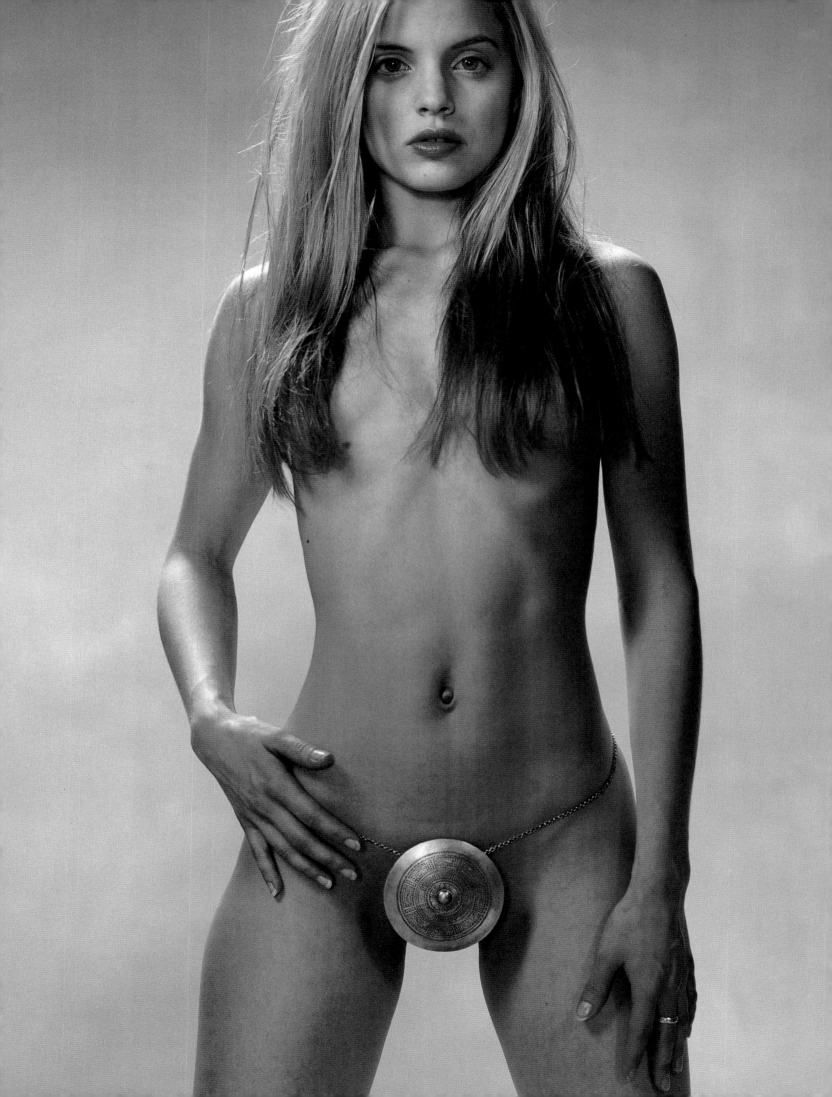

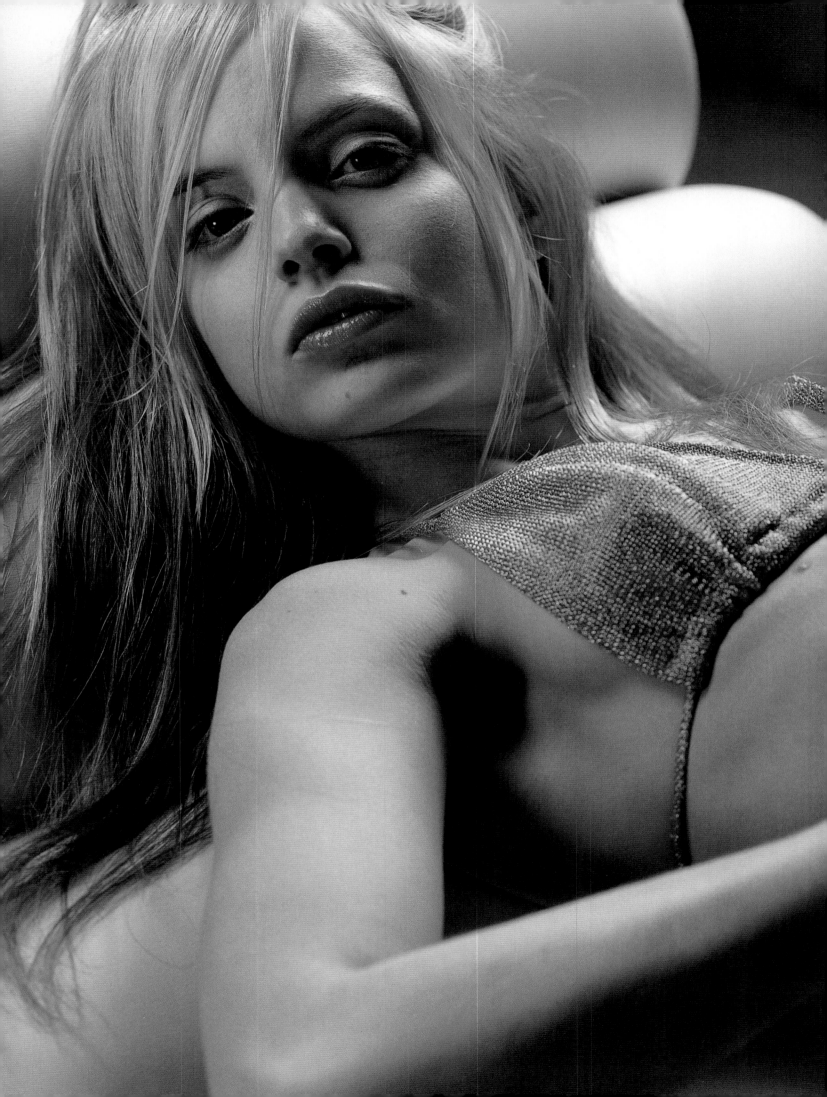

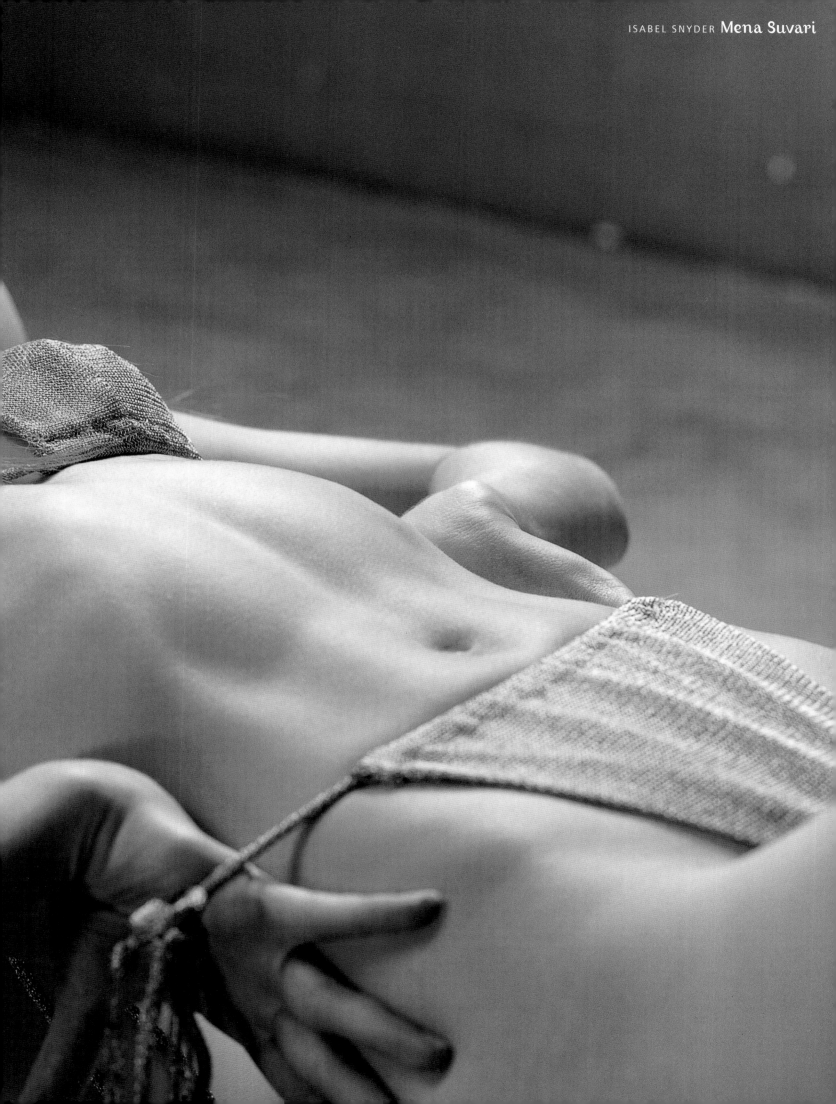

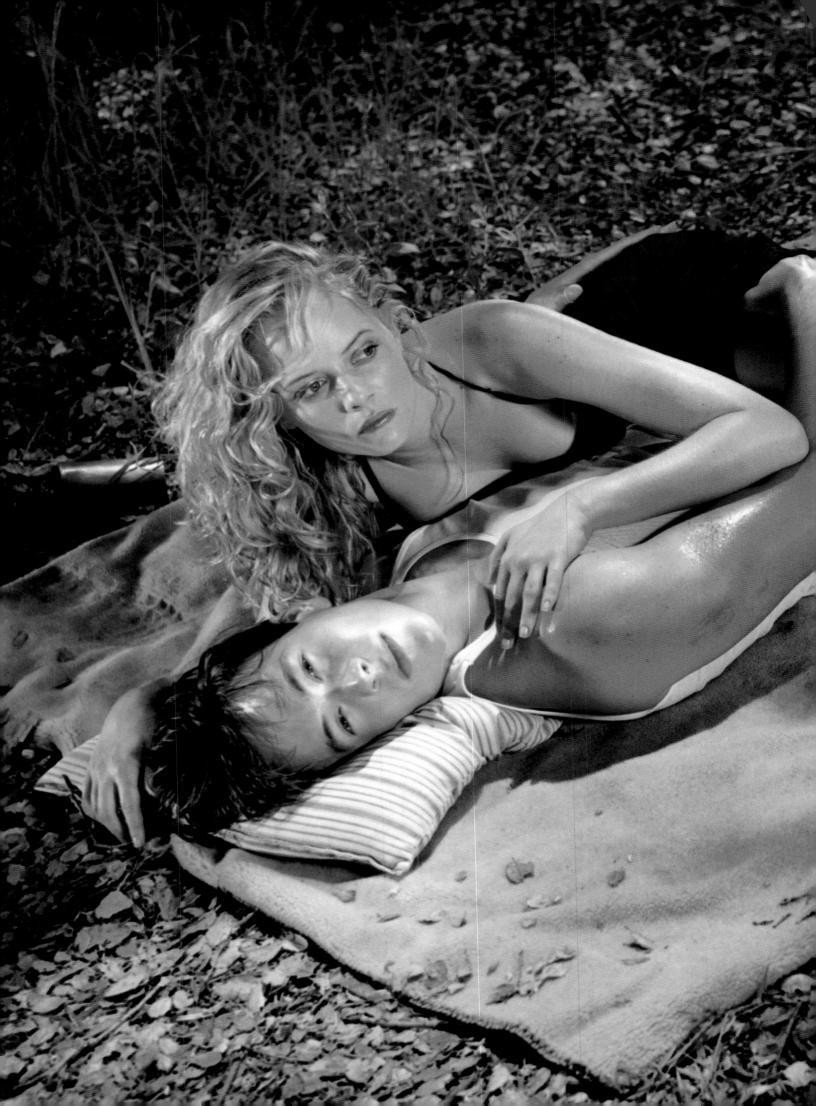

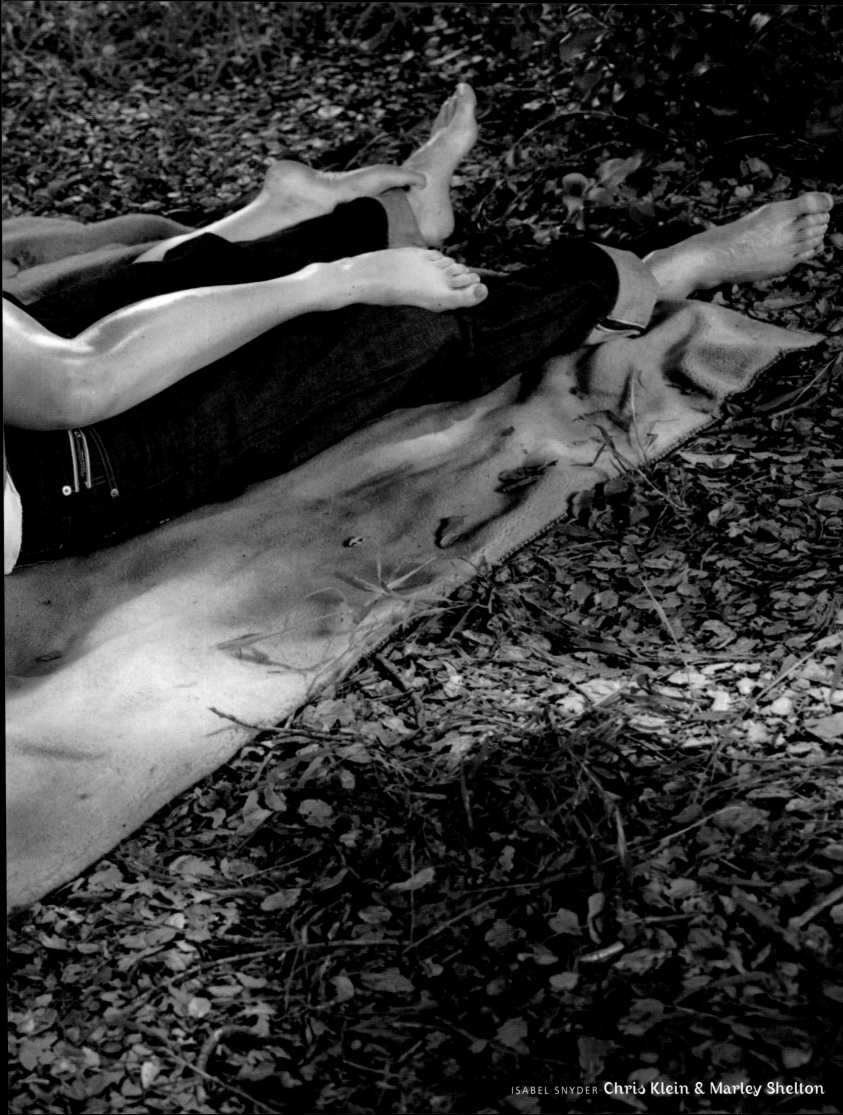

ISABEL SNYDER **Chris Klein & Marley Shelton**

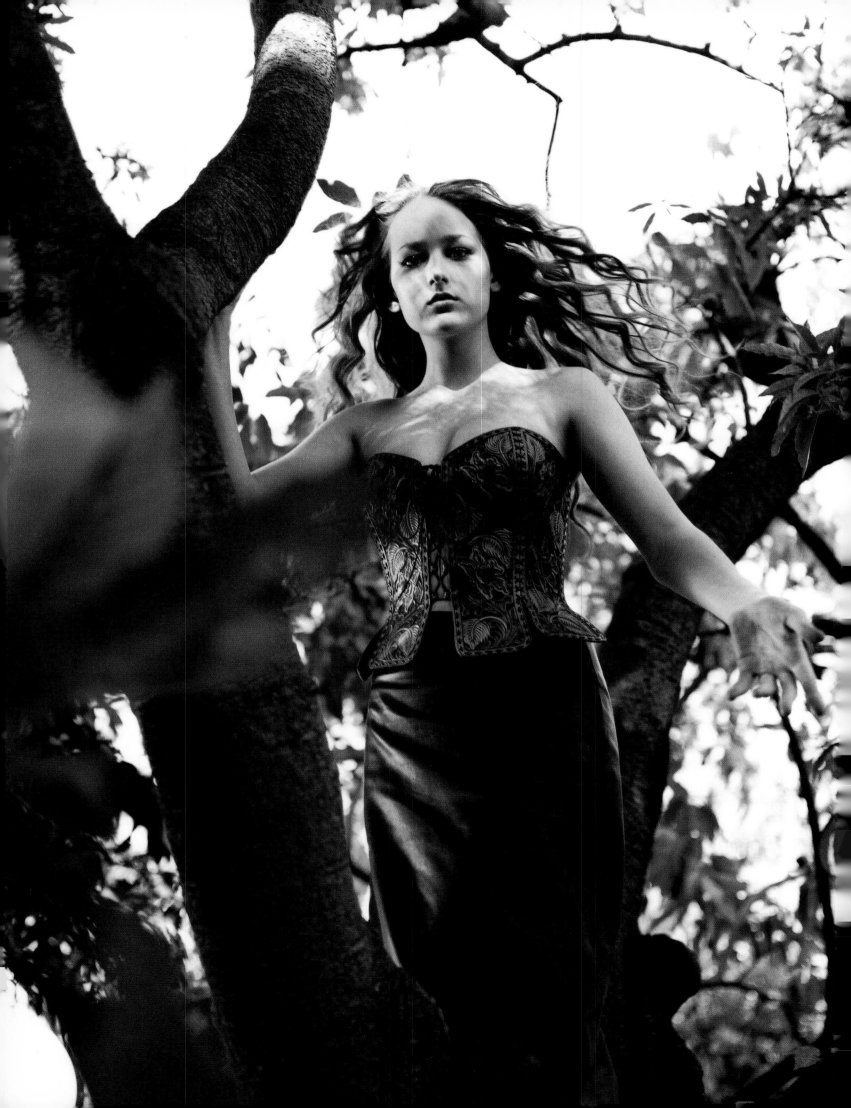

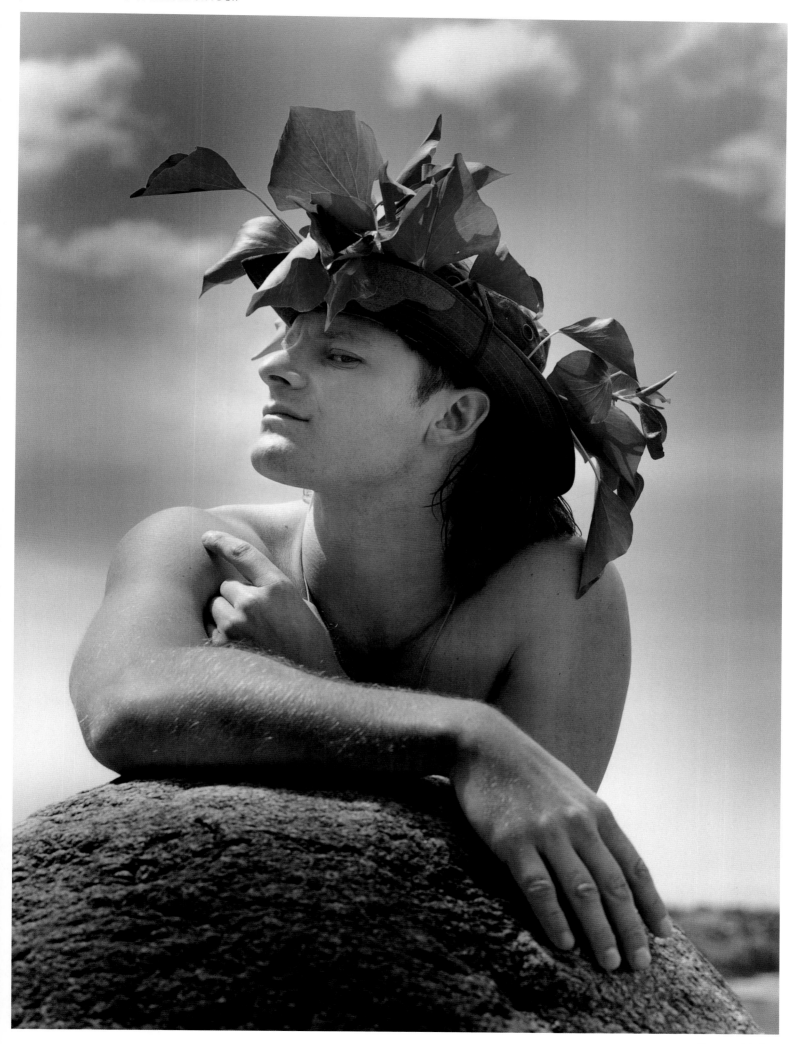

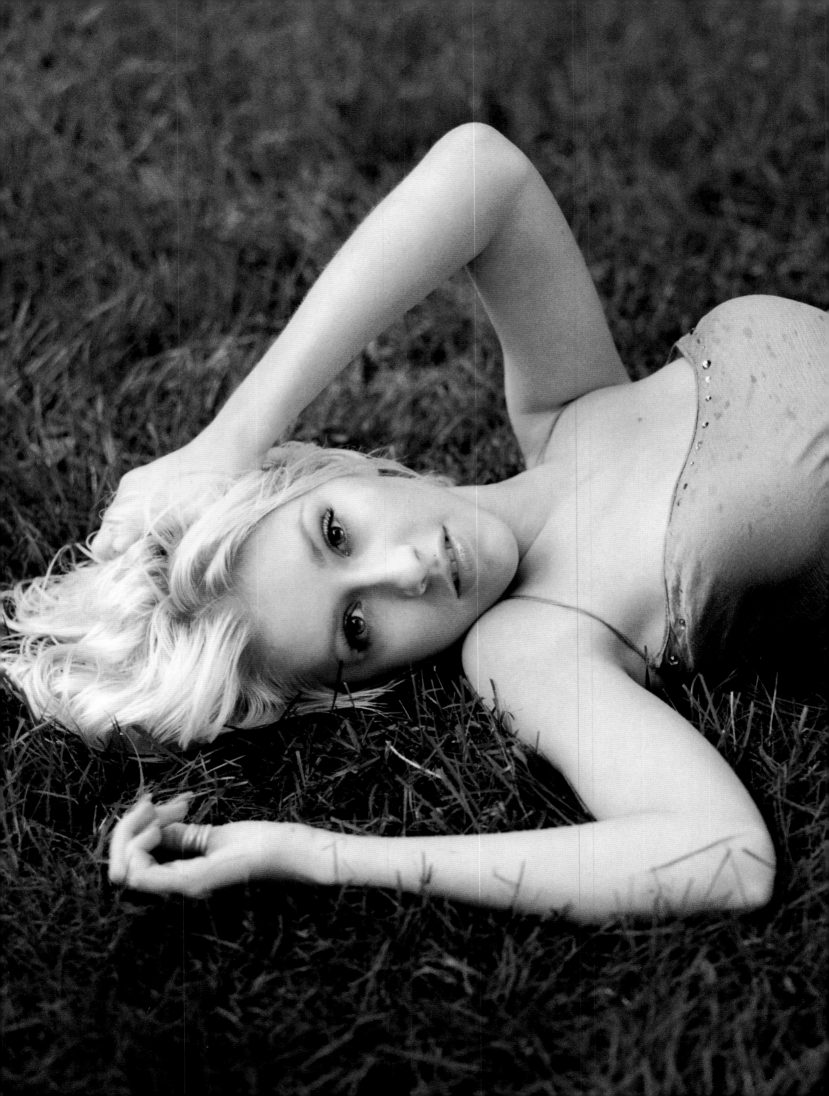

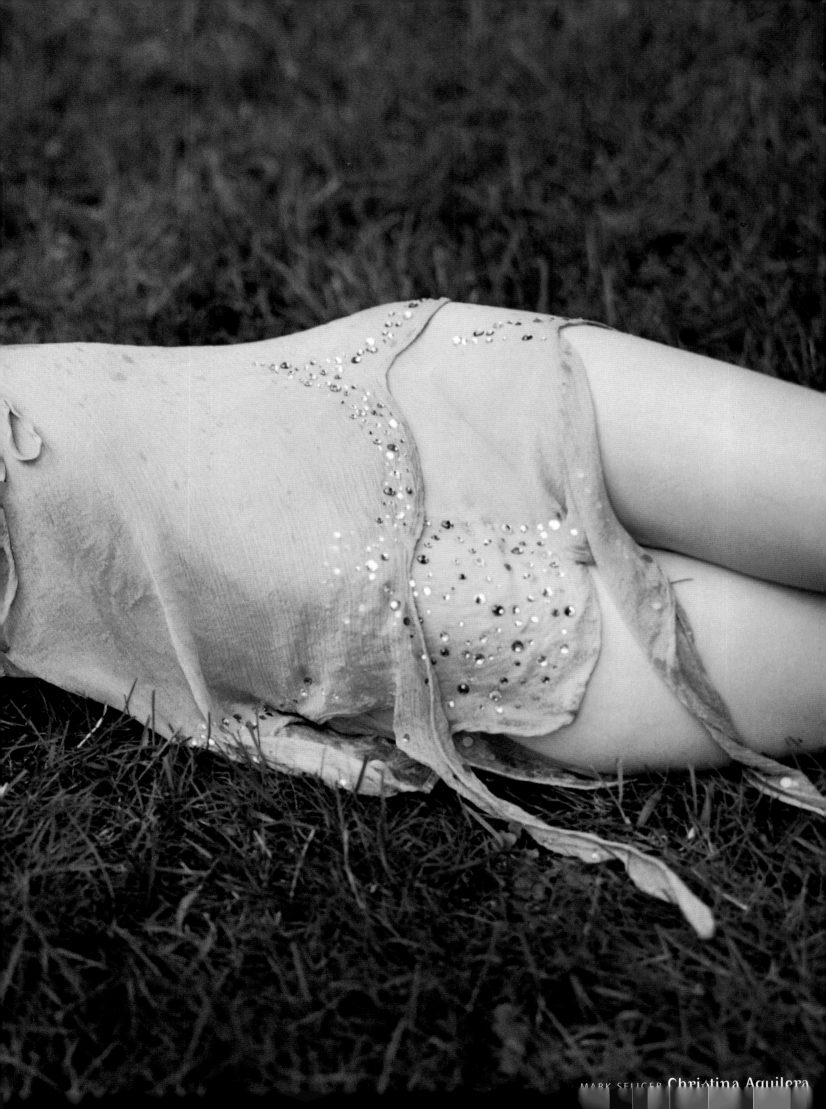

MARK SELIGER Christina Aguilera

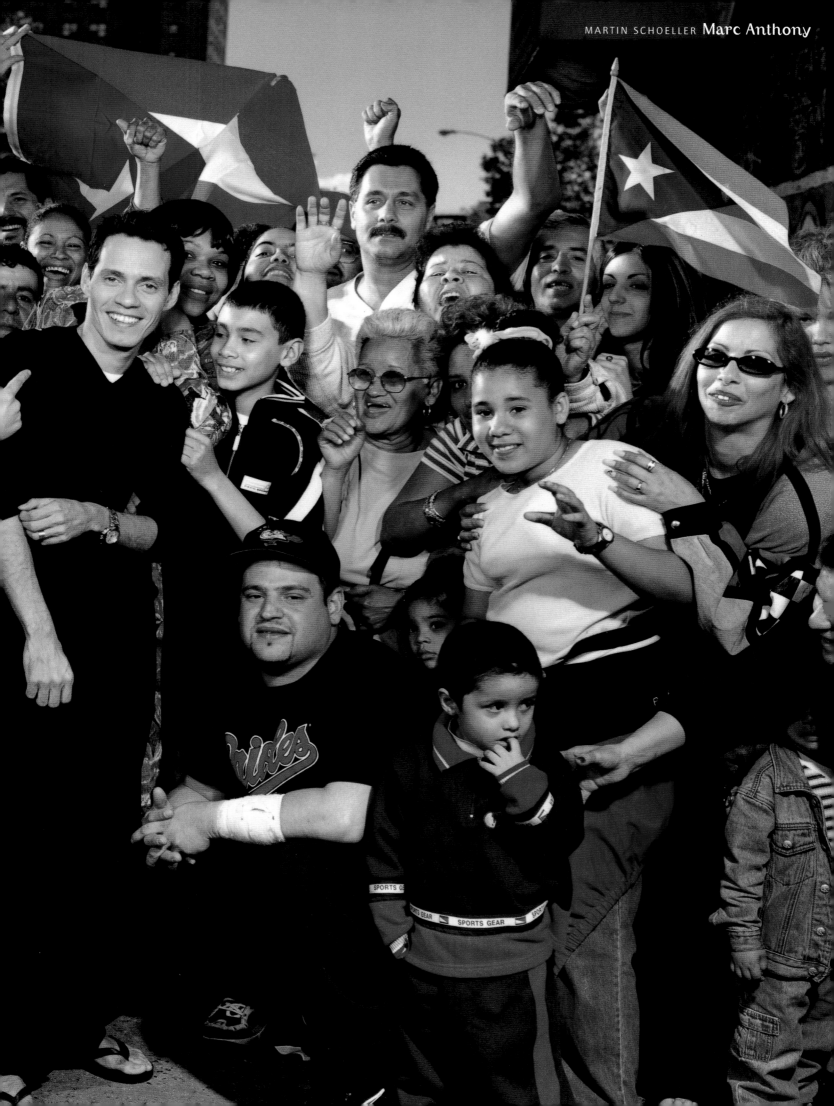

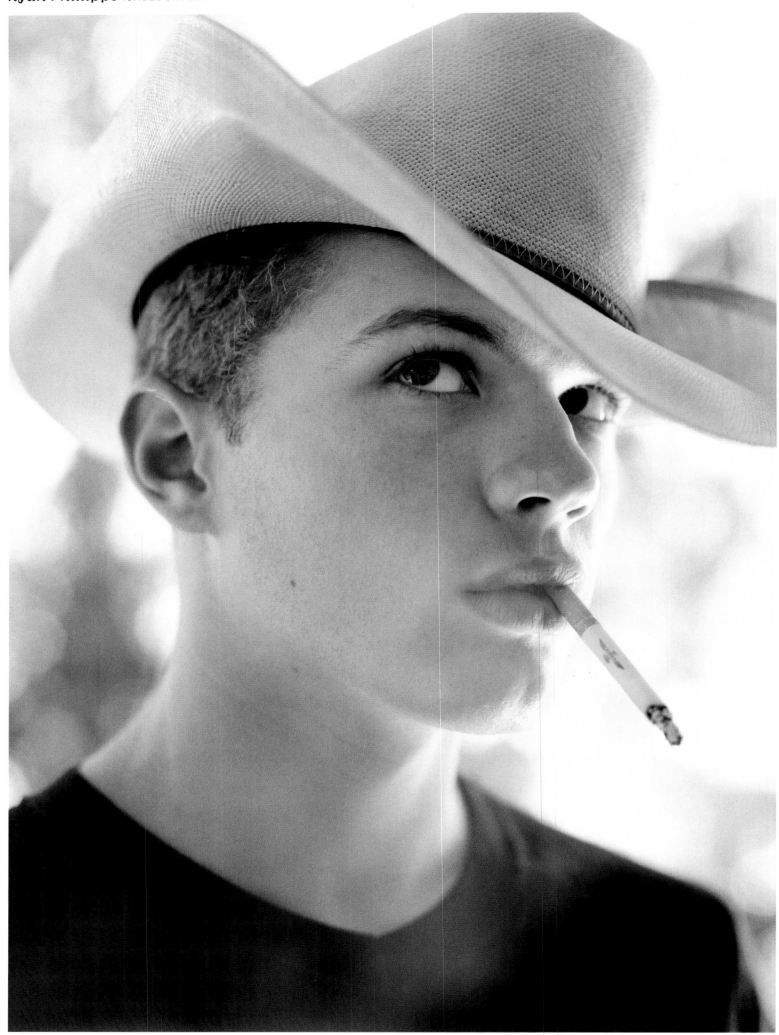

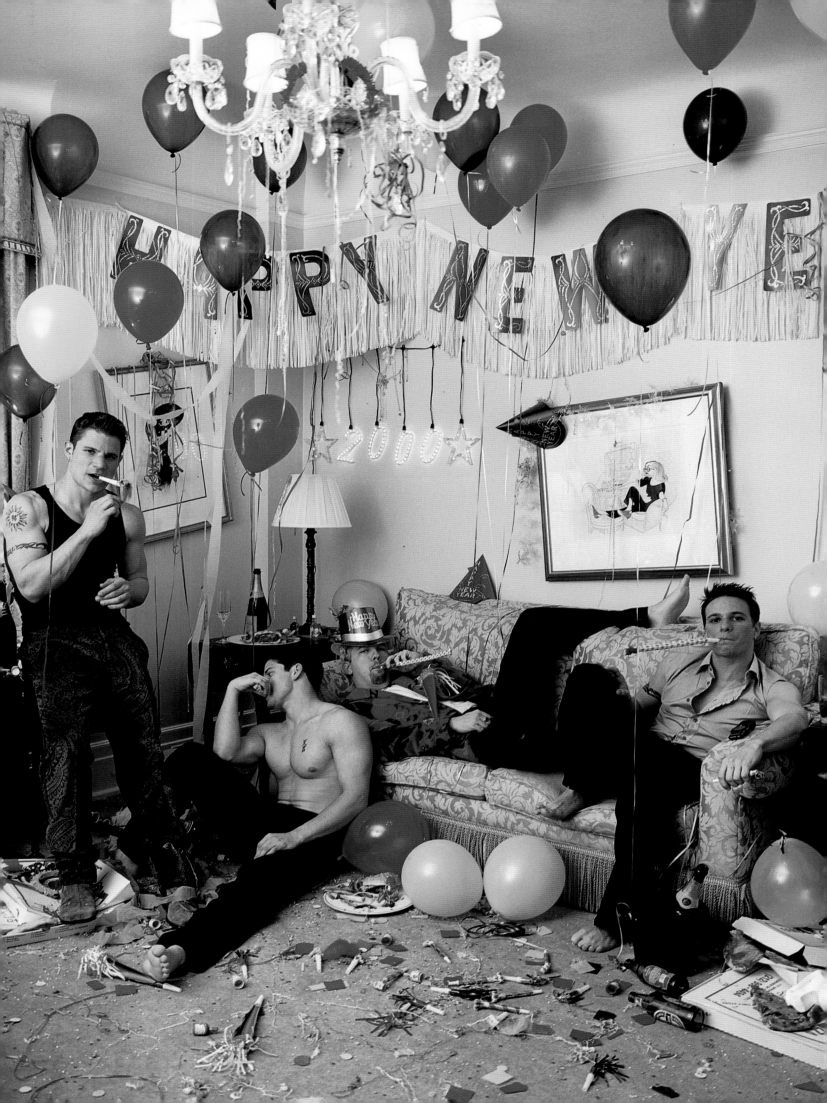

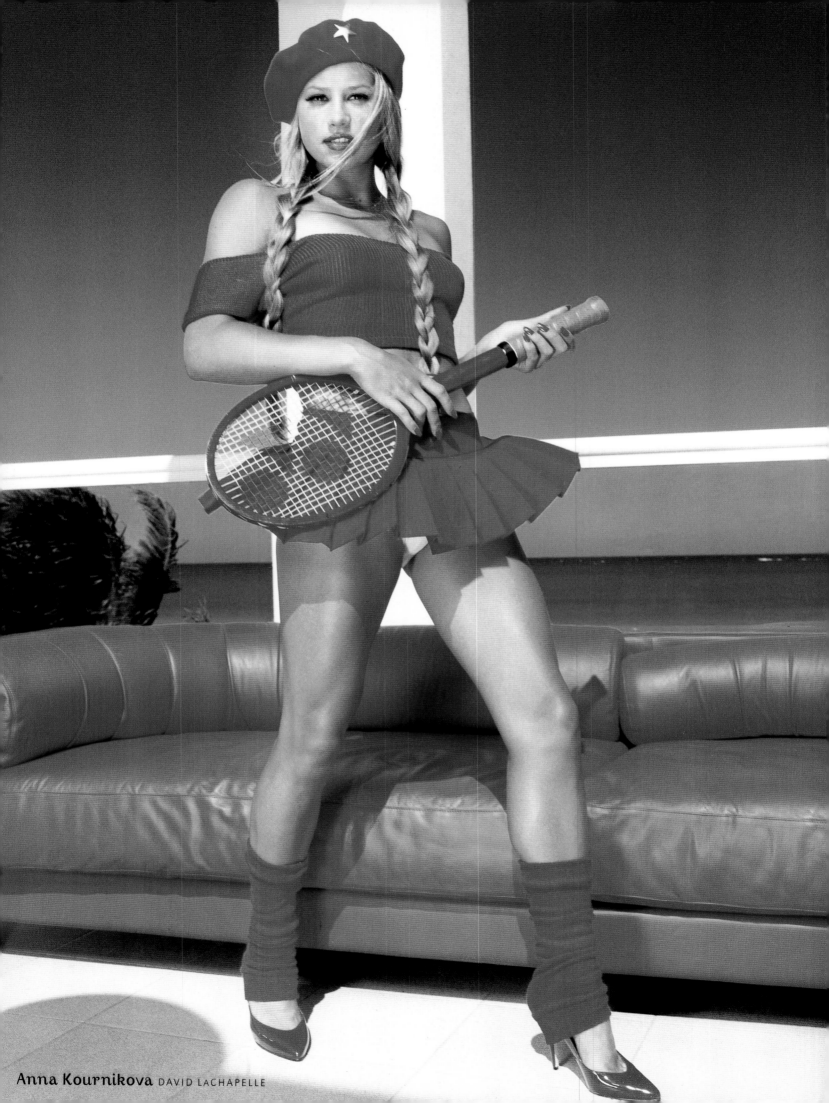

Anna Kournikova DAVID LACHAPELLE

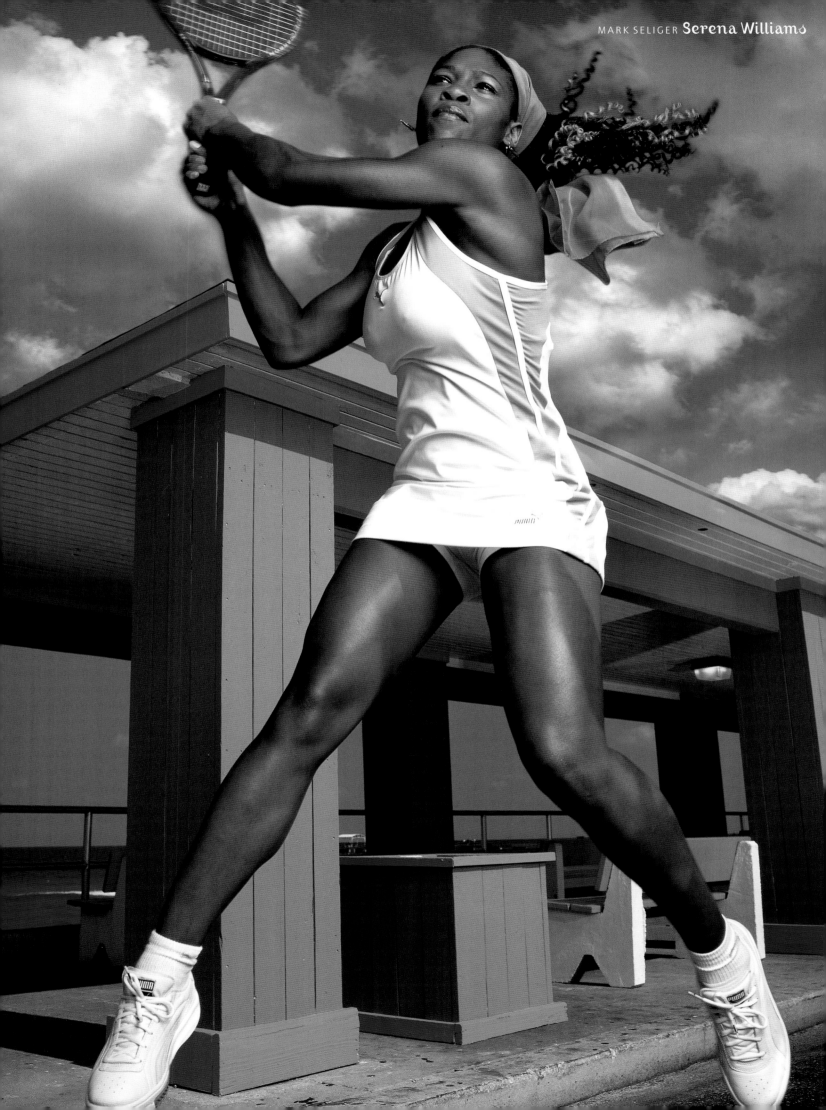

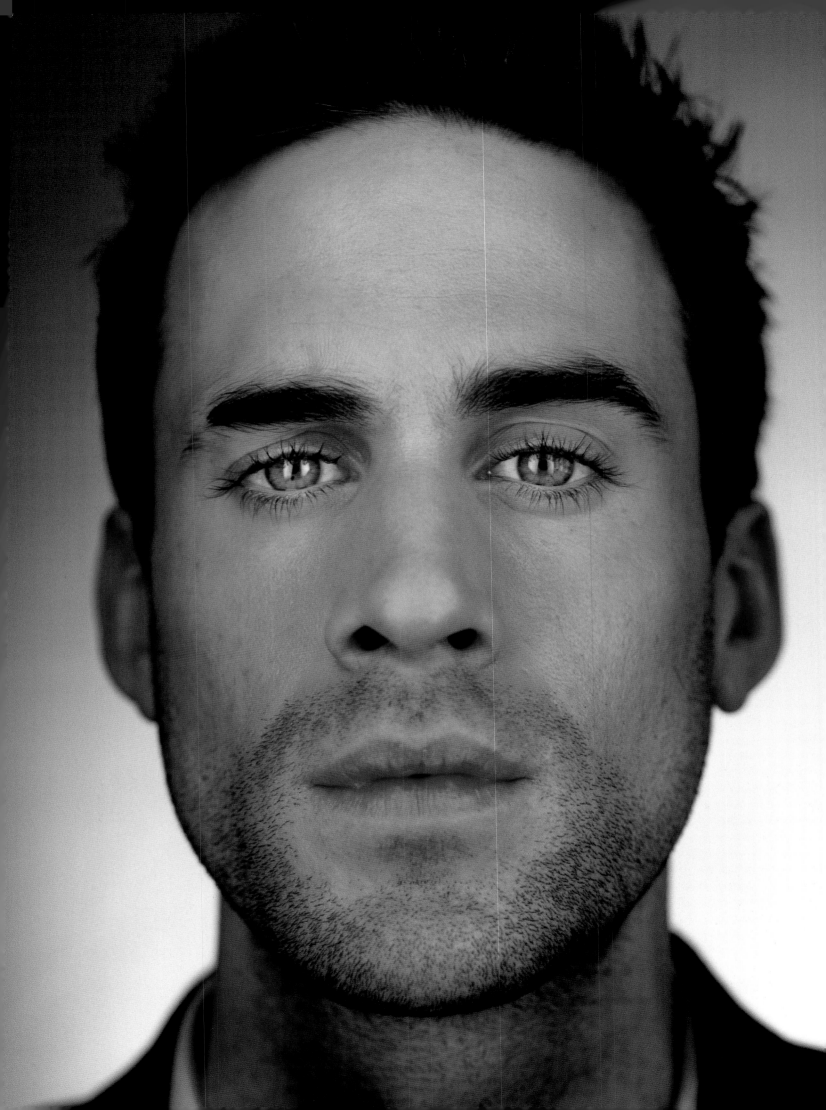

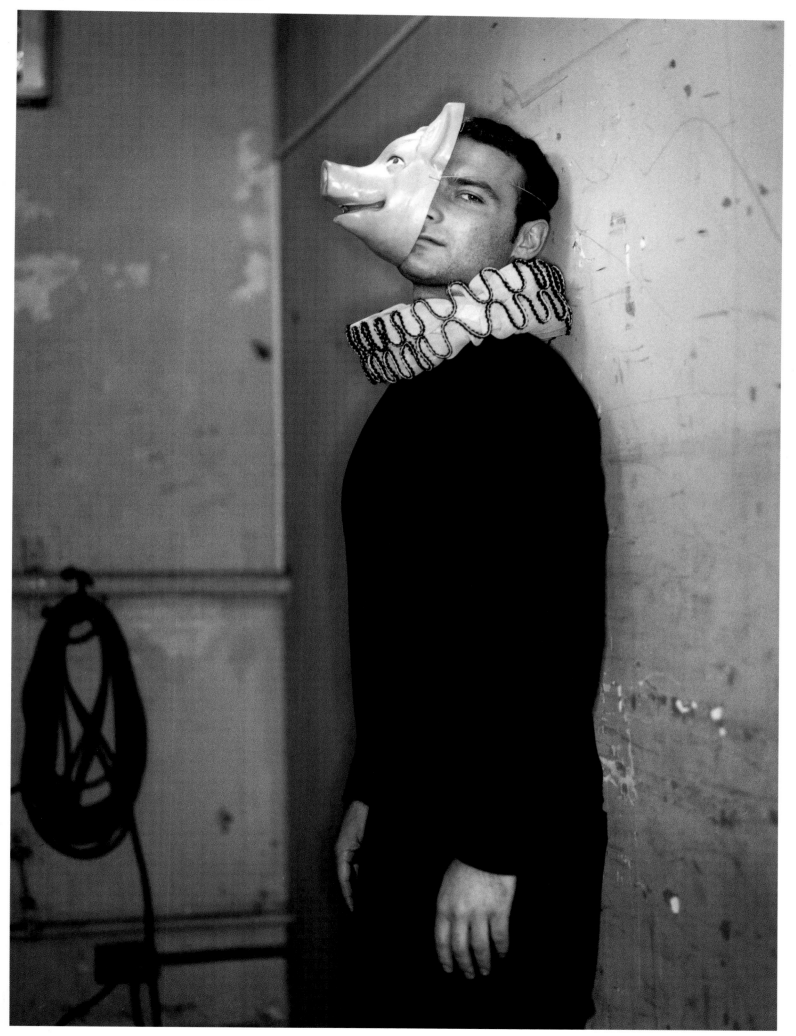

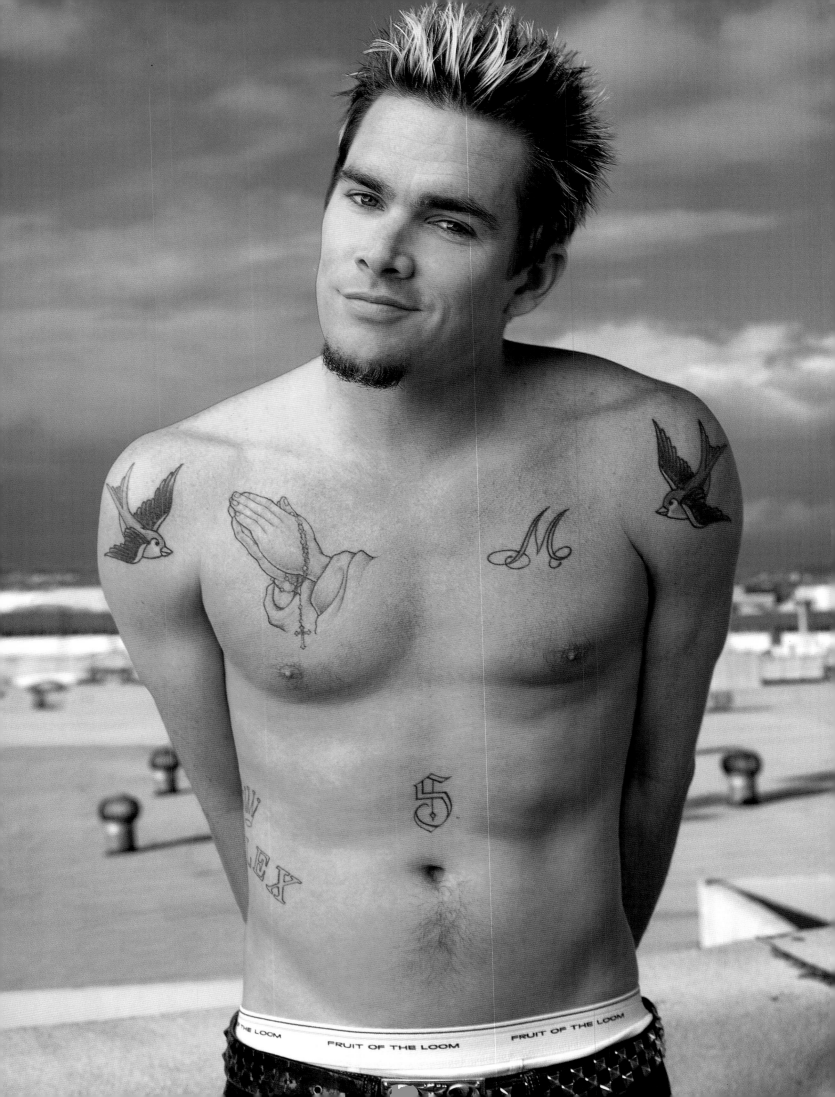

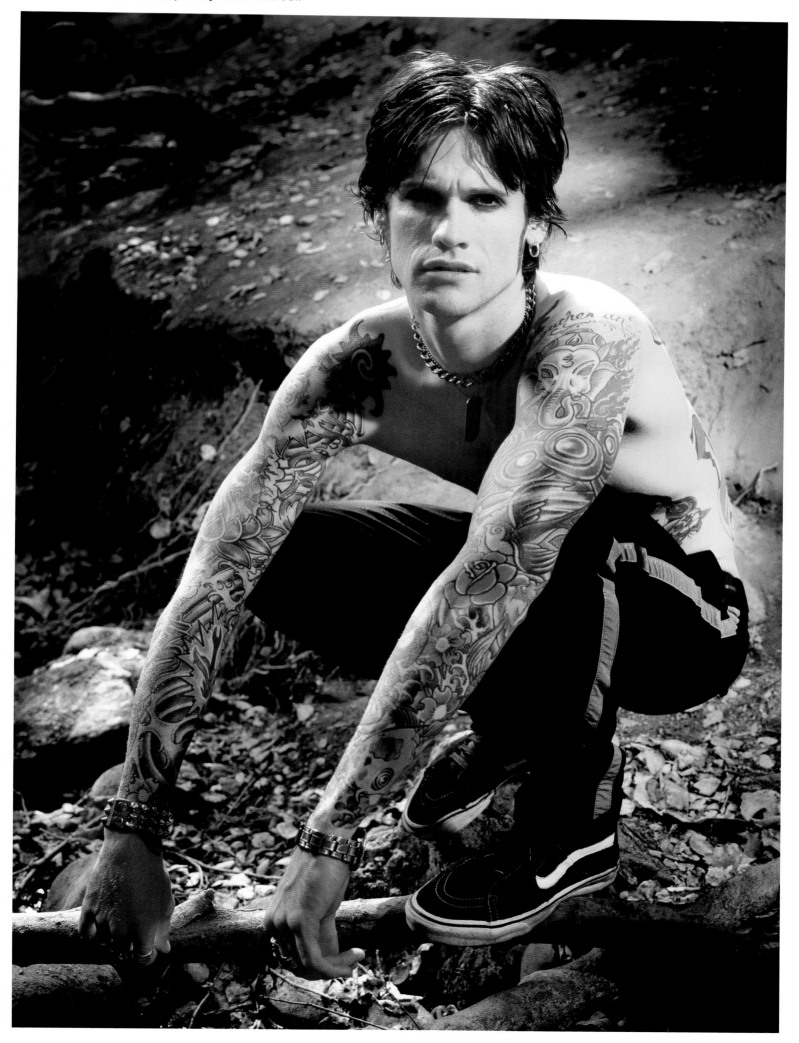

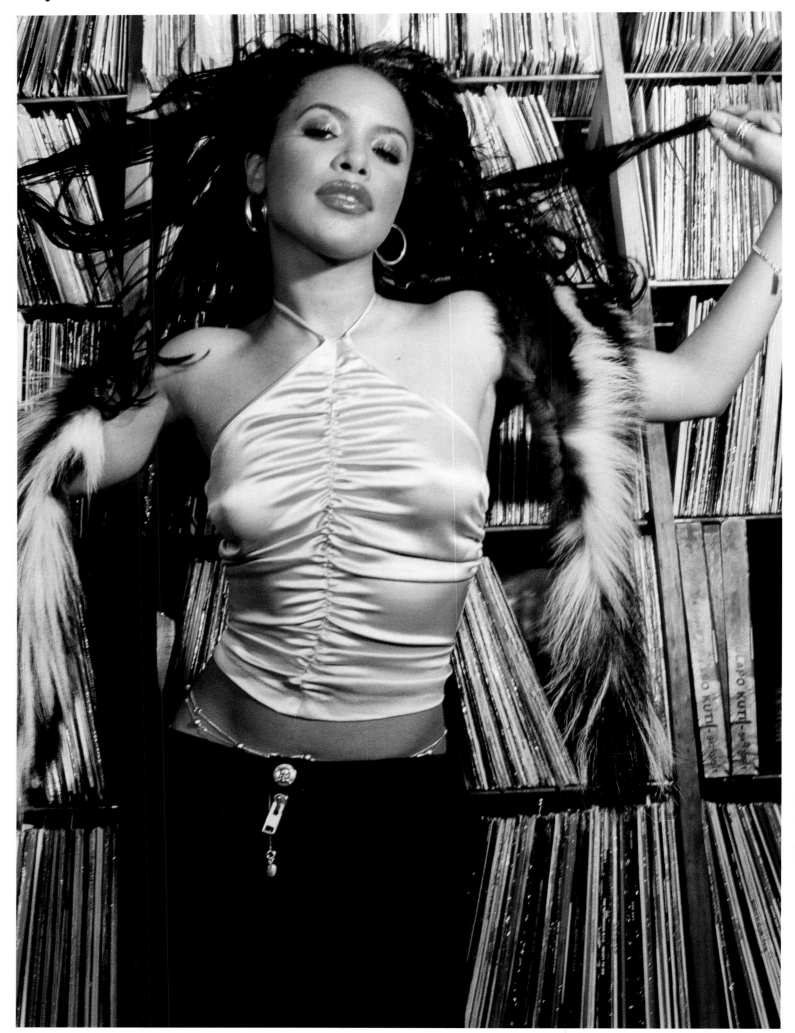

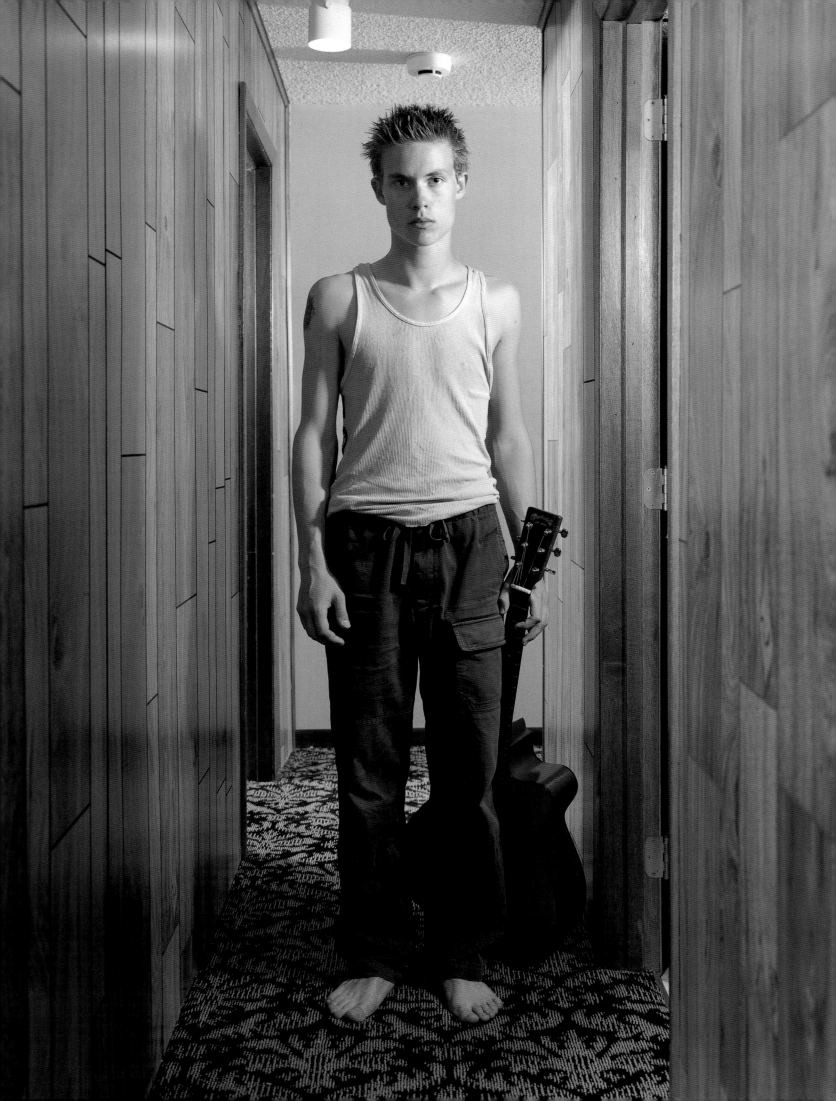

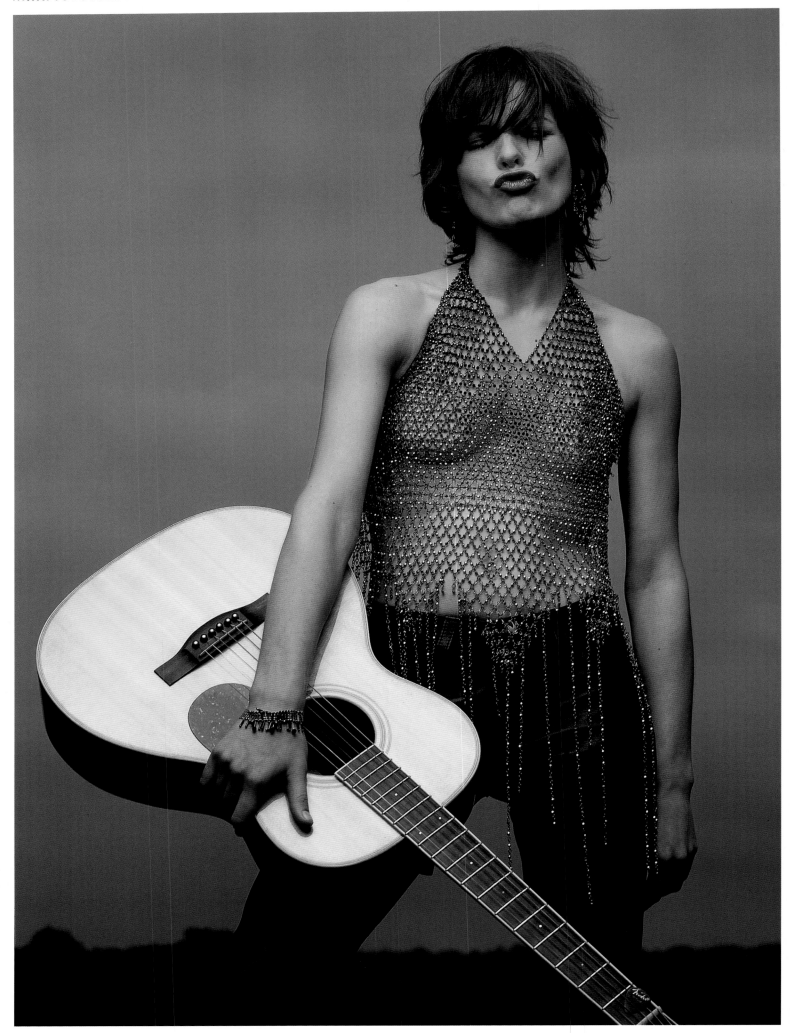

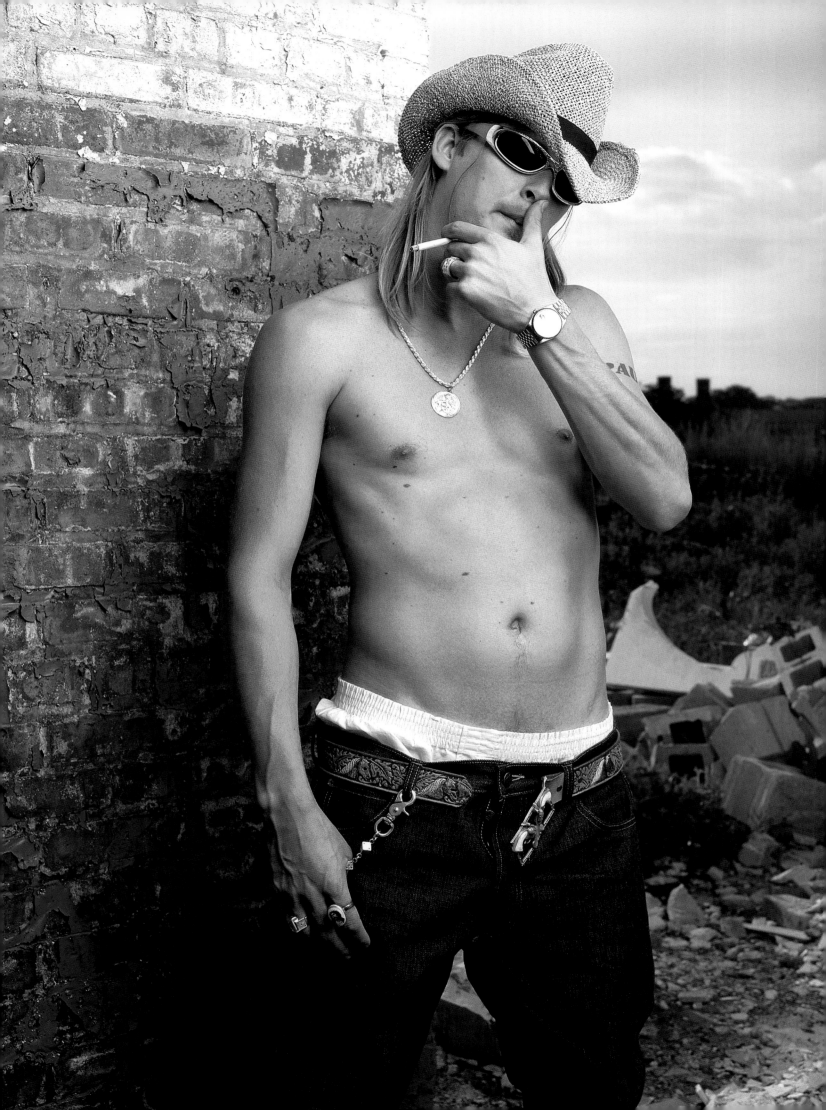

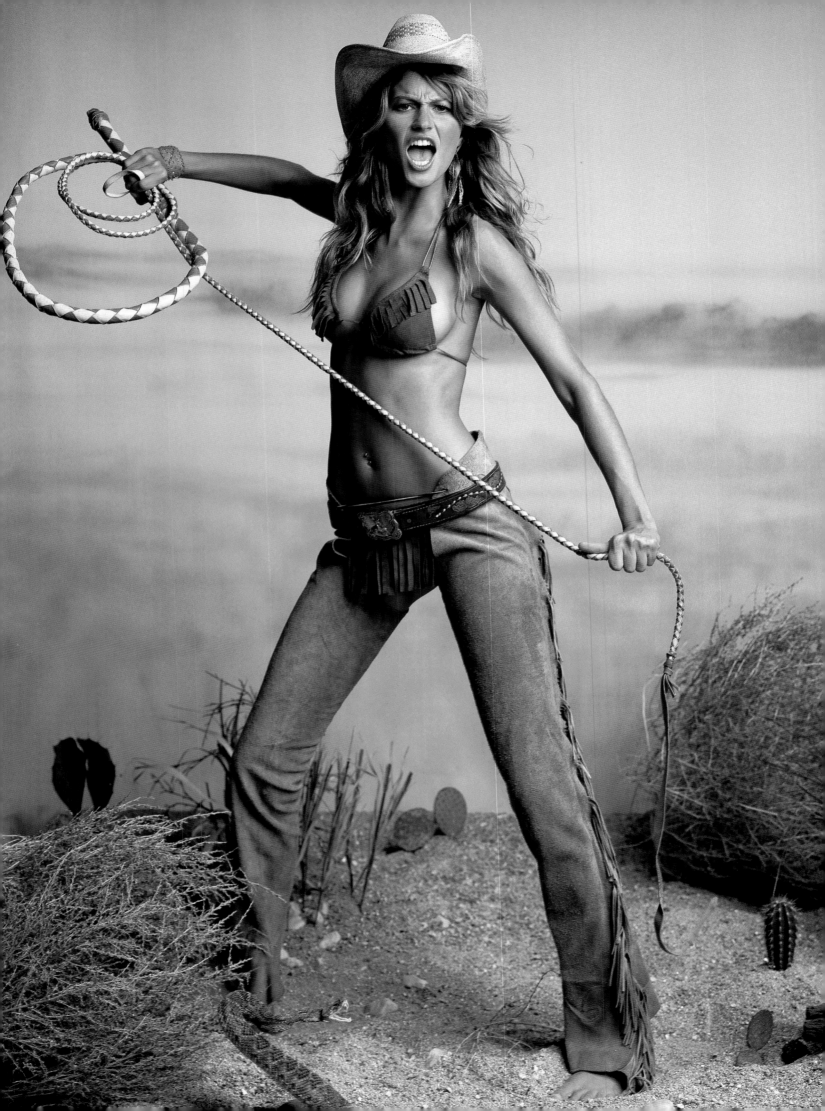

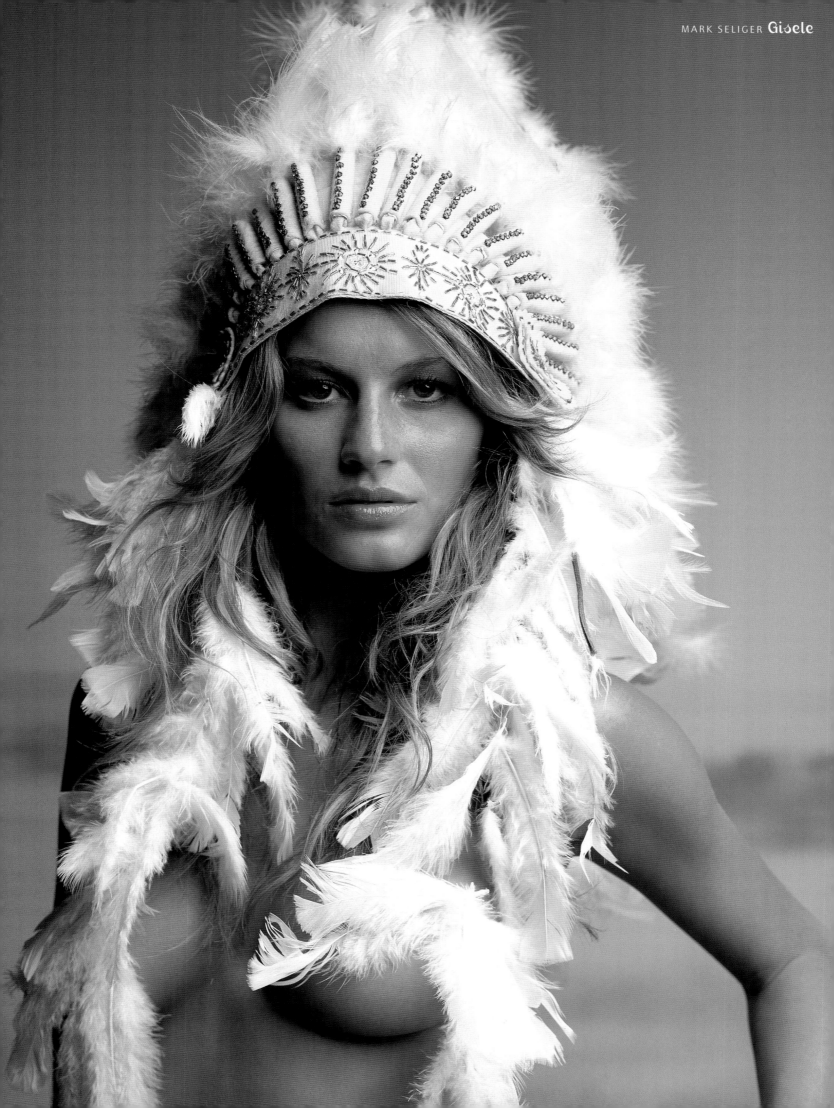

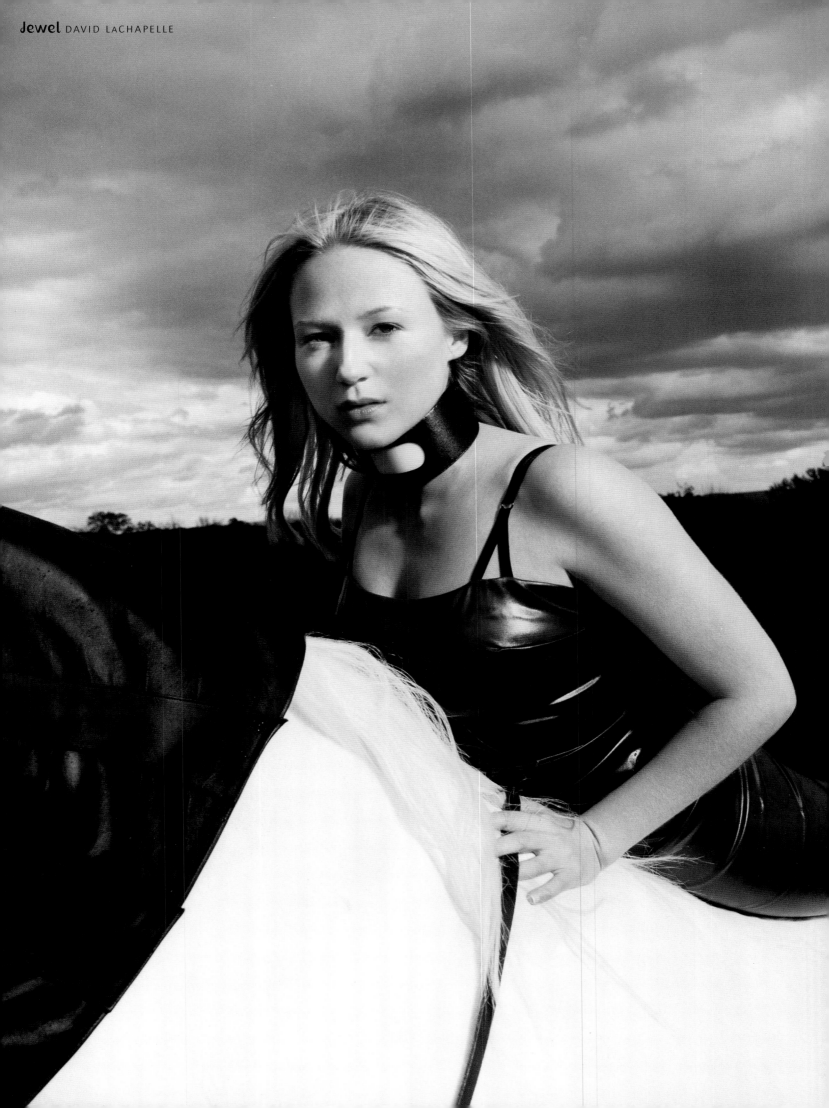

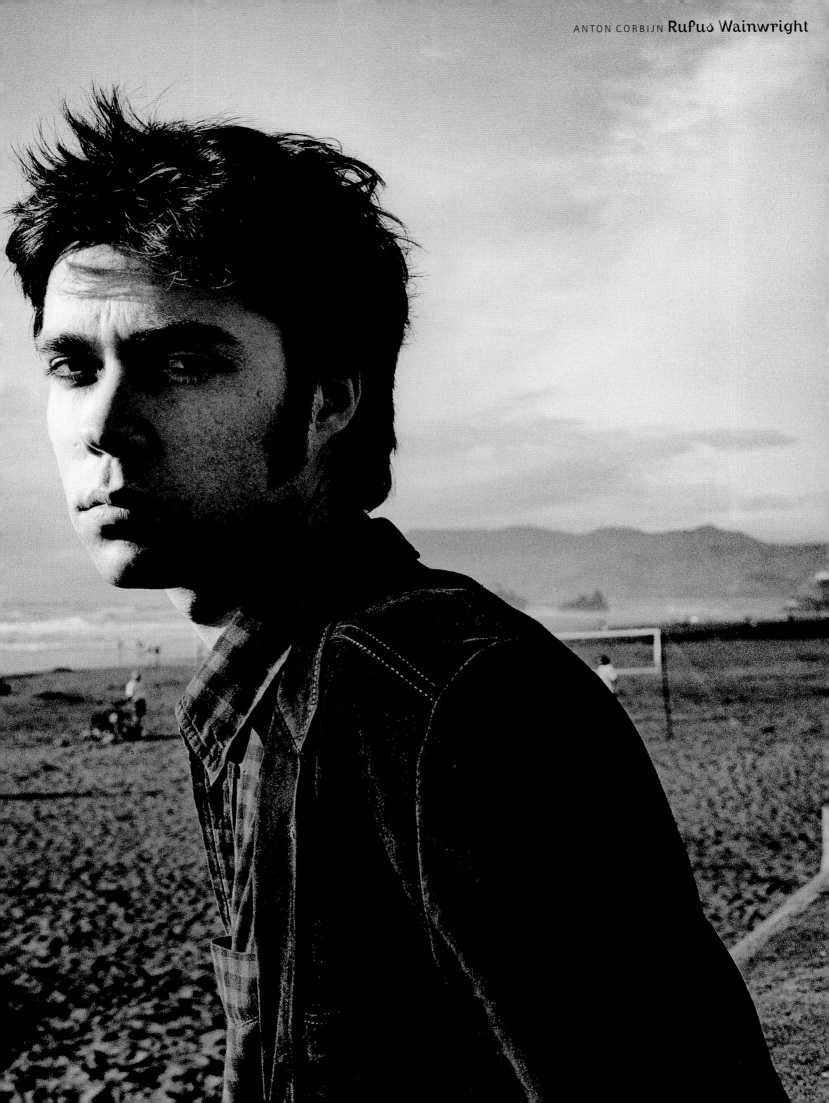

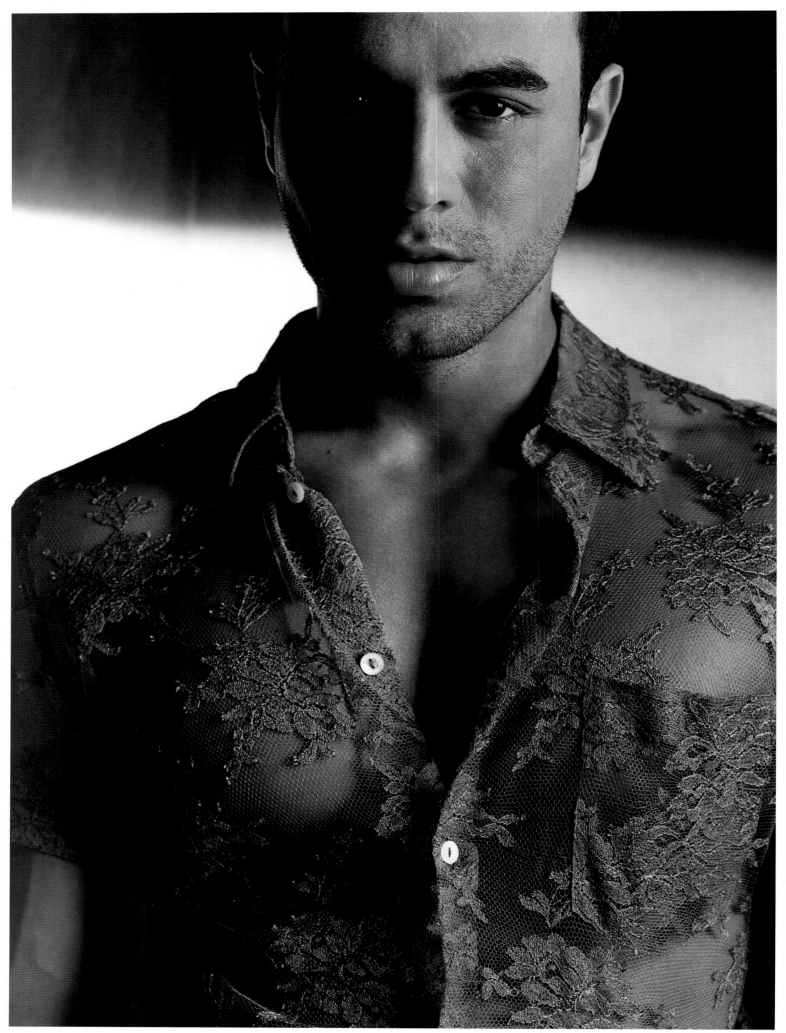

RANKIN Natalie Imbruglia»

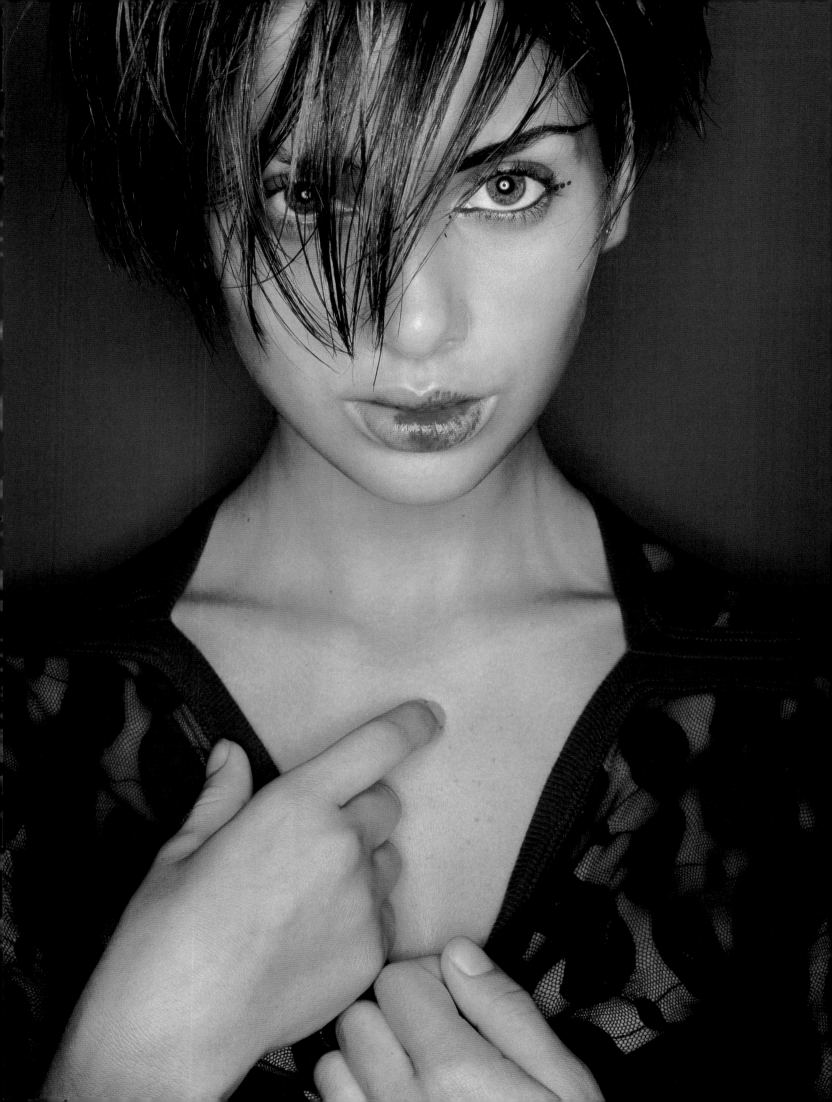

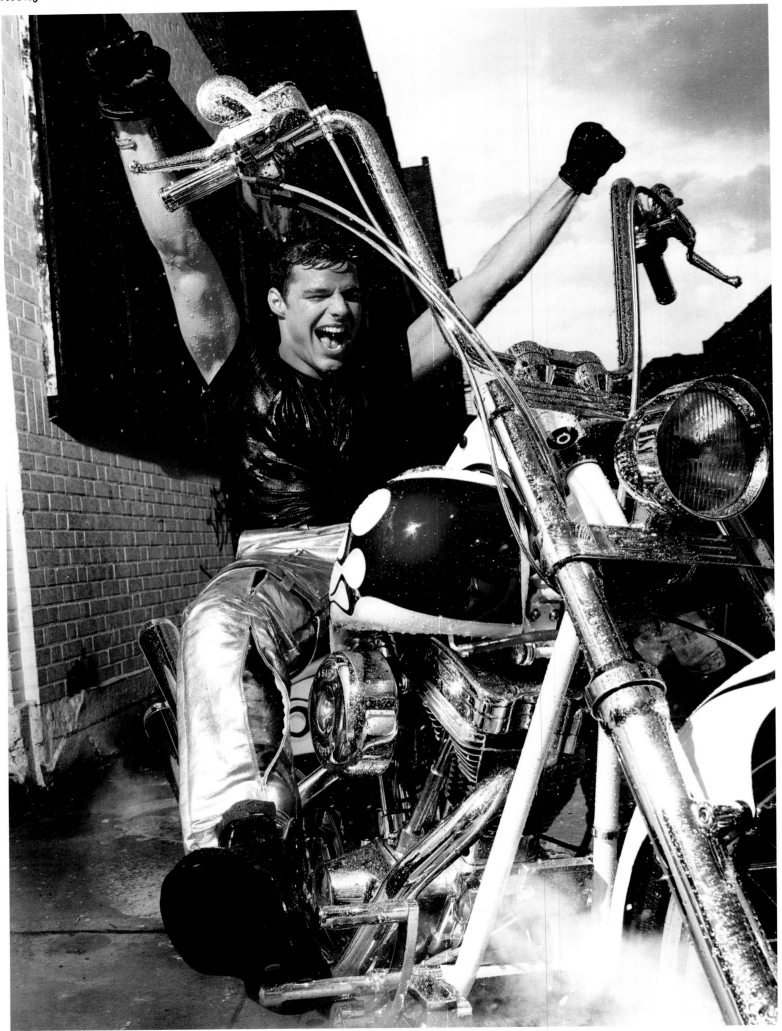

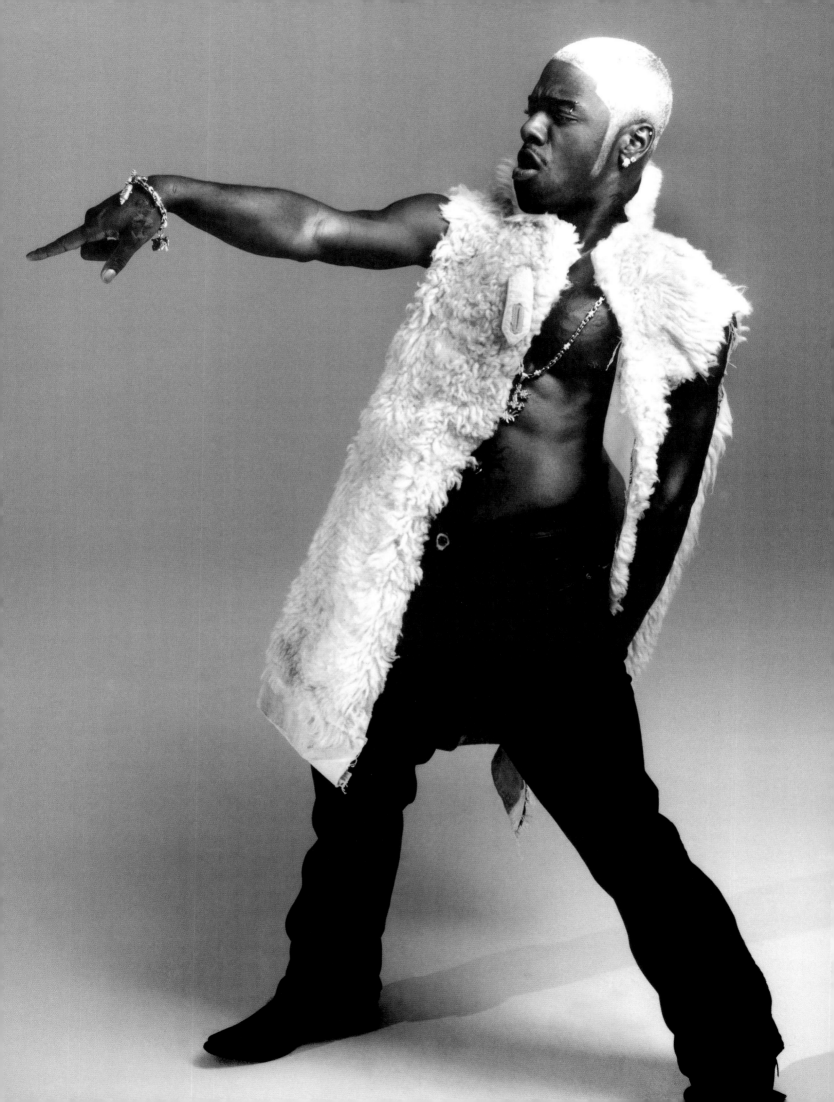

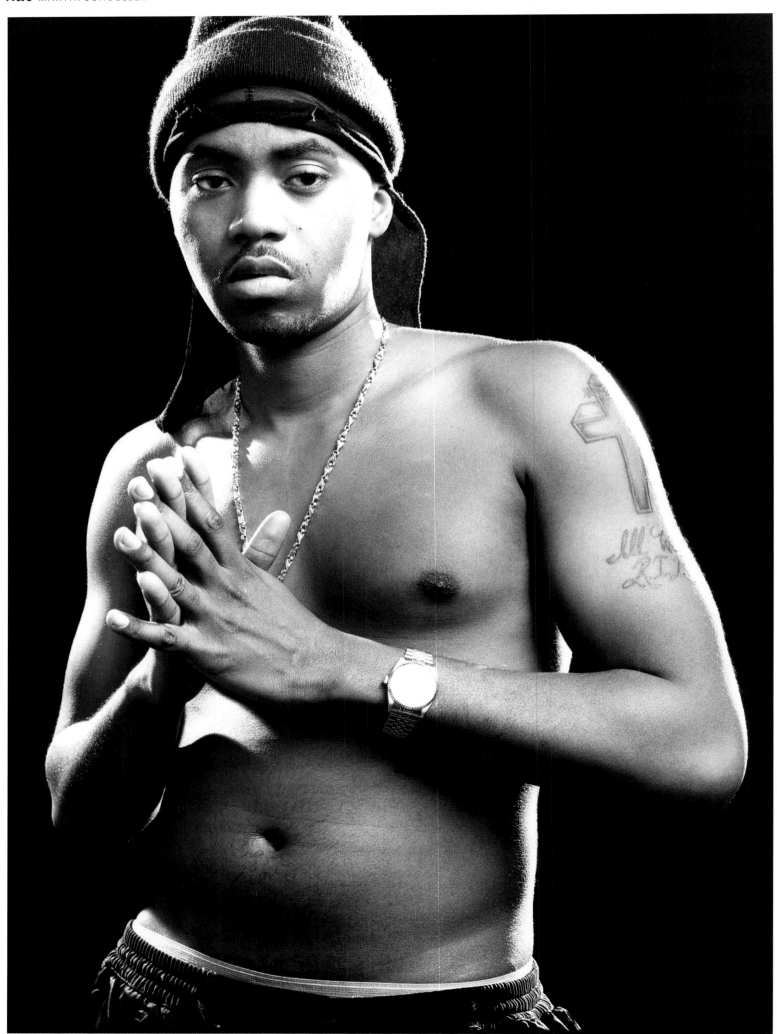

MARK SELIGER **Fiona Apple»**

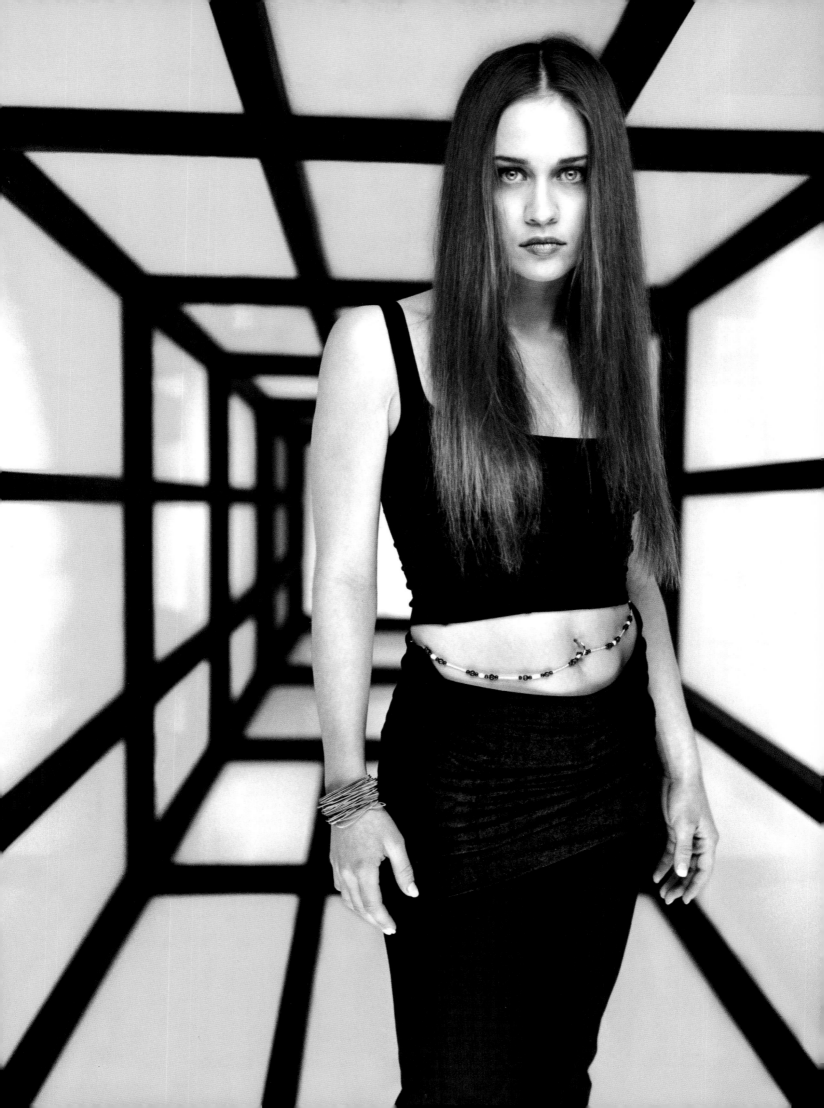

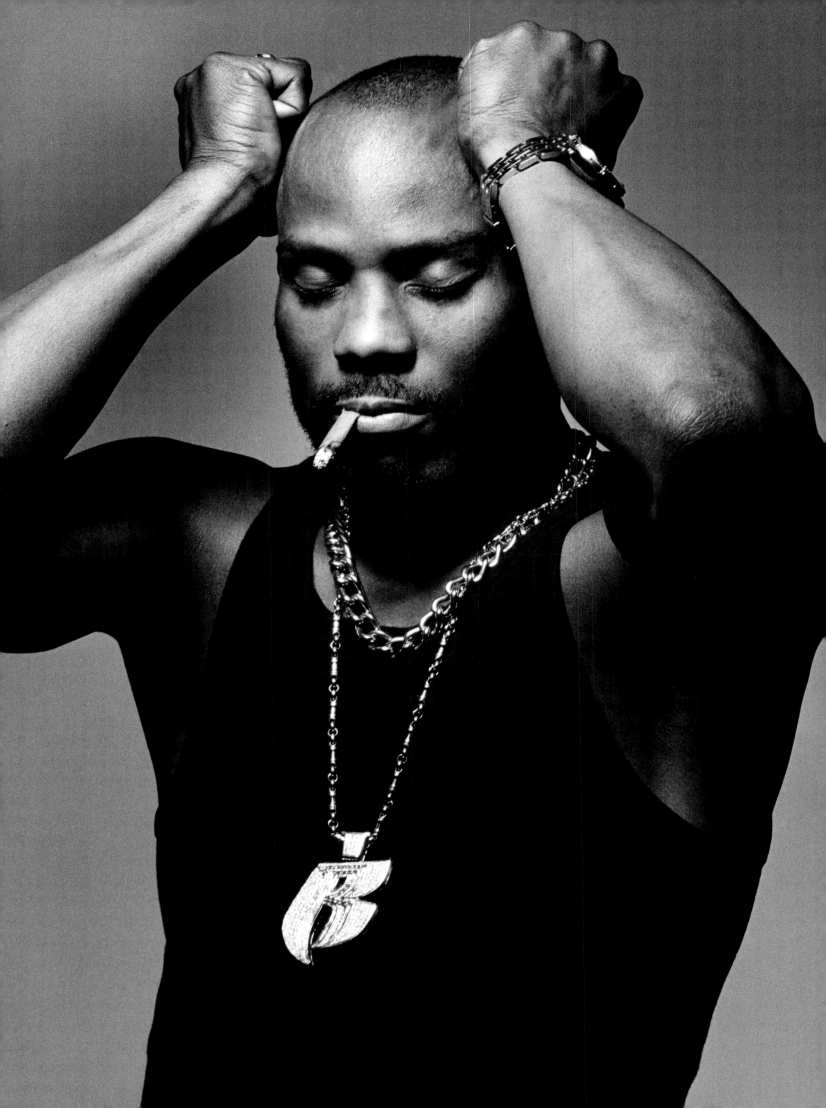

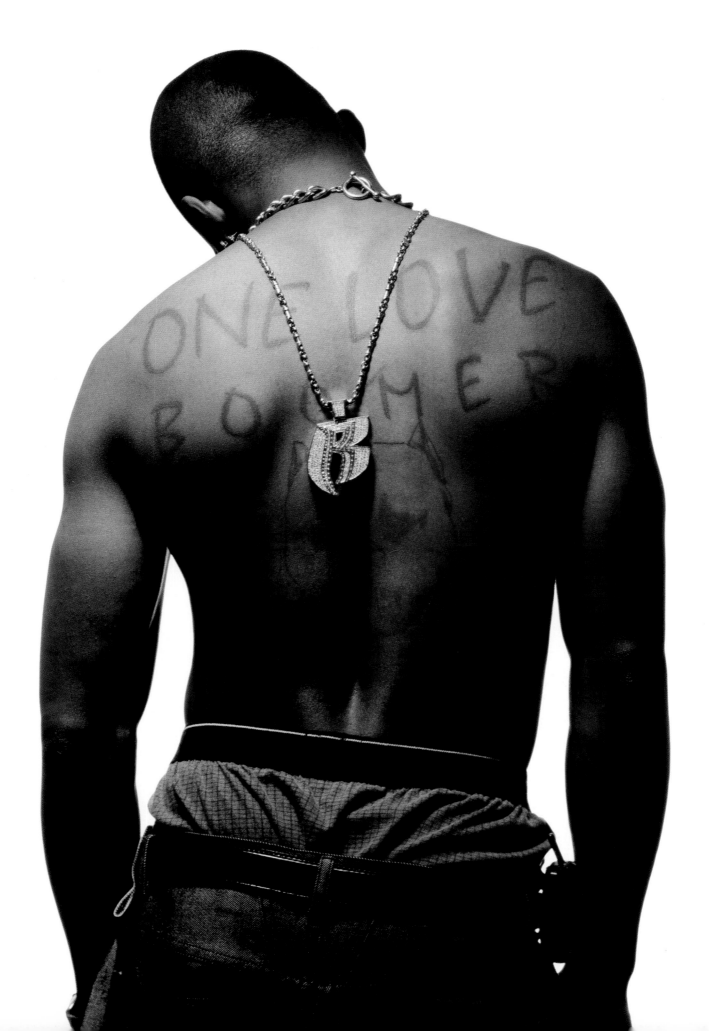

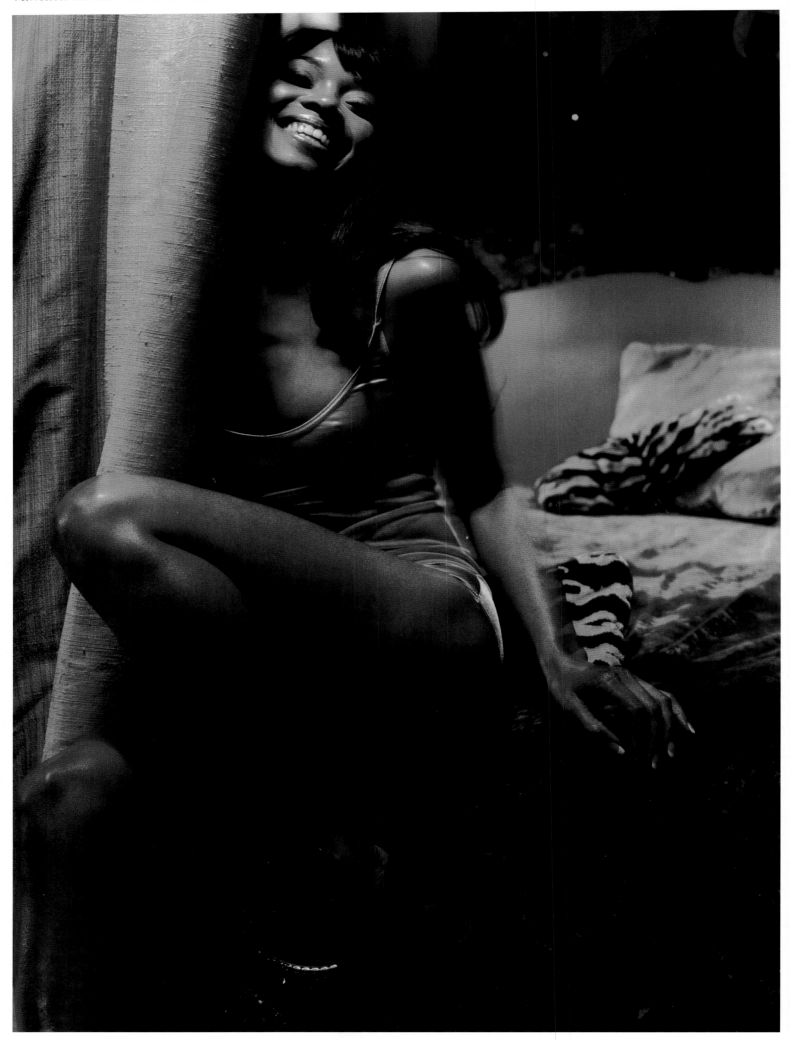

MARTIN SCHOELLER Sarah Polley»

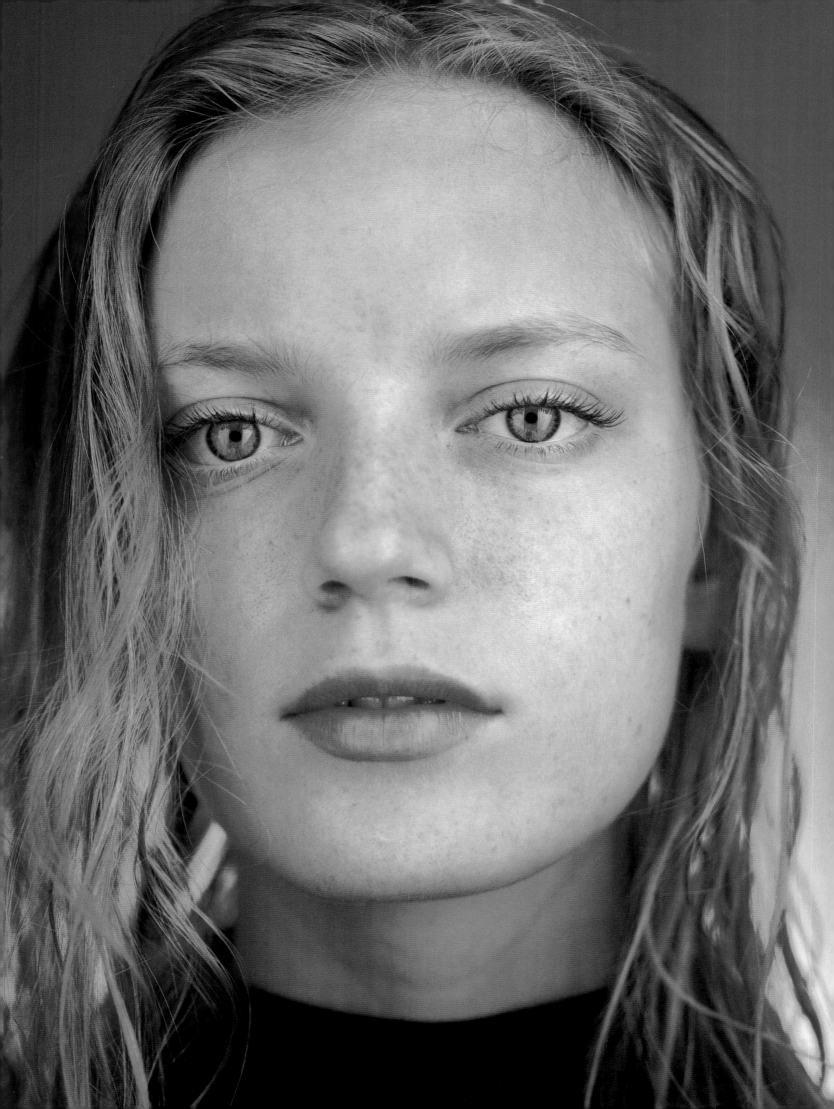

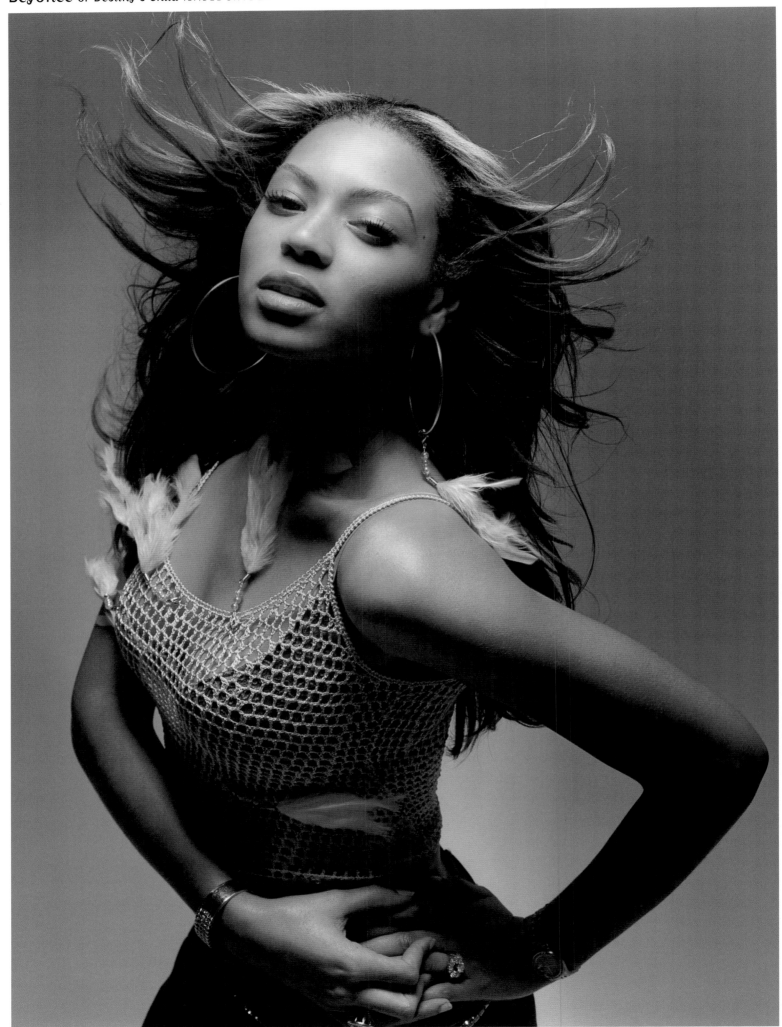

Sean Patrick Flanery *ISABEL SNYDER* »

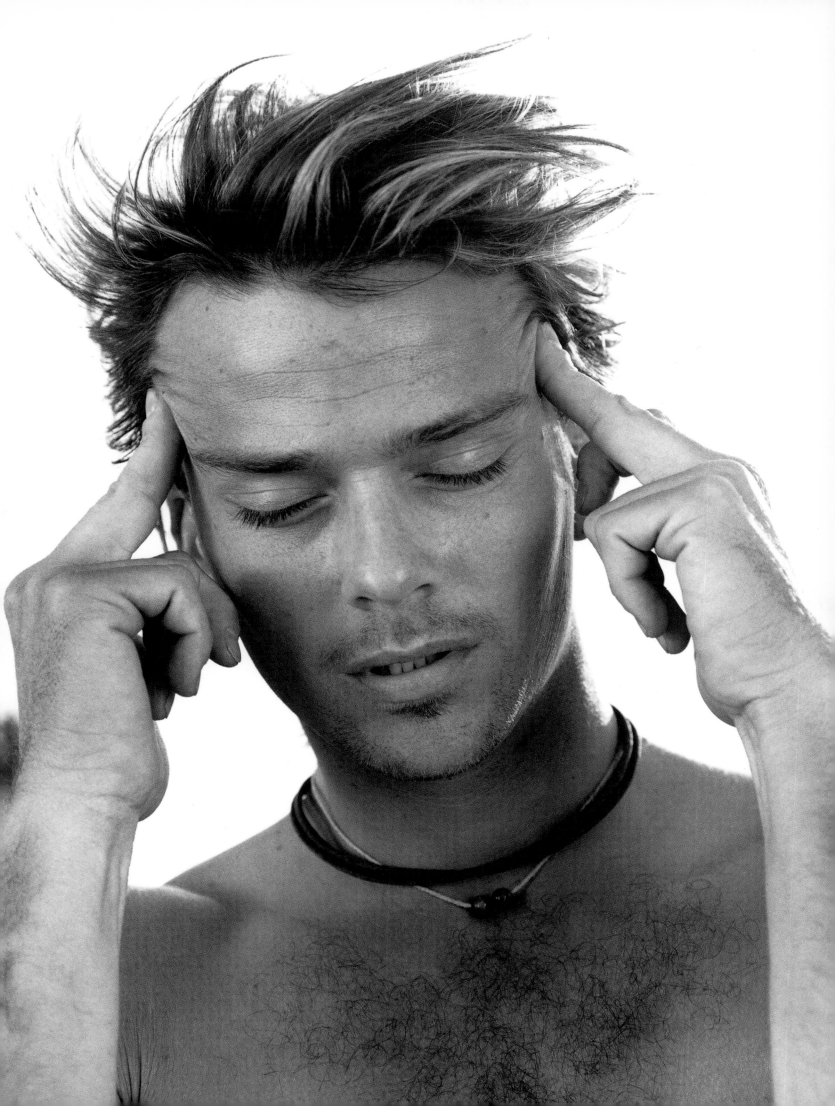

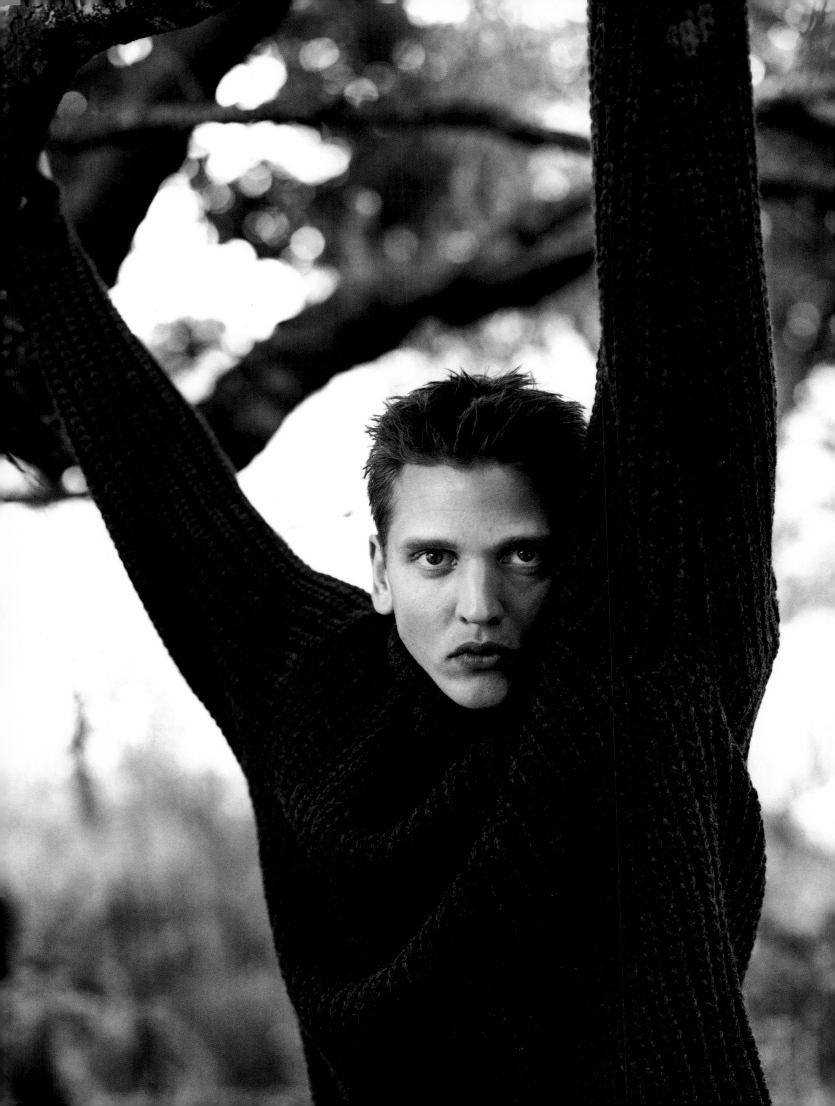

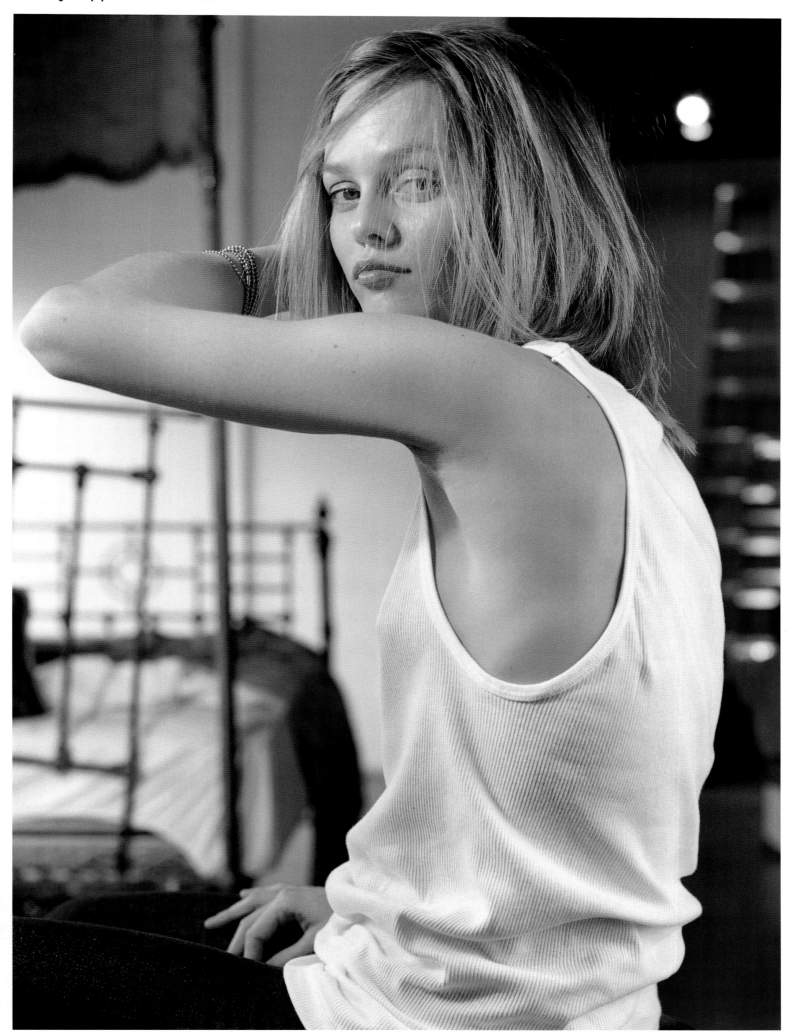

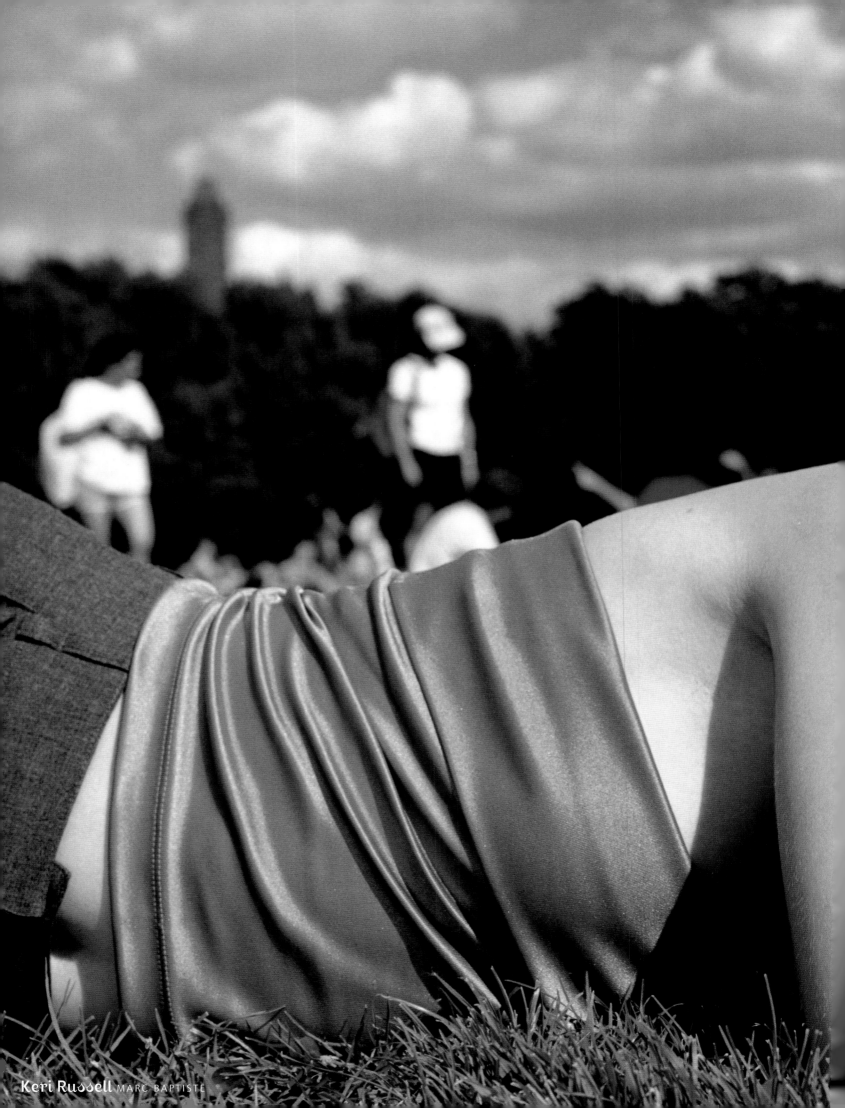

Keri Russell MARC BAPTISTE

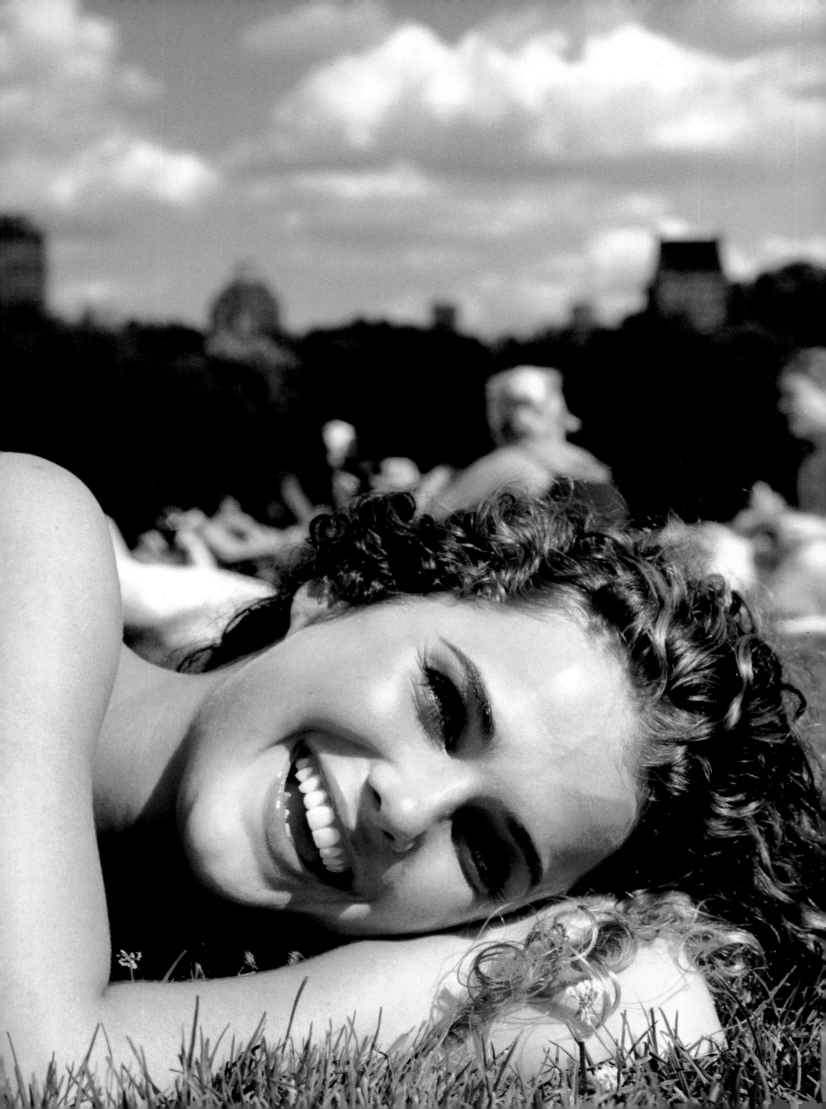

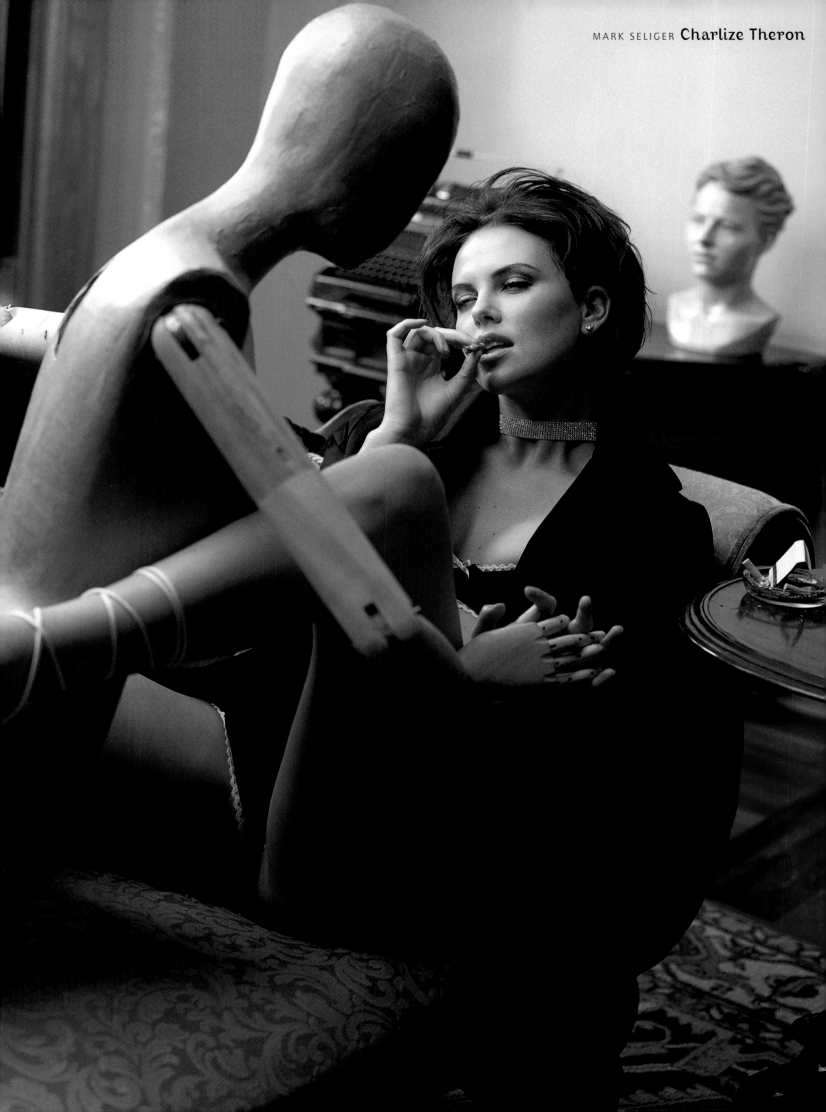

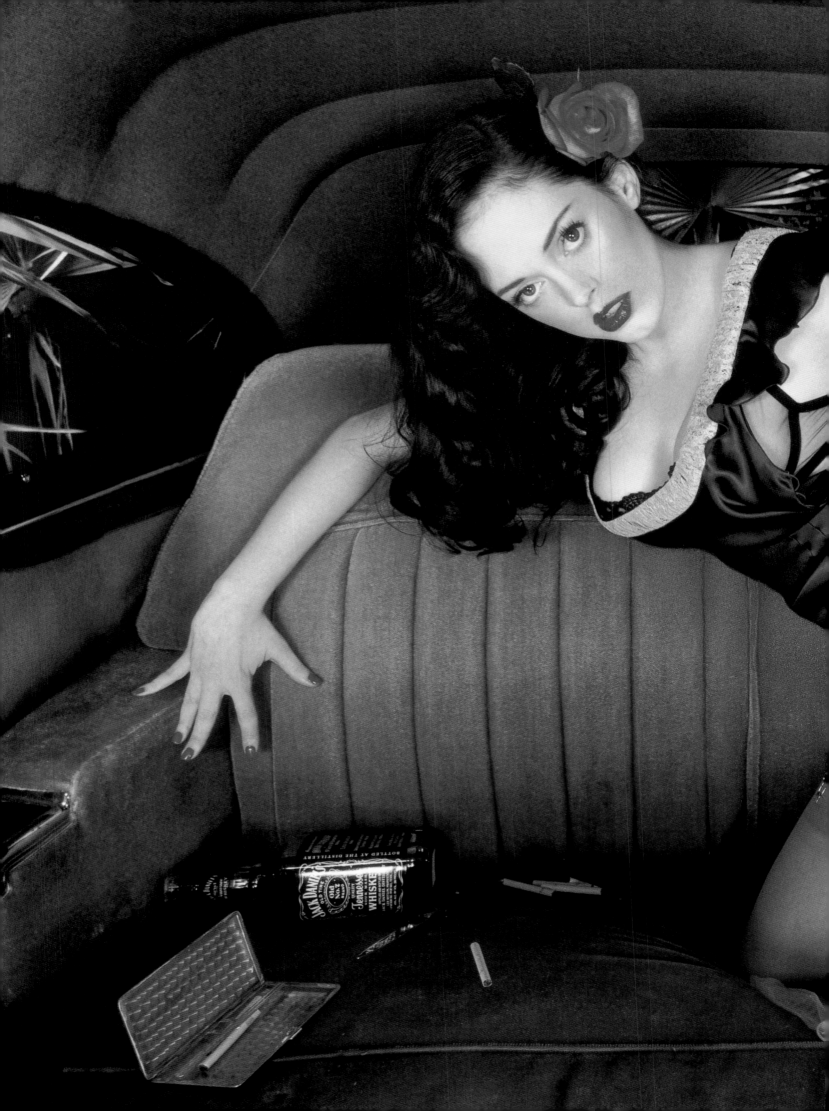

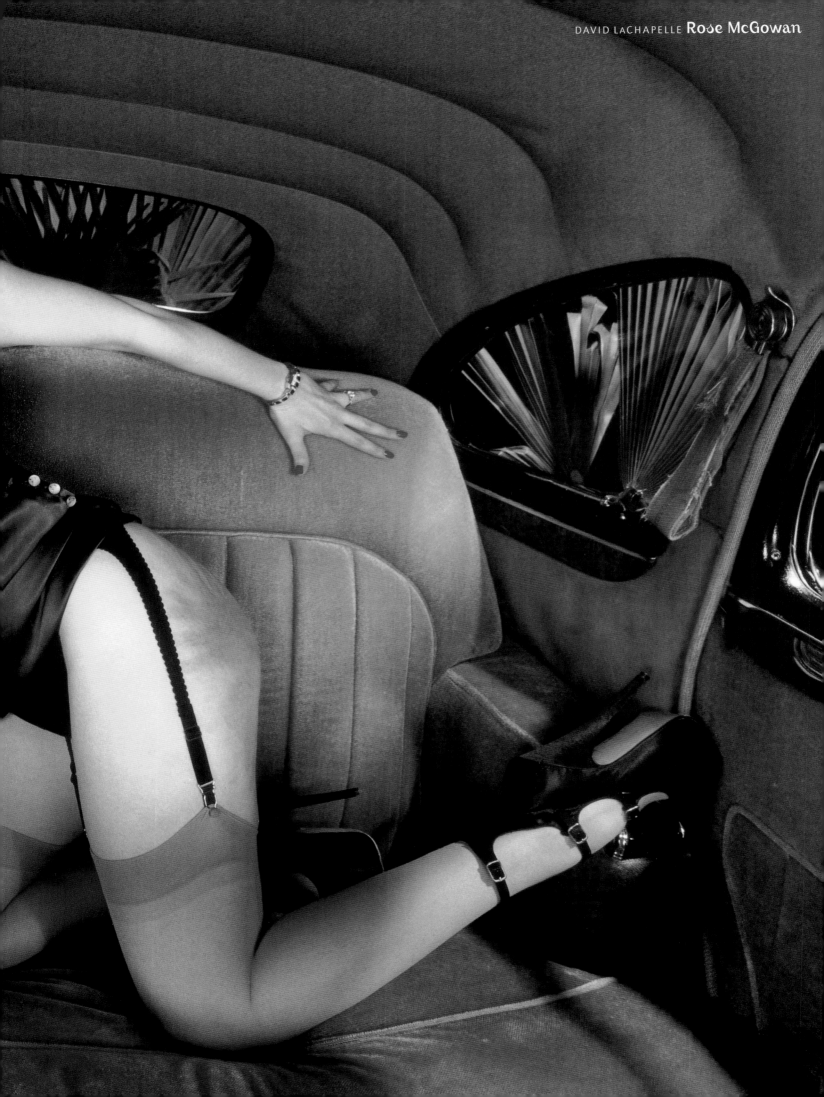

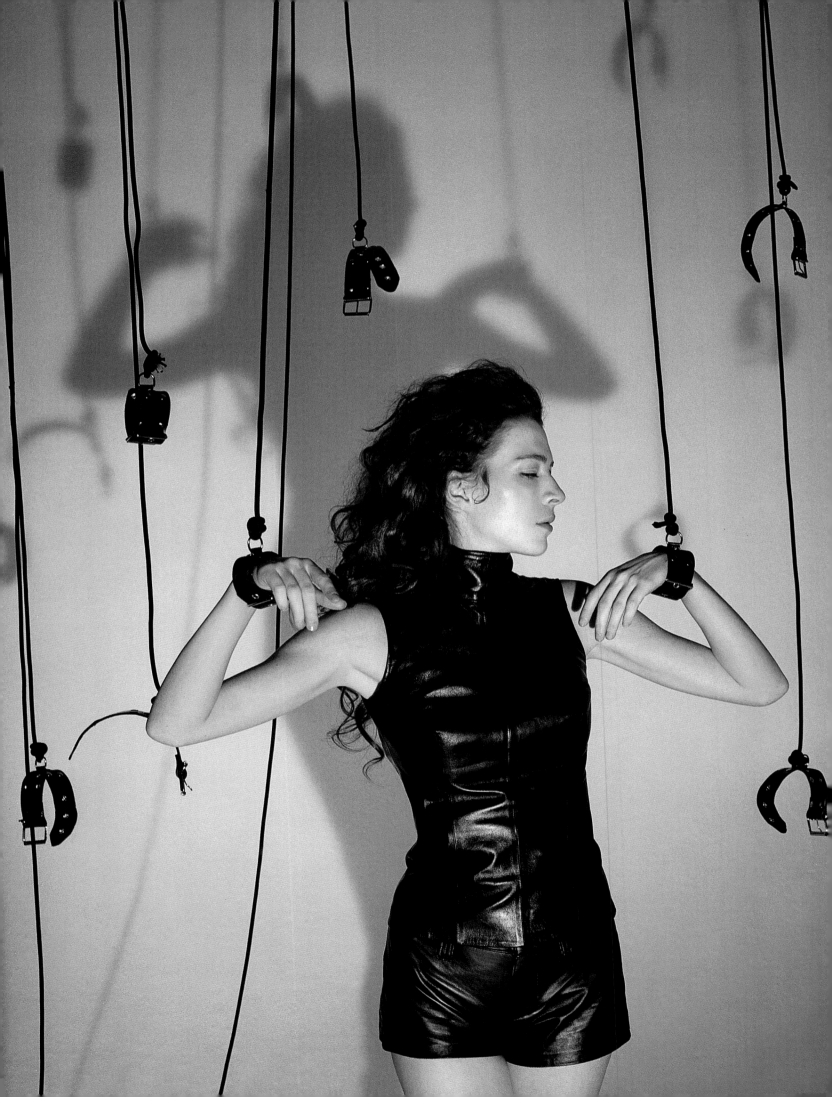

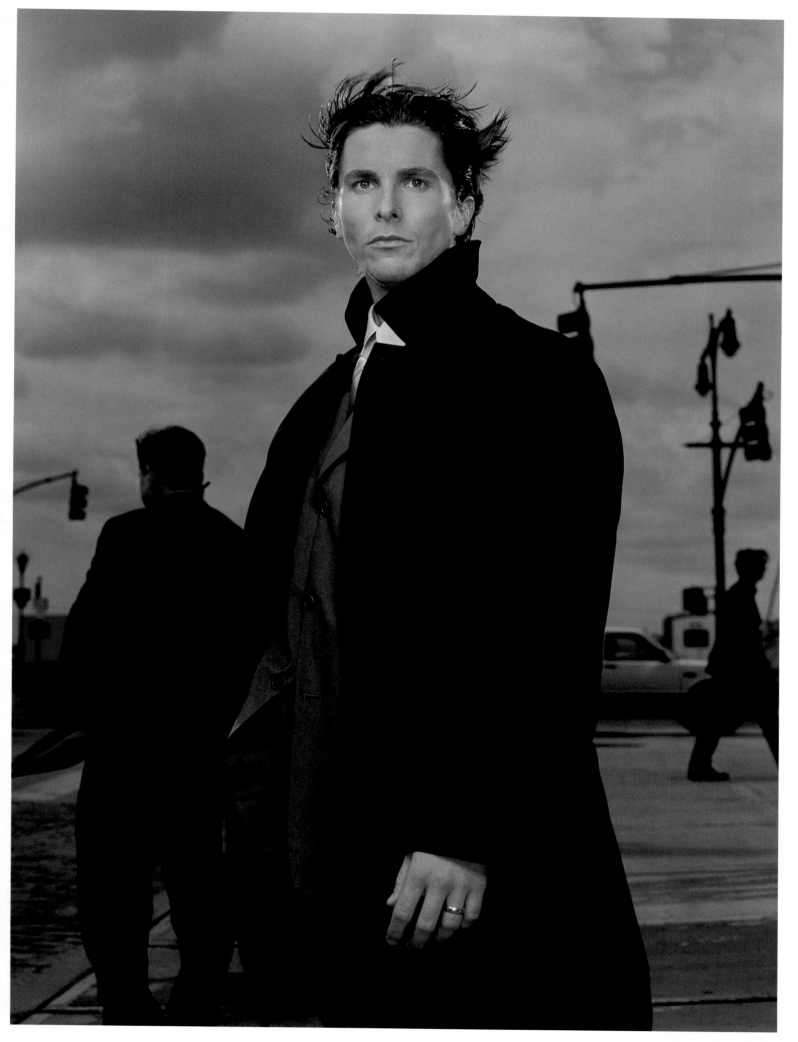

«Melissa Auf der Maur JEAN-BAPTISTE MONDINO

MARTIN SCHOELLER Christian Bale

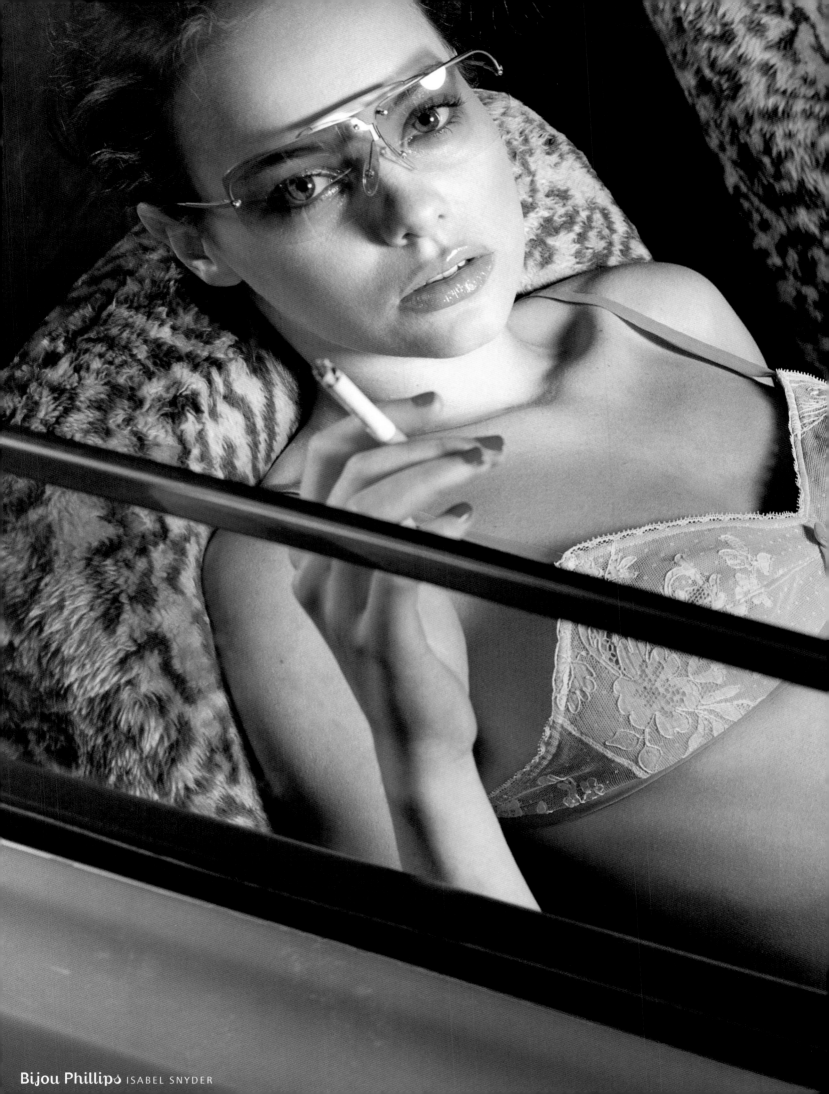

Bijou Phillips ISABEL SNYDER

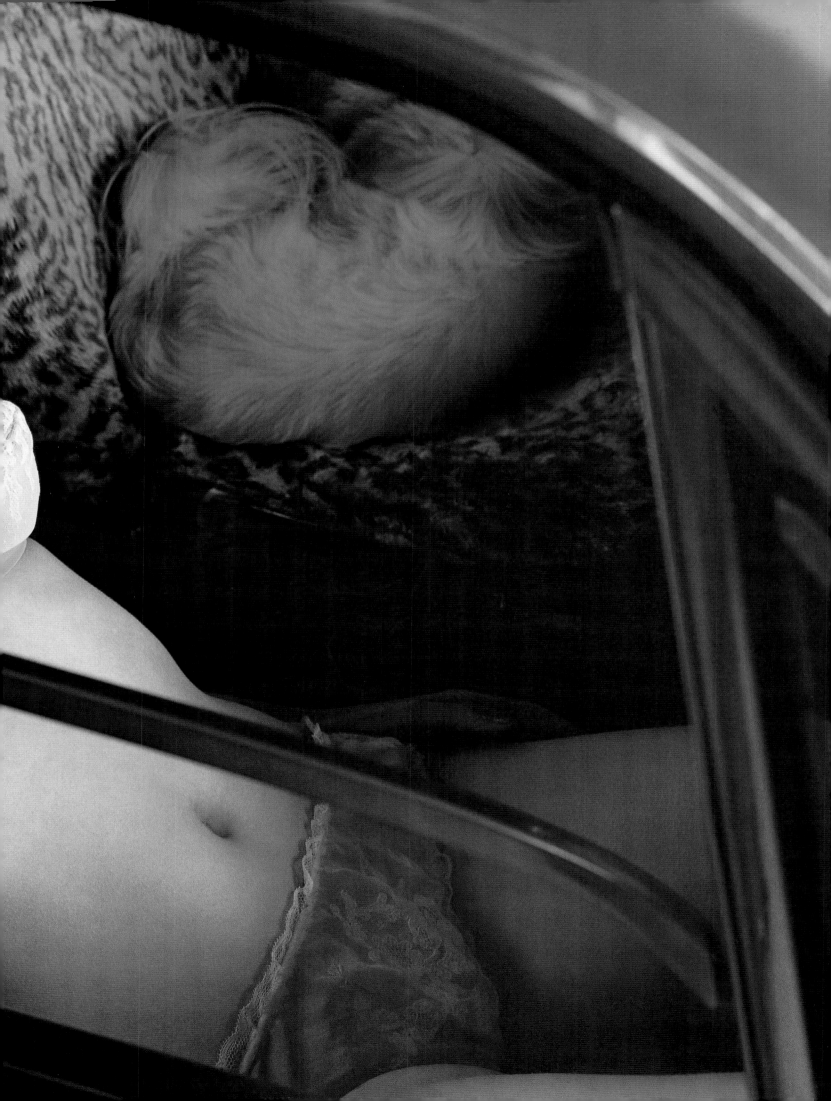

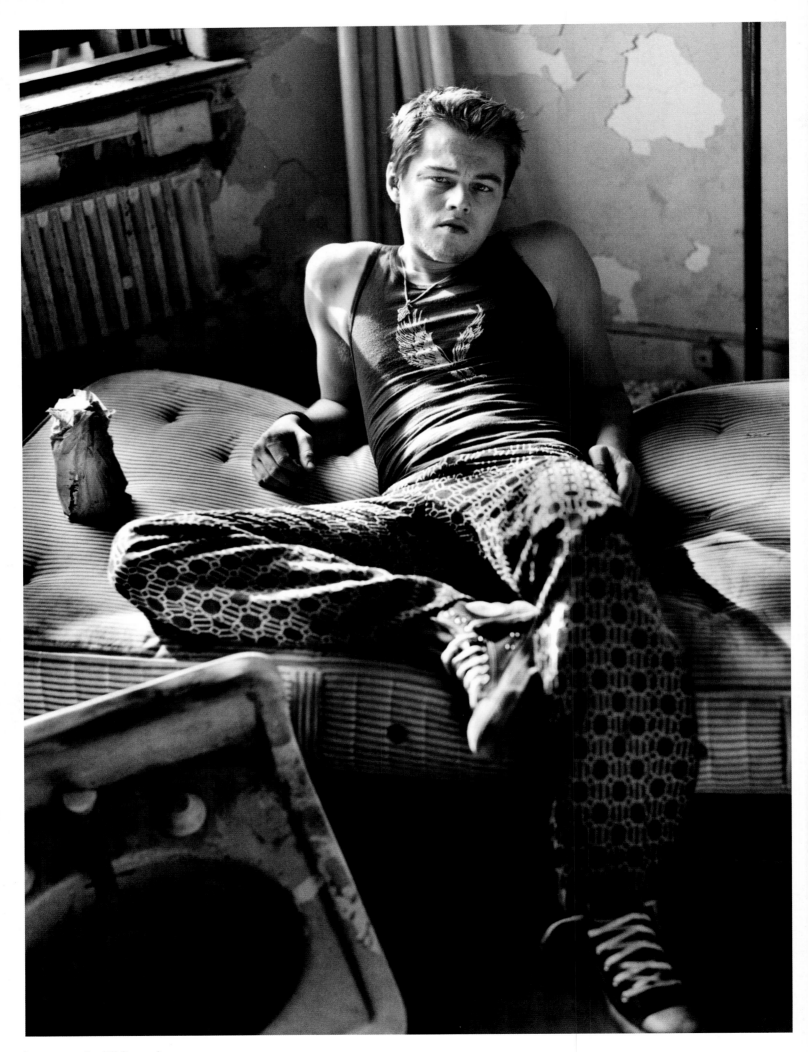

Leonardo DiCaprio MARK SELIGER

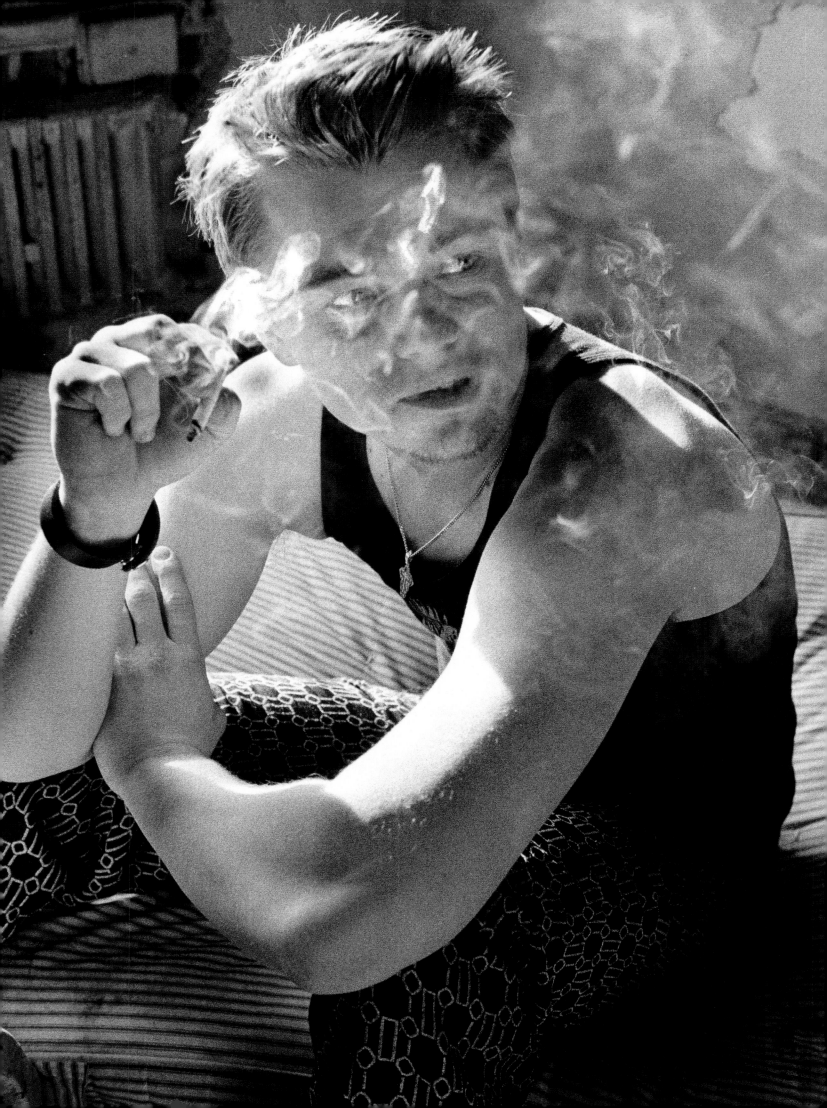

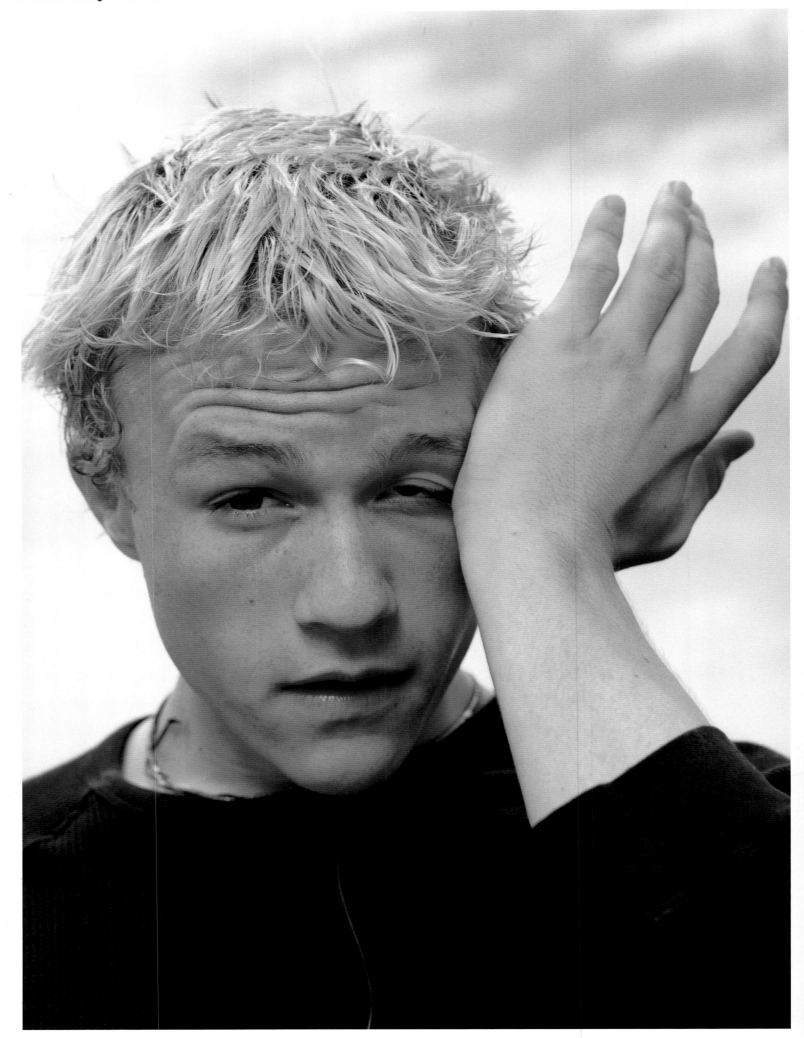

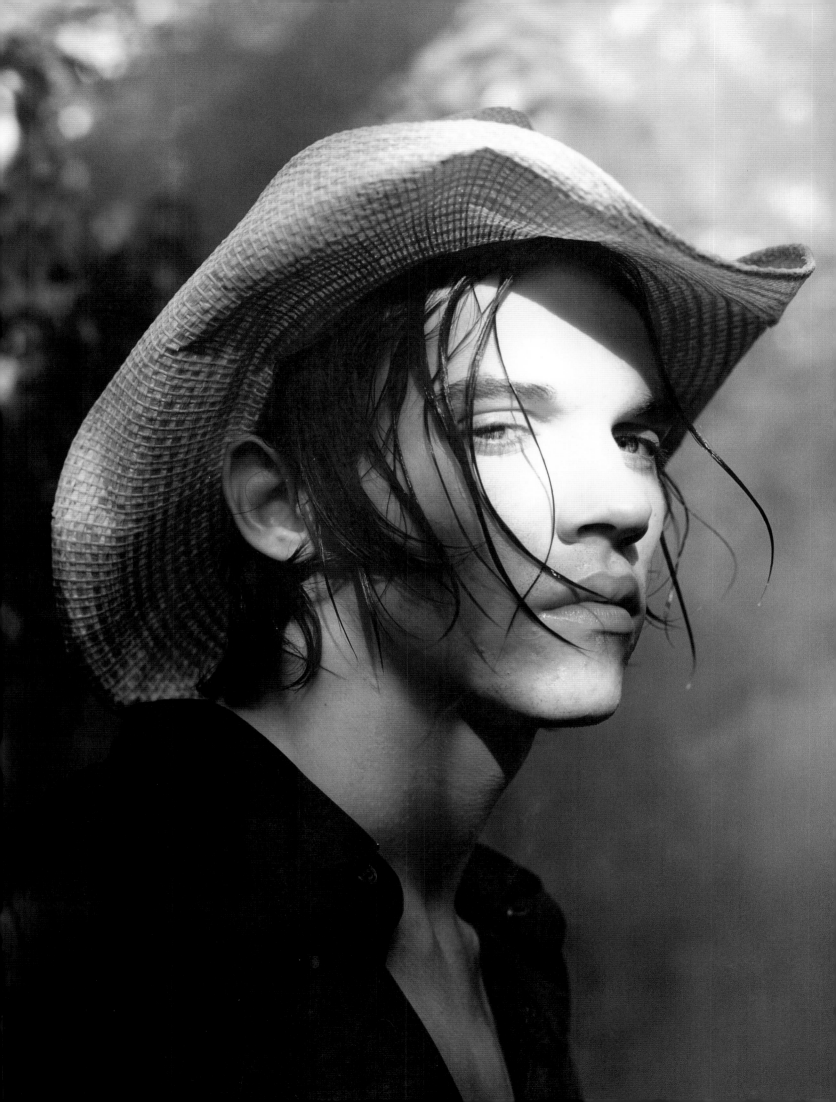

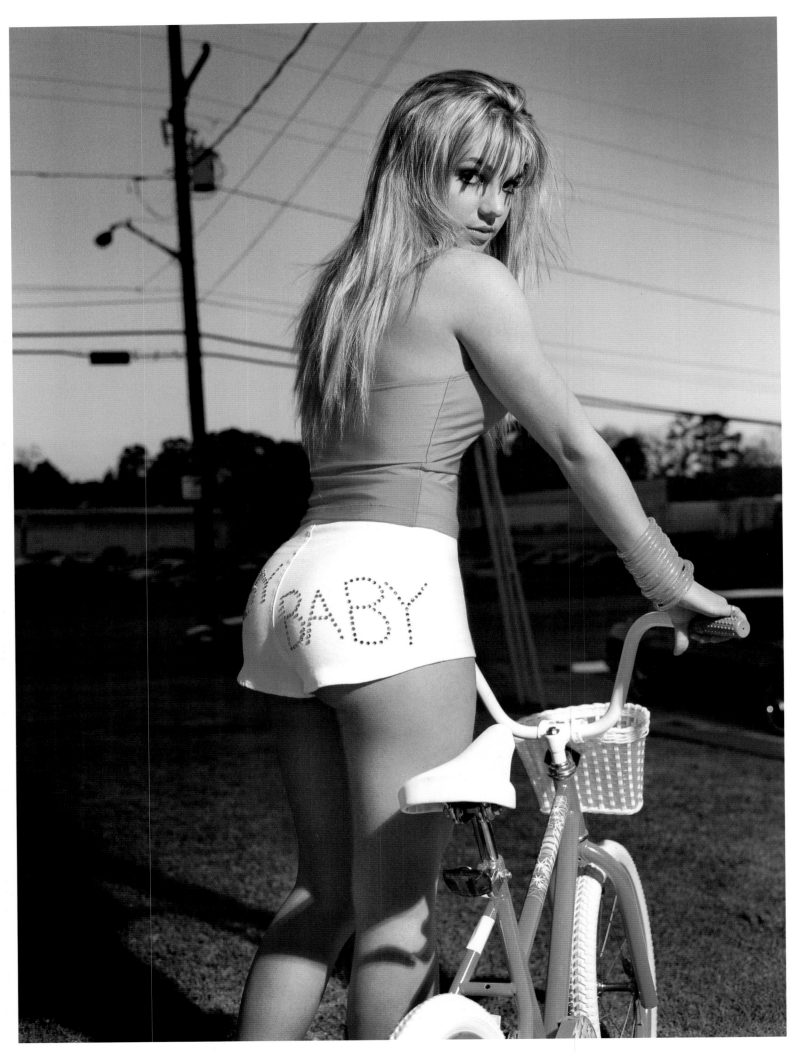

Britney Spears DAVID LACHAPELLE

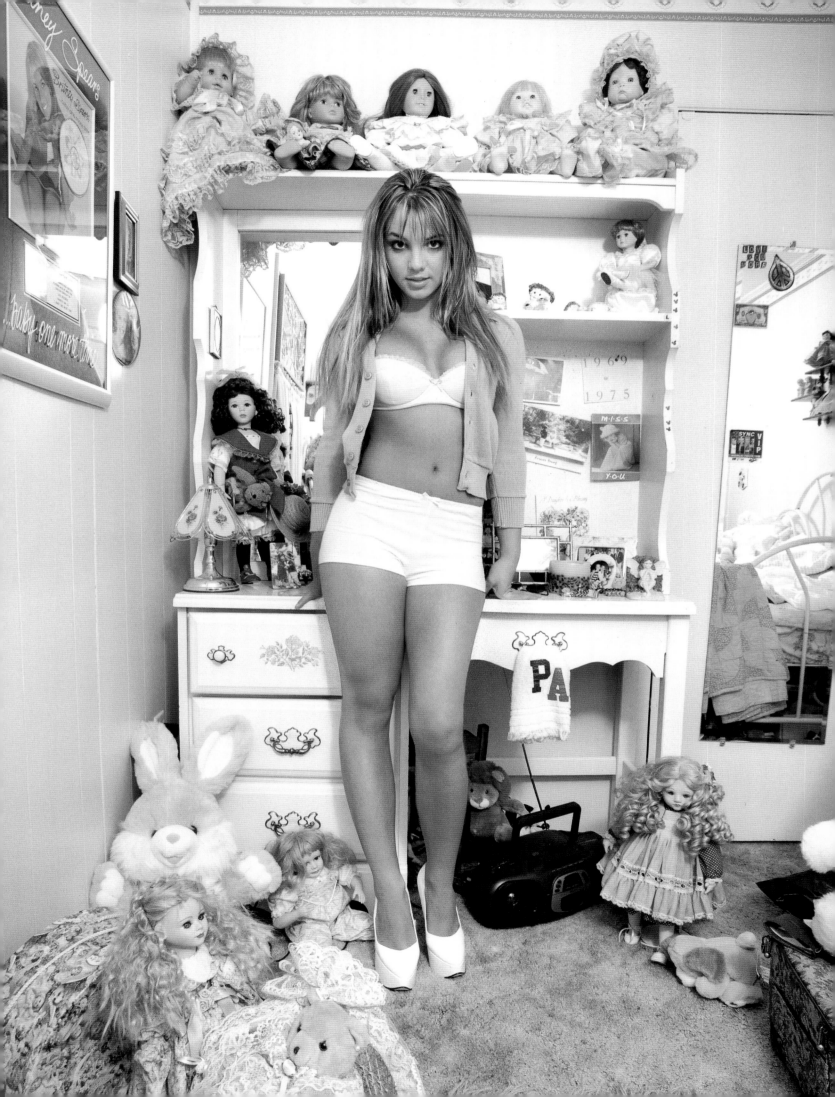

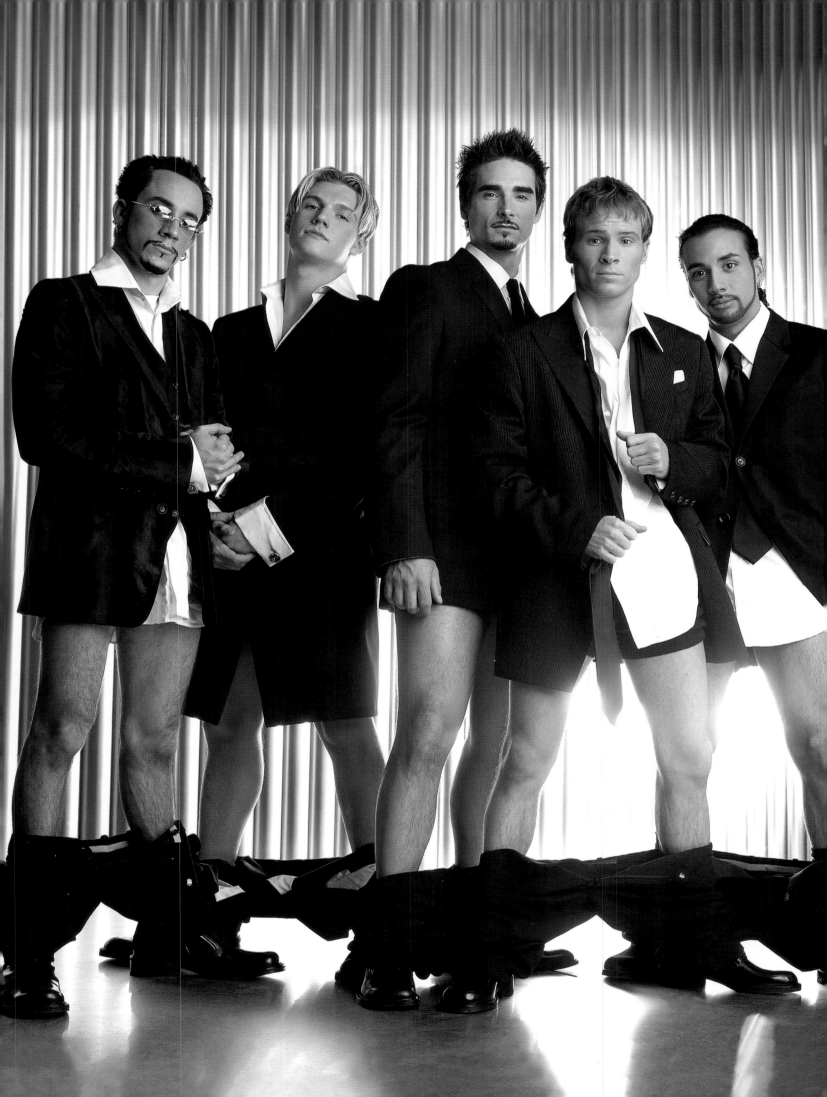

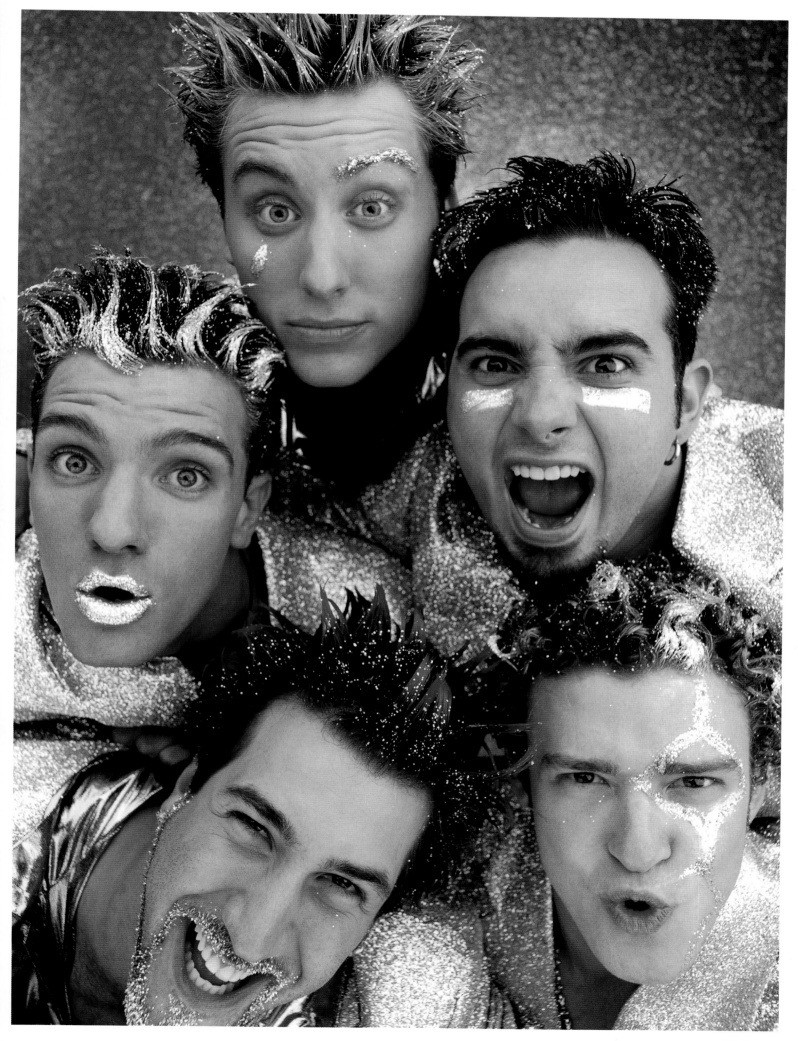

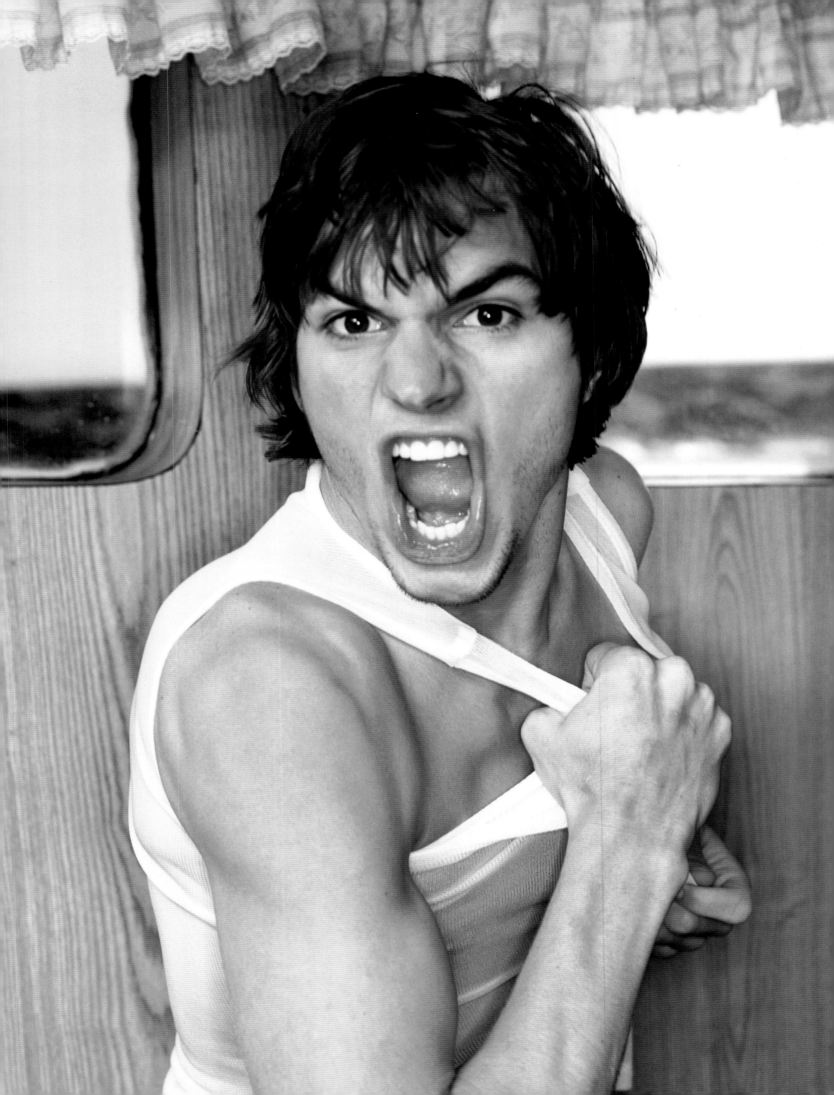

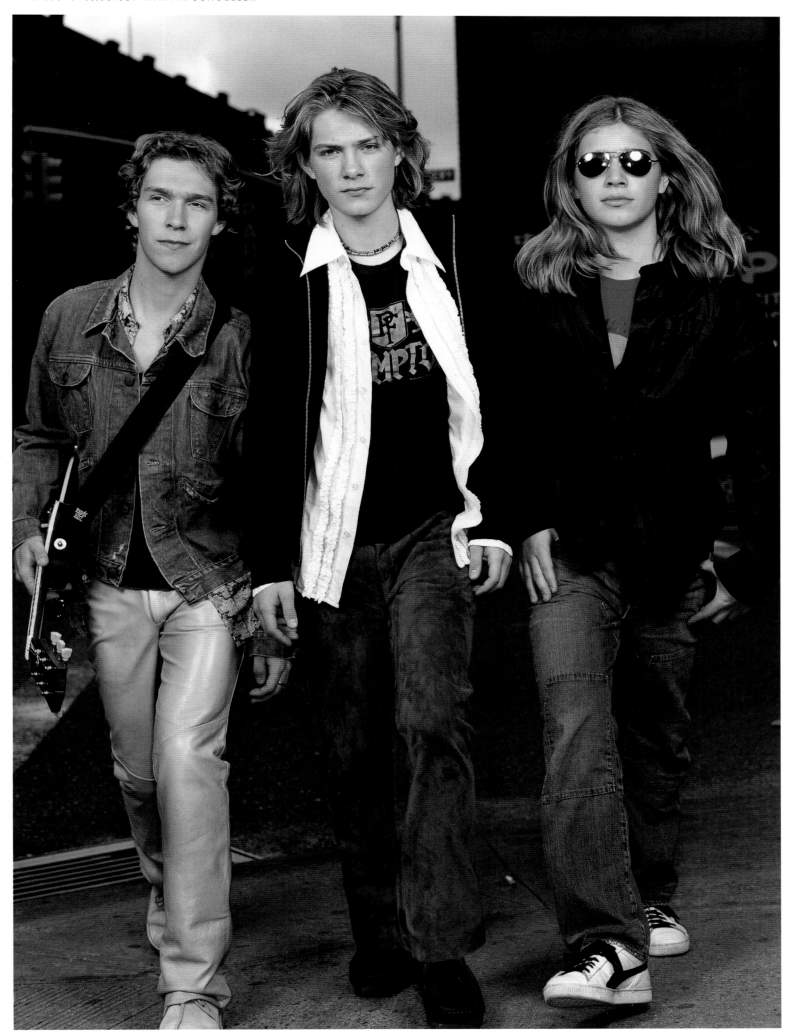

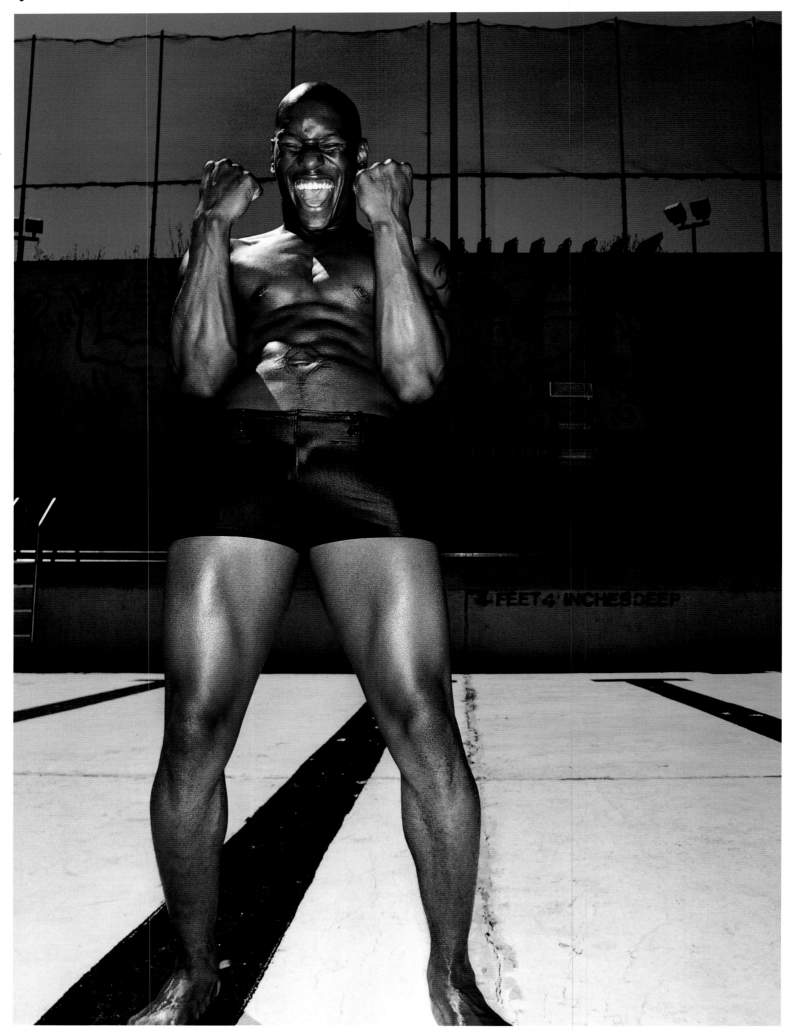

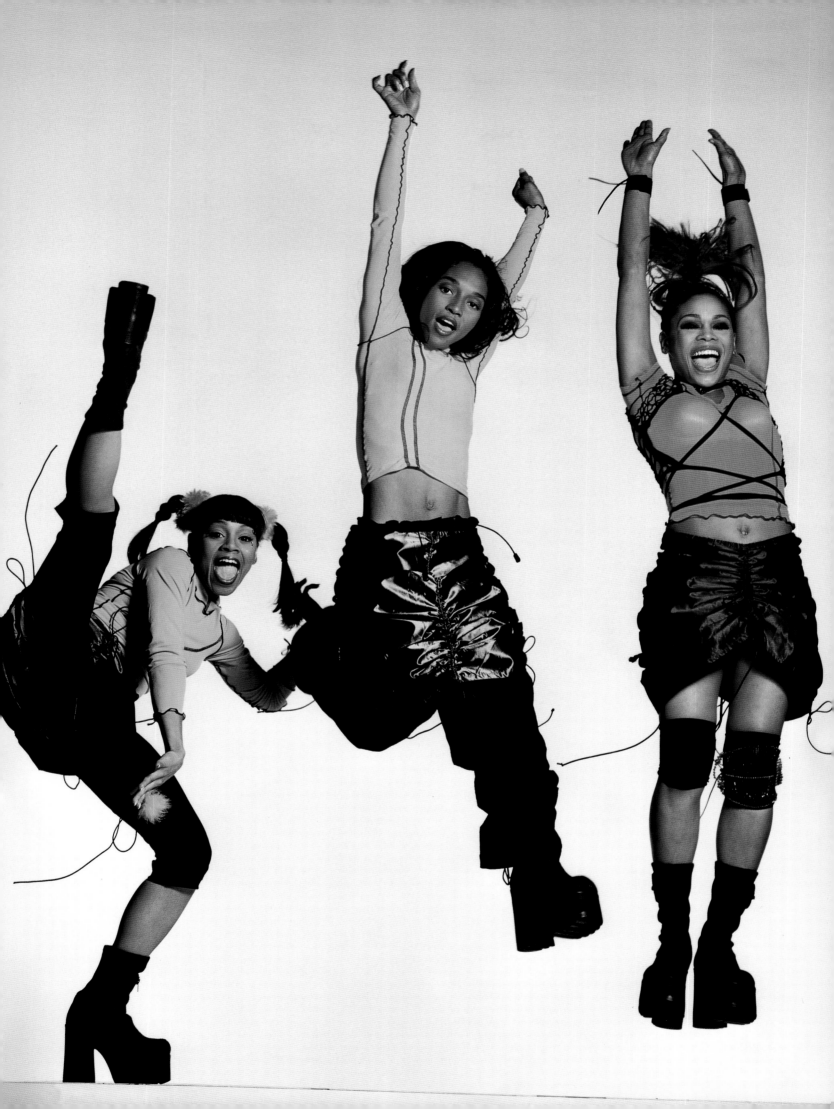

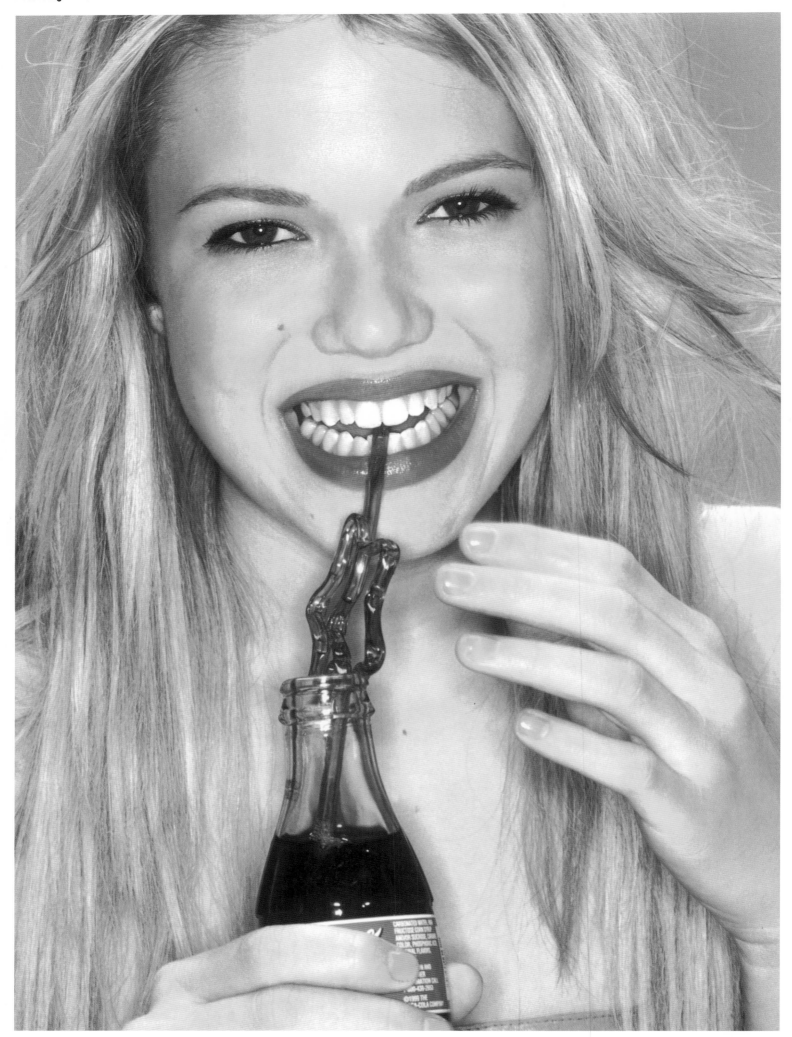

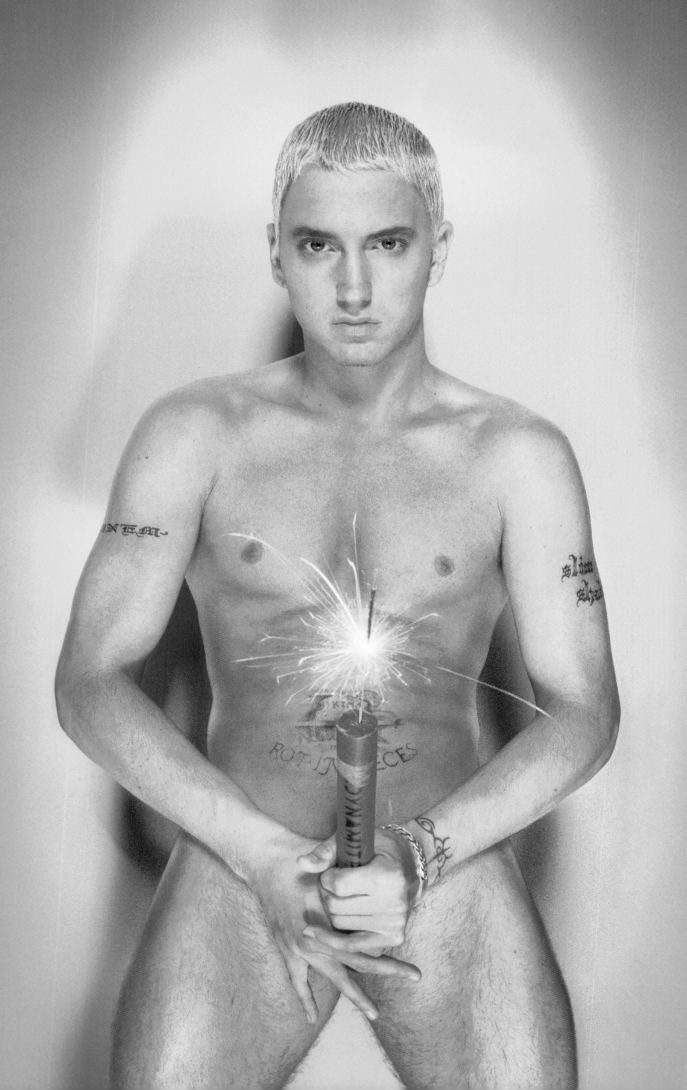

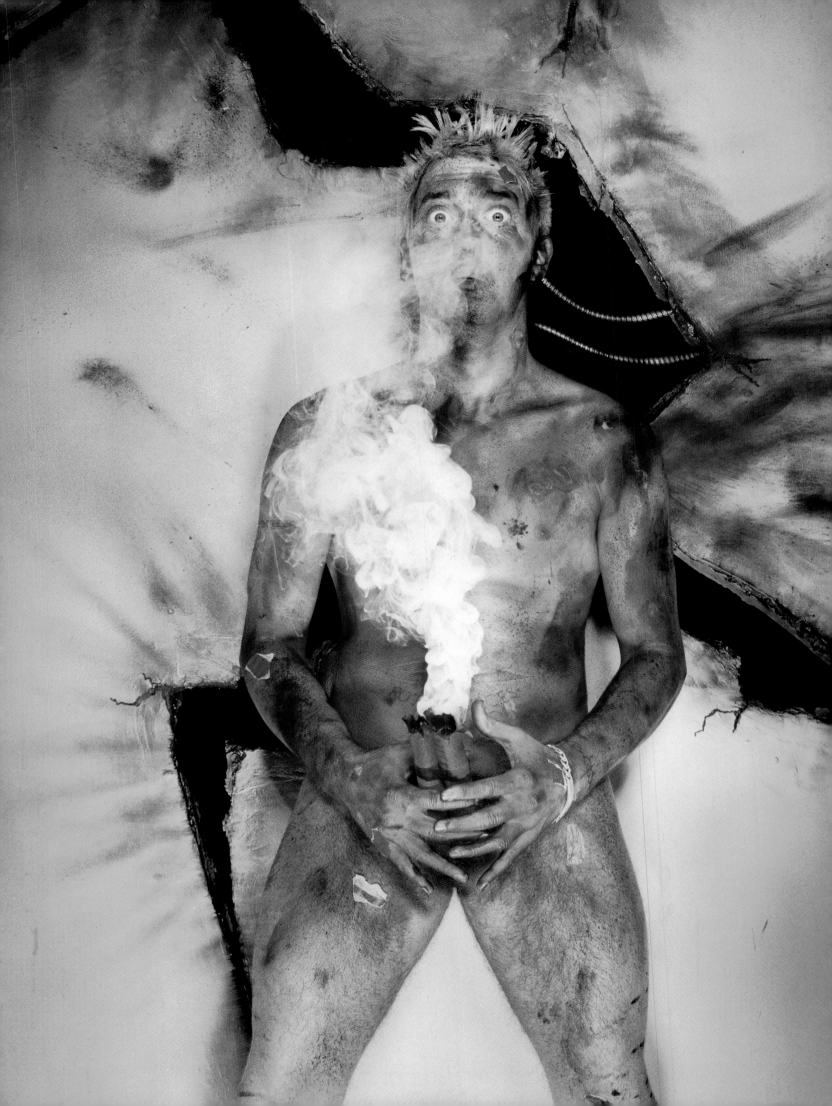

HotHouse

Editor: HOLLY GEORGE-WARREN
Associate Editor: KATHY HUCK
Assistant Editor: WENDY MITCHELL
Editorial Assistant: ANDREW SIMON
Editorial Contributor: DAVID WILD

Designer: FRED WOODWARD
Photo Editor: RACHEL KNEPFER
Design Associate: LEE BERRESFORD
Photo Researcher: ALLISON CAMPBELL

Production Consultants: RICH WALTMAN, DENNIS WHEELER

Front cover: ANGELINA JOLIE by MARK SELIGER
Back cover: TOBEY MAGUIRE by RICHARD PHIBBS

First published in the United Kingdom in 2000 by HarperCollinsIllustrated,
an imprint of HarperCollinsPublishers, 77–85 Fulham Palace Road,
London, W6 8JB.

The HarperCollins website address is:
www.fireandwater.com

A CIP catalogue record for this book is available from the British Library.

ISBN 0-00-710835-4

Printed in Singapore.

Additional Photography Credits

A+C Anthology (Inez van Lamsweerde & Vinoodh Matadin);
The Agency (Stewart Shining); Art Mix (Davis Factor); Corbis Outline (Marc
Baptiste, Justin Case, Tony Duran, David LaChapelle, Torkil Gudnason,
George Holz, Naomi Kaltman, Robert Maxwell, Richard Phibbs, Stephanie
Pfriender, Peggy Sirota, Isabel Snyder, Lance Staedler); Icon International
(Robert Erdmann); Industrie Representatives (Robert M. Ascroft II); Julian
Meier (Guy Aroch); L.Ed Services (Jeff Riedel); Saba (Martin Schoeller).

Acknowledgments

For their help in the creation of *HotHouse*, Rolling Stone Press would like to thank Fred Woodward, Lee Berresford, Rachel Knepfer, Allison Campbell, David Wild, Rich Waltman and Dennis Wheeler.

Our gratitude also goes to Wenner Media's Jann S. Wenner, Kent Brownridge, John Lagana, Evelyn Bernal, Kathy McCarver, Brittain Stone, Janice Borowicz and Hubert Kretzschmar. In addition, we couldn't have done it without the input of Sarah Lazin, Cory Halaby and Kimberly Perdue. And we're most appreciative of our editors at ReganBooks: Judith Regan and Calvert Morgan, as well as Roni Axelrod, Cassie Jones and Andrew Yamato. Ann Abel, Chris Cooper, Josh Sturtevant, Agata Zak, David Sokosh, Samantha Schwartz, Carmel Tildesley and Joseph Braff also helped in various ways. Most of all, kudos to all the photographers whose work appears here, as well as their lovely subjects.